RACHEL GREENE is Executive Director of Rhizome.org, an online
resource and platform for new media art. Educated at the universities
of Pennsylvania and Sussex, she is also a former critical studies fellow in
the Whitney Museum's Independent Study Program. Greene has been
involved with promoting new media art since 1997 and is a frequent
contributor to art magazines and catalogues. Currently she is a curatorial
fellow at the New Museum of Contemporary Art in New York.

Thames & Hudson world of art

This famous series provides the widest available
range of illustrated books on art in all its aspects.

If you would like to receive a complete list
of titles in print please write to:

THAMES & HUDSON
181A High Holborn
London WC1V 7QX

In the United States please write to:

THAMES & HUDSON INC.
500 Fifth Avenue
New York, New York 10110

Printed in Singapore

UPLOAD ➡ cannibalcorpse.mp3 BROWSE ➡ choose

SOUND OFF

roll over stripes
and choose a colour.

click songs to listen.

choose a song and drag
it onto the cd.

DOWNLOAD bb0061 db0005 sk0233 bb0061 db0005 sk0233 bb0061 d
sk0233 bb0061 db0005

Rachel Greene

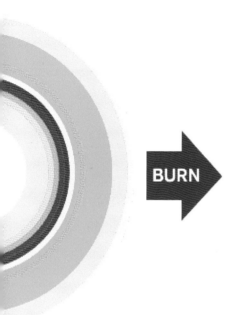

BURN

Internet Art

232 illustrations, 174 in colour

:0233 bb0061 db0005 RESET

Thames & Hudson world of art

For my dear parents, Professor Mark I. Greene and Bella Greene

Acknowledgments

I am grateful to editor Don McMahon who commissioned me to write an article for *Artforum*, which sowed the seed of this book. My interest in art history was deepened by a fellowship at the Whitney Museum of American Art's Independent Study Program in 1999–2000, and to that course, and to Ron Clark and Andrew Ross in particular, I offer my gratitude. For editorial support, I would like to thank Andrew Comer and Radhika Jones. This book evolves out of a particular culture, and my background in the internet art scene was much enhanced by the intelligence and friendship provided by my Rhizome.org colleagues – Mark Tribe, Alex Galloway and Francis Hwang. I have drawn much inspiration from the following artists, curators, writers and teachers: Rachel Bowlby, Heath Bunting, Dennis Cooper, Matthew Fuller, Graham Harwood, Natalie Jeremijenko, David Joselit, Geert Lovink, George Meyer, Shamim Momin, Anthony Morinelli, Julia Murphy, Simon Pope, Professor Rieff, David Ross, Peter Stallybrass, Elisabeth Subrin and Gloria Sutton. Finally, a deep bow of thanks to my beloved family who have always valued scholarship and have lovingly encouraged all my pursuits: Andrew Comer, Bella and Mark Greene, Sprouts Greene, David Greene and Amanda Witt, Ezra and Erica Greene, the Levinsons, the Marmars and the Sterns.

First published in the United Kingdom in 2004 by Thames & Hudson Ltd, 181A High Holborn, London WC1V 7QX

www.thamesandhudson.com

© 2004 Thames & Hudson Ltd, London

British Library Cataloguing-in-Publication Data
A catalogue record for this book is available from the British Library

ISBN 0-500-20376-8

1 **Shu Lea Cheang**, **yippieyeah Design** and **Roger Sennert**,
Burn, 2003

Designed by John Morgan
Printed and bound in Singapore by C.S. Graphics

Contents

▽ 🗀 **beta**
 ├ 📄 indexb.html ✕ ◀▶ %20Window
▷ 🗀 **1**
▷ 🗀 **img**
 ├ 📄 index.html ▶◀ ◀▶ %20Window
 ├ 📄 indexa.html ▶◀ ◀▶ Window A
 ├ 📄 indexb.html ▶◀ ◀▶ Window B
 ├ 📄 indexco.html ▶◀ ◀▶
 ├ 📄 indexon.html ▶◀ ◀▶
▷ 🗀 **rain**
▽ 🗀 **day66**
 └ 📄 index.html ▶◀ %20Location
▽ 🗀 **goodtimes**
 ├ 📄 ✕ ◀▶ %20GoodTimes
 ├ 📄 a1b.html ▶◀ ◀▶
 ├ 📄 a1l.html ▶◀ ◀▶
 ├ 📄 a1r.html ▶◀ ◀▶
 ├ 📄 a1t.html ▶◀ ◀▶
▷ 🗀 **alpha**
▷ 🗀 **godemo**
▷ 🗀 **img**
 ├ 📄 index.html ▶◀ ◀▶ %20GoodTimes
 ├ 📄 index1.html ▶◀ ◀▶
 ├ 📄 index2.html ▶◀ ◀▶
▷ 🗀 **items**
▷ 🗀 **terms**
 └ 📄 xnr.gif ▶◀

Preface

Contemporary web portals offer a broad array of resources and services, from email to search engines to shopping, competitions and promotions. This book is more like the portals of the web's first years: initial experiments in cyber-organization that featured links and contextual information, arranged by topic – for example, education, travel or birds. They were compiled by experienced users who recognized that the internet might need some signposts, and they served as conduits, guiding others to make independent voyages into the vast and protean online universe.

My intention is that this book function like one of those early portals, offering paths for readers wishing to explore the field of internet art. As an early experienced user, my own connections to the field – a long-time affiliation with the online art community Rhizome.org and familiarity with the first years of internet art, a command of programming languages, experience in the commercial sector of net development, and an interest in creating a closer proximity between this art and other fields and histories of contemporary art and media – all inform the writing.

It is an introduction to internet art, its history and the themes and topics associated with it, and hence it has been necessary to explain how to interpret and engage with particular web sites, mailing lists or software in an art-historical and contemporary context. This often required significant detail and delineation, and I had to leave out many of the extraordinary works I wanted to cover that have inspired my own interest in net art. For this reason, and to offer additional resources, an appendix of projects, archives and portals has been added to encourage readers to explore further, draw their own conclusions, and become participants in this diverse and relevant field.

2 **Jodi.org**, *http://404.jodi.org*, 1997. Jodi.org's work – which takes its name from the web browser error or, in internet jargon, a '404' – turns interactivity into a futile exercise by using email communication as its focus. The project is split into three sections – 'Unread', 'Reply' and 'Unsent' – each of which frustrates the user by deliberately rearranging or censoring his or her input (by removing vowels in 'Unread', for example, and then regurgitating them in 'Unsent').

Introduction

Both everyday and exotic, public and private, autonomous and commercial, the internet is a chaotic, diverse and crowded form of contemporary public space. It is hardly surprising, therefore, to find so many art forms related to it: web sites, software, broadcast, photography, animation, radio and email, to name just a few. Moreover, the computer, fundamental for experiencing internet art, can be both a channel and a means of production and can take the form of a laptop, a cellular phone, an office computer – each with its own screen, software, speed and capability – and the experience of the artwork changes accordingly. Beyond the internet's singular ability to host many different aesthetic activities, other novel and complicating issues make internet art difficult to summarize in a critical and historical survey such as this: its relative youth; its dematerialized and ephemeral nature; its global reach. Its location, however, is clear: like the great works of art that decorated public areas and buildings in pre-nineteenth-century cultures, internet art resides in a largely open zone – cyberspace – manifesting itself on computer desktops anywhere in the world but rarely in museum halls and white cube galleries, where the past two centuries have suggested we look for art.

By virtue of its constantly diminishing and replenishing medium and tools (e.g. software and applications become obsolete, web pages are abandoned and removed, software is upgraded, new plug-ins are brought onto the market, web sites are launched), internet art is intertwined with issues of access to technology and decentralization, production and consumption, and demonstrates how media spheres increasingly function as public space. It is inextricable from the history of military and commercial innovation; and it follows the changing roles of computers, which have developed from anonymous, unwieldy machines to reasoning, portable, customizable instruments

deployed with agency, coordination and selection. Still, there is more than an evolutionary argument for the significance of net art. It is not just that the tools and issues brought to the fore by internet art are current, and therefore relevant to how we live now. Internet art is part of a continuum within art history that includes such strategies and themes as instructions, appropriation, dematerialization, networks and information. It is important to explore parallels between net art and ideas in the work of earlier artists and movements – for example, Nam June Paik's (b. 1932) *Participation TV* (1963) [3], which took the television, traditionally a broadcast platform, and shaped it into an interactive canvas. Paik's apparatus for reception and production prefigured browser art (see Chapter 2), which treats browsers as fodder for experimentation.

This book will show how the shifts in information technologies that began during the 1990s have affected, impacted on and, in turn, been influenced by artistic practices. It will explore the field in two ways: firstly, by offering snapshots

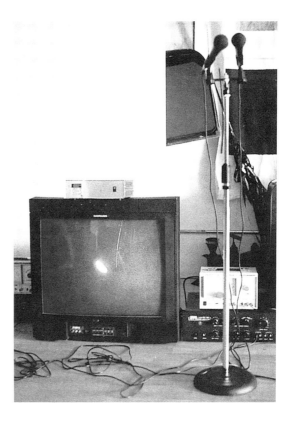

3 **Nam June Paik**, *Participation TV*, 1963 (1988 version). Paik transforms the omnipresent television – a consumer-targeted device emitting a unidirectional signal – into an interactive, participatory space. Not only does the defamiliarized commercial apparatus become a more open and responsive system for art and communication, but the screen emerges as a pictorial platform. Switching from broadcast to production within one interface is common in internet art-making.

4 *Radical Software*. This short-lived publication (1970–74), devoted to video and video art, was initiated by writers and artists interested in decentralizing media. Its contents were fundamentally cross-disciplinary and often absorbed in technological concerns, and the journal was a crucial forerunner of D.I.Y. movements such as 'free software' and 'tactical media'. All eleven issues can now be viewed online: http://www.radicalsoftware.org/

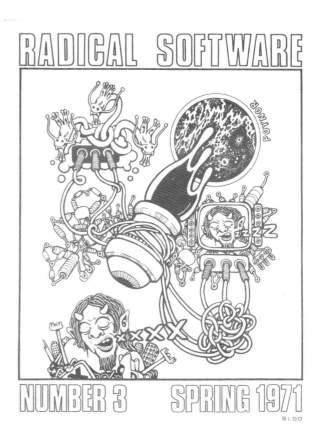

(and screenshots) of some of the diverse methods by which artists have created and shaped cultural expression by using the internet; and secondly, by presenting a chronicle of the technologies of internet art, as well as an account of its art-historical precedents, to reveal wider concerns about societies in which media, information and commerce are ubiquitous.

The geographical starting-point of this history lies in Europe, Eastern Europe in particular, where post-Cold War technology and democracy initiatives opened up spaces for pockets of advanced art-making and media activism that gave rise to the legendary 'net.art' scene (with a requisite dot), which is described in Chapter 1. There and throughout the book, I relate the ways in which internet art is indebted to conceptual art through its emphasis on audience interaction, transfer of information and use of networks, simultaneously bypassing the autonomous status traditionally ascribed to art objects. The projects of early net artists are covered in detail in this chapter and periodized to

include political conditions. Chapter 2 describes how early net artists explored the constituent characteristics of the new medium, often communicating with one another through art projects as well as on email lists. In Chapters 3 and 4, these threads expand to include other salient topics, such as infowar, gaming, software and tactical media. Sometimes politics and commerce are referred to because internet art is no straightforward complement to 'dotcom' era capitalism but something of an active counterbalance to its excesses and injustices. Often it has been net artists who, alongside various critics and activists, have formulated critiques against the assumptions built into new or existing computer and information technologies. Furthermore, net artists often generate actual alternatives, developing practical products such as non-commercial software. Their strategies imply that commercial machinations inflect art and other fields we tend to think of as removed from industry.

British critic Lawrence Alloway seemed to anticipate the net when, in 1972, he wrote 'The Art World Described as a System' about the various social, professional and critical networks in which artists and their work circulate. Alloway, ever alert to the prominence of the mass media, cited sophisticated marketing mechanisms, increased communication, rapid production and dissemination of criticism and art 'data', or documentation, noting that 'all of us are looped together in a new and unsettling connectivity'. Alloway favoured alternative exhibition venues and diversified fields of art expertise (to accommodate a youth whose grasp of popular culture could outweigh his own generation's). Without doubt, Alloway would have been intrigued to see how net artists have been able to devise alternate methodologies, goals and communities to those in the 'offline' art world. He would also have appreciated the extent to which many of the strategies and critiques introduced by new media artists secure a prominent place for the genre in the blurry and shifting space between mass media and physical being that comprises the complex fabric of contemporary life.

Indeed, compared with concurrent work by artists such as German Gerhard Richter (b. 1932) and American Matthew Barney (b. 1967), internet art has less to do with objects of social or financial prestige, and little, at least currently, to do with the cosmopolitan art businesses that thrive in New York, Cologne, London and other culture capitals. It is generally a more marginal and oppositional form, often uniting parody, functionality and

activism under a single umbrella, actively reclaiming public space and circumnavigating boundaries that seem entrenched in the world of galleries and museums. Internet art has redefined some of the materials of current art-making, distribution and consumption, expanding operations from the white cube gallery out to the most remote networked computer. As with public sculptures or murals, email, software and web sites are easy to overlook as 'art', doubtless because their functionality or location mean that users and passers-by do not readily acknowledge them as such. Though their tools and venues differ, internet art is underwritten by the motivations that have propelled nearly all artistic practices: ideology; technology; desire; the urge to experiment, communicate, critique or destroy; the elaboration of ideals or emotions; and memorializing observation or experience.

While internet art's contributions to contemporary artistic practices comprise much of this book, the conflicts that preclude its easy inclusion within traditional art-historical canons, markets and dialogues must also be explored. To confine the field to dominant art discourse would muffle its most vital anarchic tendencies and undermine the benefits of a precise study of its singularities. Moreover, one cannot gloss over the mutual suspicions between internet artists and institutions of official culture, such as museums and galleries, that have persisted since the form's inception. Internet art is sometimes viewed by the establishment as emblematic of how we live now, but at other times is taken as derivative, immature art practice. For critics, curators and viewers who take an interest in internet art, the field represents fresh aesthetic possibilities and contributes to contemporary art discourse. For those who do not support it, net art is often thought to lack the craft and direct impact of work in painting and sculpture by privileging commercial tools, veering too close to graphic design, or exploiting cheap, 'whizz bang' programming tricks (to which authentic, meaningful art should naturally be opposed). Furthermore, net practices such as software art do not align with existing gallery, museum and discursive systems, and these institutions often want to differentiate themselves from commercial fields. There is also a tendency (since the inception of video art) to place new uses of consumer electronics or practices associated with mass media in one category and art in another.

The internet's presumed banality, with its labels and commercial tools (Netscape Navigator, Macromedia Flash) and its operational requisites – the need to turn on, boot up and log in,

in order to view the art – does not help either. For many viewers, art on a computer screen is too unfamiliar both conceptually and physically, and the technical steps necessary to access it simply do not reconcile with 'art' experiences like browsing in quiet galleries or navigating vast museum collections.

Indeed, there is a kind of reversed exoticism in play. When the internet was new, different and less commercial, it seemed more avant-garde. Now that the 'internet boom' is over and its technologies are entrenched in the way we work, play and consume, its qualities are inflected with associations of labour, research or, worse still, pop-up windows and spam. While the juxtaposition of these corporate products and free-software (a diverse and international movement focused on preserving and promoting the freedom to copy, study, use, modify and redistribute software) projects offer rich material for those interested in theorizing about art, media culture and today's society, some attack the prevalence of brand-saturated tools and phenomena. For some of these detractors, seemingly, work that begins with or exists within internet or commercial formats can never rise above those limits to achieve the status of art.

A related criticism is sometimes aimed at the works' creators: that internet and software artists, often self-identified as programmers, are not 'real' artists. This critique can be taken as a symptom of the changing modes of art and the evolving expectations of what artists should be, what skills or trades they should possess, and what their critical concerns should be. The objections can be sustained only if the role of the artist as producer is imagined in limited ways, and exist, perhaps anachronistically, outside the time and reach of the web.

Internet art has also been critiqued for a perceived elitism, a reclusive position within the world and concerns of cyberspace. Some argue that the net conditions users to become indifferent to the offline world, as participants often become caught up in the field's linguistic and practical complexities. This critique, which situates the internet as a space of leisure and contemplation, a haven where one can dwell on the vagaries of net aesthetics and online communities, can, I think, be substantiated. Indeed, characterizations of the internet as an open playing field and space, untainted by gender, ethnic and class biases, or free from labour issues or ecological consequences are misleading. The sense of insularity among netheads, hackers et al has been such that many dialogues between internet art and other traditional art practices and histories remain nascent.

However, these critical issues should not obscure the fact that internet art has received attention and support from various influential quarters – curators, institutions and communities both at the edges of the mainstream art world and within it. Many major international museums, funding institutions and festivals, from Seoul to Kassel, are now supportive of net art, having recognized its importance and developed limited expertise in order to support its programming. And one could not offer a truthful history of internet art without naming the fruitful encouragement from the earliest moments provided by Ars Electronica (Linz, Austria), ZKM, the Center for Art and Media (Karlsruhe, Germany), the Waag Society (Amsterdam, the Netherlands), the Walker Art Center (Minneapolis, US), Postmasters Gallery (New York), Backspace (London), mailing lists Nettime, Syndicate and Old Boys Network, platforms such as *Telepolis*, THE THING and Rhizome.org, and print publications such as *Mute* and *Intelligent Agent*.

As someone who began to write about the topic of internet art during a time of urgent critical gestation, when artists and critics were trying to develop new vocabularies to talk about the medium, my view is that now is a more appropriate time for a book on the subject. The initial scepticism of net artists towards the traditional art world, the desire for polemics, as well as the mania and hype around the internet's novelty have all faded away substantially, and concepts such as web sites and software no longer seem as alien to the general art enthusiast. Though the momentum of change and development in media theory has been amplified by increasing usage of the net since the mid-1990s, there has been a shift away from any urge to concentrate on single authorial figures or final theories resolving the internet's impact, mastering its meaning or declaring its radical singularity. Whereas I felt a pressure in earlier years to come up with fresh critical approaches to new media or give them 'cyber' sensibilities, now it is possible to write a more open history for a wider audience, one that is in dialogue with other related art-historical and oppositional movements. These shifts in writing about internet art deepen my own interest in how the field illuminates the relationships between power, art and daily life.

The Internet's History and Pre-History
Like the histories of cable television, consumer electronics, video cameras, radio and even satellites, that of the internet is told in part via the innovators, companies, research centres, government

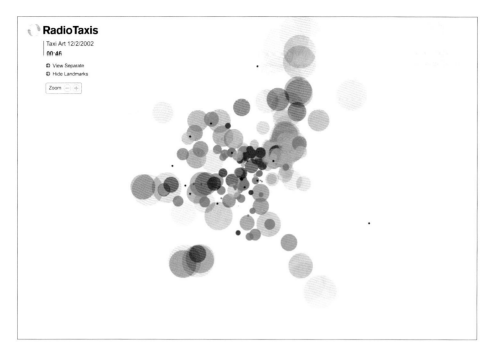

RadioTaxis

Taxi Art 12/2/2002
00:46

↻ View Separate
↻ Hide Landmarks

Zoom — +

5 **Radio Taxis**, *Taxi Art*, 2002.
Enlisting London black cabs,
satellite tracking and the internet
to orchestrate lively, colourful
maps of car movements, a British
taxi company literally forays
outside conventional art and
transport-sector zones. While its
marketing considerations are not
shared with the GPS artwork
discussed in Chapter 4, the
theoretical issues at stake are
distinctly related.

initiatives and, above all, the military development that made its
tools available. Central to the evolution of the internet are the
intertwined histories of the computer and electronic data. Charles
Babbage (1792–1871) was an early visionary of the former, a
nineteenth-century mathematics professor at Cambridge
University whose work on production and labour would be taken
up by John Stuart Mill (1806–73) and Karl Marx (1818–83), and
who designed prototypes for apparatuses that performed tasks
by following instructions, now commonly known as 'programs'.
His planned 'engines' – the difference engine and the far more
ambitious analytical engine – were flexible and powerful
calculators controlled by punch cards. The analytical engine
included many features that later reappeared in the modern
computer, such as versions of RAM and memory, but it was
designed to be huge and steam-powered and was never built
during Babbage's lifetime. One of Babbage's most significant
collaborators on the engines was Augusta Ada King (1815–52),
Countess of Lovelace and the daughter of Lord Byron, who
wrote some of the first instruction routines for the engines. Ada
would later be the namesake of internet art platform äda'web,
as well as a programming language used by the United States
Department of Defense.

The work of George Boole (1815–64), who perfected a binary system of algebra that allowed mathematical equations to be represented by true or false statements, became central to the development and use of electrical circuits in the 1930s, processing only two objects: yes/no, true/false and zero/one. Employing this method, electrical logic circuits could be built to use Boolean algebra and combined to form an electric, non-steam-powered computer. Electrically operated computers were first developed in around 1938 when German engineer Konrad Zuse (1910–95) [6] constructed a large machine, the Z1, from electromagnetic telephone relays in his parents' living room. He also used two logical voltage levels (on and off) combined with binary numbering, laying the ground for many principles of future computers. Another pioneer of computer developments was the British mathematician Alan Turing (1912–54), who not only engineered computers but also did some of the first experiments in the field of artificial intelligence, asking if computers 'could think', and how computer processes compared with human logic systems. Turing developed the world's first electronic valve computer in 1943. Called the Colossus, the computer used reader systems for paper tapes punched in by the many female military teletype operators. Data intercepted from transmissions encrypted on the German Enigma devices could be input and processed at high speeds. This application demonstrated that computer technology could be used for tasks involving characters as well as numbers.

Dr Grace Murray Hopper (1906–92) was likely the first twentieth-century woman to be involved in the development of sophisticated languages for computers. She was highly influential in the development of COBOL (Common Business Oriented Language) and its application for the US military. Besides her work on this, the second oldest high-level program, and her status – she was the highest-ranking female Navy officer of her time (rear admiral) – she is also remembered for her discovery of the first computer 'bug' in 1945, an actual moth that had flown into the circuitry of a Harvard Mark II computer. Today's 'bugs' are metaphorical – errors or conflicts in programs – but that moth symbolizes the centrality of error and breakdown to computer-related activities. It is preserved at the National Museum of American History in Washington DC.

The Electronic Numerical Integrator and Computer, or ENIAC, developed by John Presper Eckert (1919–95) and John Mauchly (1907–80) at the University of Pennsylvania in 1946, was the first digital computer and was used by the US Army to

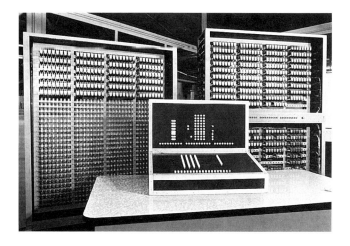

6 **Konrad Zuse**'s third computer, the Z3. After developing the Z1 and Z2, Zuse went on to build the Z3 during World War II. The machine – said to be the world's first fully functional program-controlled computer – formed the basis of Zuse's claim to have been the first in electronic computing.

calculate tables for shell trajectories. The ENIAC was enormous, consisting of more than 18,000 valves, 70,000 resistors and 5 million soldered joints. Its electrical power requirements were so great that the computer's usage is reported to have dimmed the lights in the local West Philadelphia area. Commercially available computers reached the market in 1951 with the UNIVAC (Universal Automatic Computer), and the advent of solid state electronics allowed for smaller and smaller microchips. During the 1960s, incentives to decrease the bulk and weight of computers resulted in substantial size reductions. By the early 1970s, the central components of a computer – central processing unit (CPU), memory and controls – had been aggregated on a single silicon chip.

In 1981, IBM released its personal computer, or PC. Though Steve Jobs and Steve Wozniak, the co-founders of Apple, had released several Apple models in the 1970s, they were unable to compete with the PC until they developed the Macintosh in 1984. The Mac introduced clickable icons on the screen, whereas PC interfaces required users to type instructions. Macs also popularized the 'desktop', a visual representation of the computer interface. Cursor movement was aided by an invention out of Stanford Research Institute: Douglas Engelbart's hand-controlled device called a 'mouse'. By the early 1980s, microcomputers with user-friendly software packages and applications like word processing and spreadsheet manipulation were offered by Apple, Commodore and Radio Shack. As more and more replicas or 'clones' of the IBM machine entered the market during the 1980s and 1990s, home computers became more affordable. Today, the

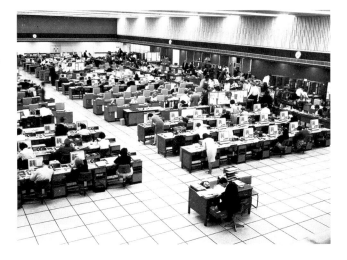

majority of North American and European schools have computers hooked up to the internet.

The history of the internet is rather more condensed than that of computers. Many would point to US Army scientist Vannevar Bush (1890–1974) as its grandfather. An MIT professor who had built mechanical computers in the 1930s, Bush imagined an intriguing system called Memex in a 1945 article entitled 'As We May Think', which was published in *Atlantic Monthly*. The Memex would be built into desks, allowing multiple users to browse various microfilms at the same time and input their own data. Though never constructed, the Memex's model of an interactive library of data as a tool for research and education was picked up by others in the field of electronic information. Theodor Nelson (b. 1937) reiterated Bush's ideas in the early 1960s, coining the terms 'hypertext' and 'hypermedia' to describe texts, images and sounds that could be interconnected within a 'docuverse' he called 'Xanadu'. Both Bush and Nelson were interested in the liberating potential of systems modelled on associative, non-linear thinking and experience. Their ideas, Nelson's concepts of hypertext especially, were important blueprints for what would become the internet. Named after the Department of Defense agency that sponsored its development, ARPANET was designed to be a communication system immune to nuclear attacks and was first implemented by four American universities (the University of California at Los Angeles, the University of California at Santa Barbara, the Stanford Research Institute and the University of Utah). This 'internet' remained largely a governmental and

research tool until 1989, when Briton Tim Berners-Lee (b. 1955) proposed a global hypertext project: the World Wide Web. The web was designed by Berners-Lee to enhance the efficiency of standard research practice, which was often hindered by the literal comings and goings of researchers to and from projects and centralized information repositories (such as a library). If data could be made available through public hypertext documents, research would be effectively decentralized, facilitated, and freed from the constraints of physical location. Accessible via powerful modems, Berners-Lee's web ran on protocols now widely known as HTML (HyperText Markup Language). These specifications were thoroughly reviewed and refined by programmers, and internet usage began to expand and develop in the halls of education. Parallel to the web's internal development, the net was fast becoming a popular hobbyist and community venue. Applications such as Gopher, Usenet and bulletin boards were turning it into a communication platform. Web browsers – applications that locate and display web pages – were introduced soon after but were initially only capable of displaying text. Mosaic (1993) and Netscape Navigator (1994) were the first multimedia or 'graphics browsers' (able to display images, video and audio). Later browsers included the open-source Mozilla application and Microsoft's Internet Explorer.

The Art-Historical Context for Internet Art
Though internet art has been discussed in a number of books and catalogues that have appeared since the mid-1990s, and a handful of net art archives are available online, the connections between net art and other art-historical movements are not well documented. In part, this may be due to the specialization of many net art critics and writers, whose methodologies are often grounded in internet culture and whose audiences remain mostly online. Their experience, useful as it is, does not always lend itself to sustained critical explorations of the relation between net art and such groups, movements and art forms as Fluxus, EAT (Experiments in Art and Technology), Happenings and multimedia art spectacles of the 1960s through to the present, as well as developments in cable and video. Within the scope of this book, there is only enough room to look at some of the works that are in dialogue with internet aesthetics.

Many net artists feel a strong connection to the work of French artist Marcel Duchamp (1887–1968) and to the participants in Dada (the international arts movement that began

in Zurich in 1916 as a reaction to World War 1 and to a traditional art public), all of whom helped to shift art practices away from traditional forms of pictorial representation. Dada firmly embraced the random as a means of expression. Its members created poetry, for example, that relied on instructions and chance word variations. The net analogue of such instructions is 'code', the algorithms (the set of steps for solving problems) that form the basis of all software and computer operations.

Events and Happenings (performance and publishing experiments) – which began in the late 1950s with artists associated with the Fluxus group, including Allan Kaprow (b. 1927) [8], Robert Watts (1923–88), George Brecht (b. 1925) and Yoko Ono (b. 1933) – were also based on the unpredictable execution of instructions or premises. Allan Kaprow's interest in the layers of time, space and interpersonal interaction, which in many ways anticipated the interactive, event-based nature of some computer artworks, came from what he saw as his inheritance from American abstract expressionist Jackson Pollock (1912–56) to 'utilize the specific substances of sight, sound, movements, people, odors, touch'.

As computer-generated images by artists such as Bela Julesz and Michael Noll (b. 1939) began entering the gallery purview in the 1960s, satellites came into use as a way of connecting art participants in dispersed locations. Stan VanDerBeek (1927–84), who built an audiovisual, satellite-linked venue for film, sound, animation and collage called *Movie-Drome* [9] in 1965, is a pioneer of multimedia-laden, network-dependent events that, as American

8 **Allan Kaprow**, *18 Happenings in 6 Parts*, 1959. Kaprow, who began as an action painter, shifted his practice to incorporate chance principles and to enable interaction and involvement. This highly scripted and rehearsed Happening, including projection, painting and performance, gave way to looser, open productions. Like many projects from this time, Happenings challenged rigid definitions of art objects.

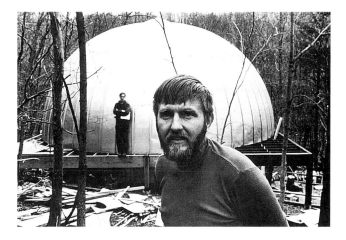

9 **Stan VanDerBeek** in front of his environmental movie theatre *Movie Drome* at Stoney Point, New York, *c.* 1966

critic Gloria Sutton has noted, seem prototypical of internet data consumption enabled by web surfing and browsing. Like many working in media art, VanDerBeek was heavily influenced by composer John Cage's (1912–92) interest in found material and debris as musical content, as well as by Canadian writer and theoretician Marshall McLuhan's (1911–80) ideas that each type of media should be considered an active metaphor able to translate experience into new forms and revert agency to the participant. Many decades later, McLuhan's rhetoric of subjective experience, feedback and choice has often been invoked in arguments that cyberspace is an open and encompassing democratic medium.

One initiative of the 1960s that prefigures internet modes of collaborative production – in which an artist might work with programmers, designers or other specialists – was EAT, a group formed in 1966 by Bell Labs engineer Billy Klüver (b. 1927). During the 1960s, EAT would involve such diverse artists as Andy Warhol (1928–87), Yvonne Rainer (b. 1934), Robert Rauschenberg (b. 1925), Jasper Johns (b. 1930), John Cage and David Tudor (1926–96). Just as 1960s visual artists opened up to dance, music and other forms of mass culture, EAT's extension into scientific engineering, funded by Bell Labs, was part of an expansion into interdisciplinary spaces that can be considered a *mise en scène* for current practices like hacking, software art or net art as 'research and development' (at the MIT Media Lab, for instance).

In the late 1960s and early 1970s, a number of exhibitions and critics began to focus on articulating critical vocabularies that went beyond the 'art object' to address information and systems. It is interesting to note that many large-scale museum exhibitions

10 Exhibition poster for
'Cybernetic Serendipity', 1968

11 **Kit Galloway** and **Sherrie Rabinowitz**, *Electronic Café*, 1984. *Electronic Café* suspended spatial and temporal divides and eschewed singular, signature modes of authorship to emphasize the interplay of participants, spectacles and performances. In light of internet art, multimedia spectacles and satellite-based collaborations such as *Electronic Café* earn new historical significance.

Cybernetic Serendipity

Serendipity

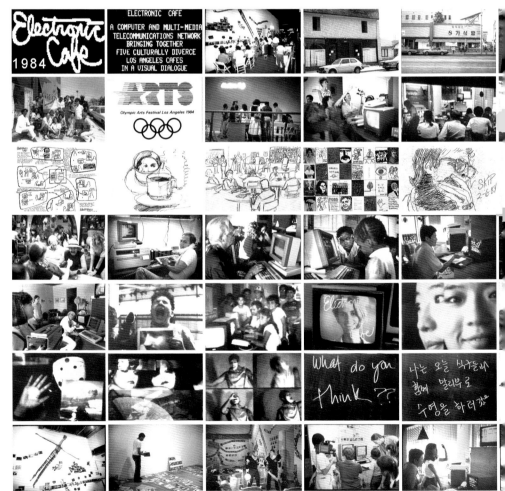

based on these somewhat radical and unfamiliar premises took place then, including 1968's 'Cybernetic Serendipity' [10] at the London Institute of Contemporary Art (curated by Jasia Reichardt), 'Software' in 1970 at New York's Jewish Museum (curated by Jack Burnham) and 'Information' at the Museum of Modern Art in New York (curated by Kynaston McShine), also in 1970. In our recent 'internet age', only a handful of new media art shows, originating at the ZKM, Ars Electronica and San Francisco's Museum of Modern Art, have equalled the scale of exhibition and venue of those that took place at that time. The curator of 'Software', Jack Burnham, who embraced cross-pollination between artists and computer scientists – showing work by computer innovators Theodor Nelson and Nicholas Negroponte (b. 1943) alongside those by self-styled 'artists' – employed computer idioms when referring to the concept and thematics structuring a work as its 'software', and the external object or form (if there was one) as 'hardware'. 'Information' took its name from the curator's sense that art was at an impasse, paralysed by world events and weighed down by materiality, and also that art was something very separate from entertainment-based spectacle. In the catalogue for the show, McShine wrote that the artists 'with the sense of mobility and change that pervades their time…are interested in ways of rapidly exchanging ideas rather than embalming the idea in an "object"'. In 2003, American critic David Joselit interpreted McShine's essay as proposing two significant claims, namely 'that by 1970, objects had come to seem practically obsolete', and that 'a dynamic exchange of information would only be "embalmed" if given permanent form'.

During the 1970s and 1980s, relatively affordable technologies of video, fax and cable television, as well as satellite, came into wider usage by artists, amplifying the themes of transmission, information and networks formerly investigated by minimalism and conceptual art. Artists Sherrie Rabinowitz (b. 1950) and Kit Galloway (b. 1948) secured funding from NASA to bring remote participants together to dance in the *Satellite Arts Project* (1977), creating a new type of performance that allowed what they called 'image as place'. The duo's *Electronic Café* (1984) [11] joined up various areas of Los Angeles in 'telecollaboration', yoking together art, distribution and communication, a portent of net performance models. Other kinds of network art took biological or social systems, rather than technological ones, as their materials – Ray Johnson's (1927–95) mail art projects, for example, are part of the New York Correspondence School project of the 1960s and are

precursors of email art. Jack Burnham's technological titles had actually been inspired by artists working with more natural phenomena. In 'Real Time Systems', one of his seminal essays on systems as a way of thinking about contemporary art, published in *Artforum* in 1969, Burnham cited organic systems as revealed by Hans Haacke's (b. 1936) 1966 plans for a work: 'I would like to lure 1,000 sea gulls to a certain spot (in the air) by some delicious food so as to construct an air sculpture from their combined mass.' Haacke's turning away from the art exhibition space to ornithological organization is emblematic of the period's varied anthropological explorations of process and immersion in fields usually relegated to the scientific.

Likewise, television art is a pertinent precursor of internet art and, in terms of scale of distribution and access, more relevant than cinema or satellite. Forward-thinking galleries like Howard Wise Gallery (New York) supported the format as early as 1969. 'TV as a Creative Medium', an exhibition curated by Wise in 1969, signalled the widespread influence of Marshall McLuhan and engineer, mathematician and architect Buckminster Fuller (1895–1983) and galvanized an interest in mass-media-based art. Soon after the exhibition, Boston public television station WGBH produced and aired its series *The Medium Is the Medium*, and *Time* magazine reporter Michael Shamberg, so impressed with the work of video pioneers Frank Gillette (b. 1941) and Ira Schneider (b. 1939), co-founded the artist collective the Raindance Corporation in 1969, together with Gillette, Schneider and Paul Ryan (b. 1944). Raindance was associated with the important publications *Guerrilla Television* (1971), offering a blueprint for the decentralization of TV networks, and *Radical Software* (1970–74) [4], featuring more interdisciplinary and technical approaches to democratizing media. At 'TV as a Creative Medium', Gillette and Schneider showed the important work *Wipe Cycle* [13], in which viewers saw themselves on a monitor at eight- or sixteen-second intervals, while other monitors played live television or footage. Gillette described his premise of underlining the relationship between seeing an image and assimilating the information it contains: 'The intent of this overloading (something like a play within a play within a play) is to escape the automatic "information" experience of commercial television without totally divesting it of its usual Content.' Also included in that show was *Participation TV* by Nam June Paik, the iconic artist who in that work and others like *Magnet TV* (1965) [12], as well as his many multimedia tapes for television, generated televisuals via participation or externally

12 **Nam June Paik**, *Magnet TV*, 1965. Paik applied a large magnet to a consumer television, morphing its signal into an abstract composition. In the process, he gave the monitor a sculptural character, disrupting its standardized form and function. Photo: Peter Moore © Estate of Peter Moore/VAGA, New York/DACS, London, 2004

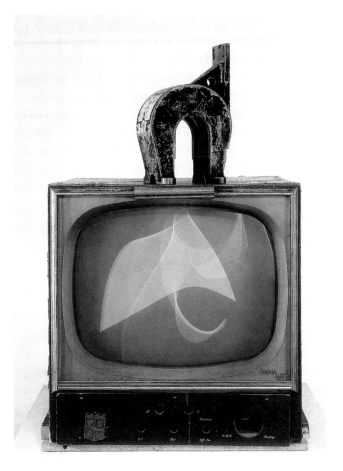

13 **Ira Schneider** and **Frank Gillette**, *Wipe Cycle*, from the 'TV as a Creative Medium' exhibition at the Howard Wise Gallery, New York, 1969

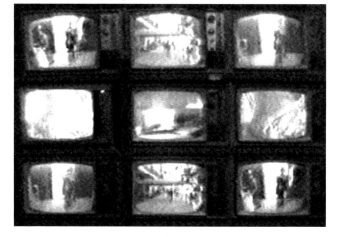

25

applied means. Television art never really managed to hold its ground as commercial networks became increasingly centralized, though European channels continued to programme it, like the video sketchbook *Video50*, curated by Robert Wilson, from 1978.

Some relevant points of comparison from art of the 1980s and 1990s include identity-based work, which succeeded in highlighting various inequalities both within and beyond the reach of fine arts. As a precursor of internet art and activist strategies, this kind of practice often forced its makers to represent stereotypical behaviour or images, breaking down widely held assumptions about, for example, a woman's relationship to her body, and then replacing them with new representations. Similar strategies are seen in some net art – for example, when artists reference corporate tactics and formats to reclaim and contest the colonization of public space or information.

Other salient trends in the 1980s included appropriation and hyperreal and simulationist techniques. These were bolstered by the influential writings of social theorist Jean Baudrillard (b. 1929) specifically and French literary theory more generally. In his 1981

book *Simulacres et Simulation* and elsewhere, Baudrillard's formulation of the simulacrum – the copy for which there exists no original – focused closer attention on the dialectic between the virtual and the real, and the role of a work's context and aura, as seen in the rephotography works of Sherrie Levine (b. 1947) and Richard Prince (b. 1949), or the photorealistic paintings of Malcolm Morley (b. 1931). Appropriation and plagiarism, just a keyboard shortcut away when using a computer to copy a file, have become fairly standard forms of making in net art. A range of painting strategies, coupled with ongoing debates about the 'death of painting', focused critical energy on questions about medium-specificity, questions that become more complex when dealing with the multiple (e.g. text, broadcast and audio) formats of internet art. During this period, works by American artists Peter Halley (b. 1953), Barbara Kruger (b. 1945) and Jenny Holzer (b. 1950) borrowed from systems, theory and advertising, respectively, and sculptures by Israeli–American Haim Steinbach (b. 1944), American Ashley Bickerton (b. 1959) and French Sylvie Fleury (b. 1961) dealt with the objects and materials of consumer culture.

Cuban-born American artist Felix Gonzales-Torres (1957–96) and Thai artist Rirkrit Tiravanija (b. 1961) [14], both of whom came to prominence in the 1990s, worked in the installation mode, functioning as producers or facilitators more than masters of craft. The creation of participatory social events, a signature aspect of Tiravanija's work, is emblematic of what French critic Nicholas Bourriaud calls 'relational aesthetics'. In his book *Relational Aesthetics*, Bourriaud describes an emergent practice of relational and transitive art, writing that 'the artist produces connections with the world broadcast through works of social gesture, sign and form'. While this highly influential term was discussed without specific reference to the internet, net artists and critics developed like-minded models often informed by network technologies and systems such as free software or the email list.

Other artists of this era with explicit import for internet art include video artists Gary Hill (b. 1951), Bill Viola (b. 1951) and Tony Oursler (b. 1957) [15], who, as David Joselit writes, explore the 'colonization of the flesh by electronic technologies of communication' using video and installation. This is a persistent theme in net art. Installation artist Maureen Connor and photographers Isabell Heimerdinger and Cindy Sherman (b. 1954) [16] developed languages engaging with the iconophilia and

14 **Rirkrit Tiravanija**, *Community Cinema for a Quiet Intersection (after Oldenburg)*, 1999. Tiravanija's organization of screenings (including *Casablanca*) in Glasgow, Scotland, crystallizes five loose themes of 1990s artwork: relational aesthetics, ephemera, networks, the cross-pollination of disciplines, and new forms of public art. The artist as production coordinator, as opposed to mere craftsperson, resonates with internet artists who often collaborate with programmers and designers.

15 Tony Oursler, *Judy*, 1997. Oursler's portrait of *Judy* defies any secure perception of the subject or object: a range of expressions projected across the surface of a doll evokes psychological variation as well as television and surveillance technologies. An exploration of multiple personality disorder in relation to media structures, this work brings the portraiture tradition in line with the culture of channel surfing.

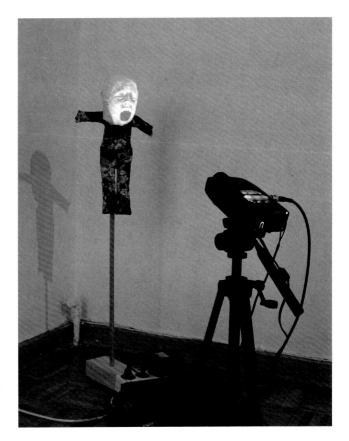

16 Cindy Sherman, *Untitled Film Still*, 1978. This still, one of an important series of photos initiated in 1977, features Sherman impersonating the iconic, if ostensibly prosaic, postures and expressions of young actresses. In Sherman's work, one of Hollywood's great legacies is revealed to be the invasion of thoughts, emotions and actions by media and information technologies.

17 Ken Feingold, *JCJ-Junkman*, 1995. Feingold sets an image of the worn-out ventriloquist puppet-head against a black background, surrounded by various changing 'buttons', which are difficult to catch and remove any element of calculated choice. By clicking on these 'buttons', the user can make the puppet-head speak an incoherent language – made up of snippets from public-domain archive files found on the internet – to produce what Feingold describes as interactivity 'reduced to a zero-degree'.

internalization of media (for them, film and television) experience. Net artworks on surveillance similarly develop and modify media *mise en scène*. Installation artists Toni Dove, Jeffrey Shaw (b. 1944) and Shu Lea Cheang (b. 1954) used computer technology to create immersive, interactive environments, or, like Julia Scher (b. 1954), Perry Hoberman (b. 1954) and Ken Feingold (b. 1952) [17], addressed computer-dependent culture. Works by these artists made the claim that consumer technologies and daily life are intertwined in complex ways – a claim that has been easier to sustain and illustrate the more developed internet culture and technologies have become.

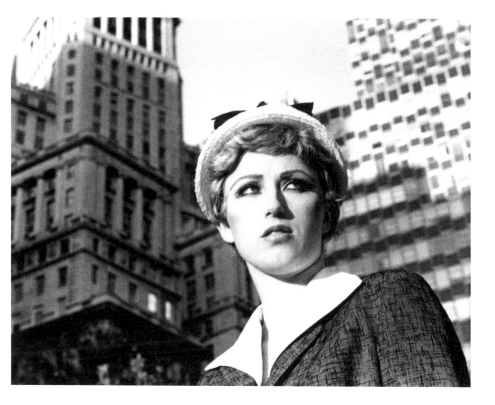

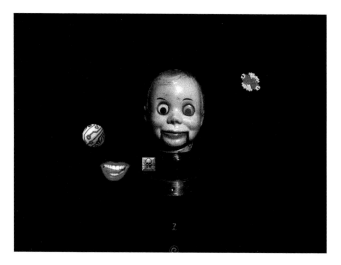

Back | Forward | Stop | Refresh | Home | AutoFill | Print | Mail

Address | @ http://ca80.lehman.cuny.edu/davis/Sentence/sentence1.html | › go

Favorites | History | Search | Scrapbook | Page Holder

Welcome to the World's First Collaborative Sentence:

I DID NOT FEEL SEPARATED I FELT VERY CLOSE EVEN THOUGH WE WERE THOUSANDS OF MILES APART AND I WAS SURROUNDED BY PEOPLE HERE I FELT CLOSE HOW ARE YOU THIS IS DURBAN WE FEEL WE ARE A PART OF THE WORLD AT LAST IN THE PALACE HERE I AM WAITING FOR THE PRESIDENT I SEND YOU GREETINGS HERE I AM IN THE GALLERY LOOKING AT THIS BIG PENCIL I AM LAUGHING COGITO ERGO SUM GO GO GO SENTENCE swing swing swing ring ring ring ring ring let herethereeverywhereGUMBOGUMBOhellholeI DON'T KNOW WHAT TO SAY A LITTLE LEARNING IS A DANGEROUS THING FREEDOMFREEDOMFREEDOM**GET OFF ME GET OFF MY BACK** SCRATCH MY ASS DOUGLAS HOW ARE YOU? FAR AWAY YET FREE DONT COME AFTER ME PHI KAB NAUNG LANG PHAU PHI NAUNG SEX RELATIONS BETWEEN FIRST COUSINS ARE FORBIDDEN THE MOON BRIGHTENS THE BATTLE CAMP SO YOU LIKE TO LOOK AT ME PAY FOR IT YOU PAMPER ME SO MUCH YOU MAKE ME FEEL LIKE A QUEEN I SEND GREETINGS FROM FRANKFURT GOD BLESS AMERICA AMERICA NEEDS IT ANIMALS ARE GOOD TO THINK AND GOOD TO PROHIBIT BE GOOD IT IS THE TIME TO BE GOOD I LOVE EVERYBODY I HATE EVERYBODY THE SON IN LAW MUST NOT ENTER ENTER THE SLEEPING QUARTES THROUGH THE DOORWAY OF THE PARENTS IN LAW CALL ME RIGHT NOW TO SAVE THE WORLD I LOVE YOU WORLD WORLD WHEN WILL YOU SEE HOW BEAUTIFUL YOU ARE STOP DYING WORLD HERE IN THE BRONX WE HATE THE POLICE GIVE ME YOUR HAND I FEEL YOUR FINGER HERE MANY MILES APART I THINK IN BASEL WE UNDERSTAND AND APPRECIATE YOUR WORK KEEP GOING WE ARE BEHIND YOU NO BODY CAN SWEAT SO MUCH WE FIND YOU NEAR EVEN WHEN FAR TO THE HEALTH OF DON CESARE'S WOMA N AU REVOIR MONS ENFANTS RED RED RED RED RED RED RED RED RED RED RED RED RED BLUE BLUE BLUE BLUE I AM SO BLUE I SAW A MAN HE HELD A STICK OUT TO ME I HOLD THIS STICK OUT TO YOU ACROSS THE WORLD I ASK YOU WHEN WILL YOU COME TO MOSCOW AGAIN DOUGLAS er mirror mirror mirage THE BUSHES TWITCHED AGAIN THE STICK BEGAN TO GROW SHORTER IN BOTH ENDS HERE IN KAUNAS WE HAVE SATAN MAKING LOVE TO AN ANGEL IS THIS WHAT DROVE HIM INTO HELL WELL THis thing of of writing in all caps is getting a bit tiresome and why does **this sentence** have sound so *disgusting and arty* who do think we are

james joyce's greatgrandchildren

> or some kind of gertrude

1. stein
2. stein
3. stein

at least there are a few things that could be done to make this page look a little more attractive or at least more readable but thEN DON'T BE *SO F***ING LITERAL YOU #@%*!* THIS ISN'T A TYPOGRAPHY LESSON LIke the one that beautiful Swedish girl gave me on the train to Gdansk and then later in the cargo hold of the ship with the moonlight on here snowy-white scandanavian breasts which made me feel so arf arf arf This is another lustless technical test before all hell breaks lose with artists contrbuting scatological prose and poetry, but is this really art, or is it so what else can be said, anyway and more and more and more but what difference is this making WELL ISN'T IT JUST FUN TO WRITE TOGETHER LIKE THIS millenial exaggerations overstate our singularity,basic humanity is as lonely as (I'm feeling a bit spacy) there are a lot of things that could be said, but i don't know what to say but i want to say it my father is coming near have to stop now he always comes upstairs like this in the middle of the night dust follows dust in the endless progression of biological kitchen-ware 1001001 SOS 1001001 IN DISTRESS 100100 Everything is deeply interwingled I want to be unique, just like everyone else After this, Jon decided, finally, to attempt to bring the killers to justice, in his own way, of course, and, in so doing, rid the world of a terrible scourge, reviled by all yet fascinating as well to a small, perverted subset of the community who had watched their antics progress from random, petty violence to the full-fleged sociopathic acts they had been performing, almost as if for entertainment for our benefit, for the last eight months all this mirroring the other night, when, travelling uptown on the 6 train, a man and a woman got on at 23rd street, laughing and babbling to one another in some uncomprehensible language while I leaned back against the bench, trying hard not to fall asleep, and the woman sitting next to me jabbed at my arm and asked me creakily, a microphone held up to her neck because I think her larnyx had been removed, "What language you think they're talking" the problem for the revolutionary artist in the nineteenth century--perhaps it is still the problem--was how to use the conditions of artistic production with easel, in the studio, in the salon for a month, and then on the wall of a sitting room in the Faubourg Saint-German? how to a

Chapter 1 Early Internet Art

Early internet art is very much inextricable from the technology and politics of the 1990s and early twenty-first century, although its preoccupations with themes such as 'information', 'communication', 'interaction' and 'systems' linked the genre to postconceptual art. As artist and theorist Peter Weibel (b. 1944) has noted, cyberspace seems a '1960s idea', even if it was not technically viable until decades later. As important as these historical connections are, net artists have also developed and created new methods for production, consumption and exchange. Not only do net art practices extend the arena, capability and reach of artistic production, but they have offered ways to remix and revitalize categories often reified in the art world and beyond.

Internet art is buoyed by the technological, economic and social specifications of its medium. Though still evolving today, dominant tools are email, software and web sites. Unique economies of attention exist, in which international web traffic and email forwards and downloads are the indexes of the public consumption and success of the art, as opposed to conventional means of valuation, such as visits to a museum show, magazine reviews or monetary worth. Rapid rates of reaction and widely available production tools have also been defining. For example, if one does not like a web site, chances are that one can offer feedback (email) or find tools to create an alternative (web publication). Those who view commerce as irredeemable corruption will be pleased to know that, as yet, there exists no viable or stable market for net art. As a result of this isolation and specialization, internet artists often develop close-knit online communities, and oppositional and radical content has remained an undiluted component. Net art's audience is a social medley: geographically dispersed, varying in background, these art enthusiasts are able to morph their involvement constantly,

18 **Douglas Davis**, *The World's First Collaborative Sentence*, 1994–present. Composed by internet participants, this ongoing collaborative work, which initially only supported text, now hosts multimedia entries. Polyvocal, international and seemingly endless, the project is often held up as an emblem of internet aesthetics.

drawing from roles such as artist, critic, collaborator or 'lurker' (one who just watches or reads, without participating). Finally, 'viewers' have a direct relationship with net art: they can log on from any computer with net access and the right software, see an artwork, download it, share it or copy it.

In the early 1990s, however, internet art was just one small part of widescale proliferations of media and consumer technology. People in the West were becoming increasingly reliant on television, satellite and cellular devices in their everyday lives. The first Gulf War exemplified the ubiquity of globalized media, with CNN, an international, twenty-four-hour television network, broadcasting weaponry deployed and operated via sophisticated computer systems. At around the same time, reality television became a hit among young Americans. MTV's *The Real World*, in which people living together were taped, edited and broadcast, made theatricalized and mediated daily life friendlier, hipper and younger. Cellular phones began to be used widely. A new tempo and frequency of communication and device usage was evolving. Although the internet began as a project of the US Government's Department of Defense, more and more civilians, office workers, students and artists used it following the development of graphics and HTML viewers, called browsers. Email and the World Wide Web (the 'web') became tools for work and home, with email allowing for instantaneous communication, and the web supporting various graphic and communication applications, and endless nodes for text and image publication – web sites. These events were symptomatic of significant cultural changes, suggesting emergent social groups in which divisions between behaviour, emotions and thoughts – and media, technology and commerce – were blurred.

From its earliest moments, the ways in which commercial and governmental interests and technologies powered the net's development were obvious. One would experience the web with a commercial browser, such as Netscape Navigator, that had been designed according to corporate interests, not educational or aesthetic ones. Commercial interests, which were receiving ample attention from the venture capital sector at the time, operated next to social communities and organizations. These diverse collectives were based on everything and anything, from the pragmatic, like news groups (an internet bulletin board system requiring special software) for car mechanics, to the more scholarly, such as mailing lists focused on Virginia Woolf criticism.

Though marketing and press outlets touted the rise of internet culture as 'democratic' and 'revolutionary', the writers and artists

who searched the net for new possibilities during these early years were often more restrained in their enthusiasm. In fact, those who sought to find contemporary art on and about the internet had to look quite closely. Not only would a search engine not provide the right kind of results for a quest for 'art', but directories such as Yahoo! or Netscape tended to bury net art under many layers of web pages. Even beyond its text-heavy aesthetic, the net elided evidence of being an easy or refined venue for artistic production. Its ability to realize international and relatively inexpensive communication and exchange, however, was potent. And internet art's earliest beginnings crystallized within this matrix of communication technologies.

Art and communication were at the centre of many initiatives undertaken by European non-governmental organizations (NGOs) and the European Commission in Brussels after the collapse of the Soviet Union in the early 1990s. In the mid-1990s, these new computer centres and media art programmes became more prominent fixtures in the European and Russian culture- and leisure-scapes, offering events, education, internet access and production tools. The internet was emblematic of the increased access to information in these regions, and the opening of international borders, and was very appealing.

Many net artists, such as Heath Bunting (Britain), Olia Lialina (Russia), Alexei Shulgin (Russia) and Vuk Cosic (Slovenia), worked as offline artists, photographers, graffiti writers and filmmakers before experimenting with art online. Leaving behind more accepted aesthetic practices, they came to make art from media centres like T0 (Vienna), C3 (Budapest) and Backspace (London) via computers in their living rooms, or from desks at their day jobs. Instead of film or oil paint, they used low-fi net production tools: HTML, digital graphics and Photoshop were likely requisites (later, Java, Flash and Dynamic HTML). They were introduced to one another via the internet and became contemporaries, friends, collaborators and travel companions, meeting face to face at technoart events like Next 5 Minutes, the Cyberfeminist International and Ars Electronica. These artists were able to draw on the work of 'early adopters' of the internet's most basic offerings, like bulletin board systems (BBS) and email. They also benefited from the experience of the respected figures who worked with technology-informed installations or intermedia involving video, satellite, sound and computers, such as Robert Adrian X (b. 1935), Hank Bull (b. 1949), Roy Ascott (b. 1934), Sherrie Rabinowitz and Kit Galloway.

This early generation of internet artists exhibited a diverse set of interests. Some wanted to realign traditional modes of communication and audience address, pursuing direct dialogue and exchange with other artists and art enthusiasts from around the world, independent of the cumbersome commercial channels of galleries, museums and dealers. To some, the digitized screen and computer aesthetics were dominant preoccupations. These themes were explored through configurations of six main net art formats between 1993 and 1996: email, web sites, graphics, audio, video and animation. These often appeared in combination – communication and graphics, or email, texts and images – referring to and merging with one another. Whatever the premise or organizing principles, artists were internationally dispersed, working from wildly disparate local contexts and using different tools. But along with developers, programmers, critics and media outlets, all of these artists were watching net culture evolving on their screens, even as they helped to shape it.

Participation in Public Spaces
The earnest, straightforward tone of Heath Bunting's instructions on the web site *King's Cross Phone In* (1994) [19] belies the significance of what the artist points towards: an opening up of web page capabilities to extend into public spaces, enabling play, subversion and artistic intervention. On a simple, white web page with black text, Bunting listed the numbers of public telephone booths surrounding London's King's Cross station. Designating a time and date for a collective, international phone-in, the artist orchestrated a telephonic musical in a public transportation and commuter hub. These participatory and playful aesthetics, significant to early net artists, also stand as part of a twentieth-century avant-garde interest in instigating activity, replacing passive consumption of a medium (the web site) with engaged response (making a call, chatting with a stranger). Disrupting the flow of pedestrian traffic in and around King's Cross station and channelling web functionality into friendly phone calls from around the world, Bunting and his group of participants conducted chance encounters in an unlikely venue. It was one of Bunting's earliest web projects but it bears many of his hallmarks: minimal ornamentation and low-fi graphics, a basis in direct action and the capacity to unite fields of public art, hacking and street culture.

King's Cross Phone In came out of Bunting's explicit goal to 'bring high tech to street level'. In addition to his introduction of train workers and commuters to the internet as an art platform, it

also bears the hallmark of situationist works, echoing that international artistic and political movement's (1957–72) famous tactic of transmogrifying existing elements into more radical or oppositional forms. Bunting (b. 1967) follows the situationist recipe almost to the letter. The quotidian forms that are put to use in *King's Cross Phone In* – public phones, ring tones and a web page – retain their everyday qualities but, in their means and manner of deployment, change the tenor of a particular setting and time. Though Bunting can be seen as travelling paths broken by artists of earlier generations, with this work he sets up a collaborative performance that is unlike those of his forerunners by virtue of its manifestation of the web's capacity for international organization and collective performance. 'I basically spent most of my time wandering the streets at that point doing graffiti and looking in trash', Bunting says, describing his research for the project. Inspired by forms of public and street art, Bunting's interests at that time also focused on expression and communication via new technology: he ran a BBS out of his living

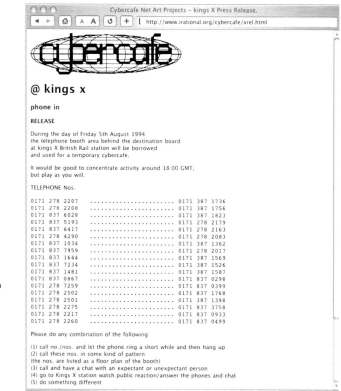

19 **Heath Bunting**, *King's Cross Phone In*, 1994. In this work, the web was used to transform a commuter hub, King's Cross train station, into a venue for social and musical spectacles. Though internet art rarely dominates political or artistic life, the theoretical reach of a web page is such that artists interested in public, open contexts, such as Bunting, found it to be a rich creative platform.

room and had a voicemail system based in his kitchen cupboard. For his experiments, the internet was 'the next logical step – i.e. cheaper and wider audience'.

Russian Internet Art Scene
In the same year that Bunting organized his *King's Cross Phone In*, three major factors were encouraging internet art practices in Russia. Firstly, net technologies synchronized with artists' reactions against a local commercial and publicity-driven art scene. In addition, though the internet as a commercial venture was marked as American and European from the beginning, it offered ways for Russian new media artists to communicate beyond their borders and reinterpret the net in their own ways. Finally, Russia's rich history of avant-garde film schooled many young artists in narrative and screen-centred visuals that could be extended and reconsidered on a computer screen with more interactive capabilities. We see these elements evolve in the work of Olia Lialina (b. 1971) and Alexei Shulgin (b. 1963), who first began to use the net in the mid-1990s as a distribution platform outside the Moscow film and art worlds, respectively. Both quickly adopted its idioms and tools as the core of their practices.

Contrast the directness of *King's Cross Phone In* with the more medium-conscious approaches of Lialina's project *My Boyfriend Came Back From the War* (1996) [20], or Shulgin's *Hot Pictures* (1994) [21], both of which were made at a time when the web could support only the simplest graphics and text. The former creates an oblique, dramatized romantic narrative, set against the backdrop of war, and uses frame programming (in which HTML is divided into quadrants and subdivisions on a single web browser window). Its balance of text and image across a darkened screen has been described by new media art theorist Lev Manovich in the 1997 essay 'Behind the Screen' as a manifestation of a Russian legacy of screens, and film director Sergei Eisenstein's (1898–1948) theories of parallel montage. It is also one of the earliest examples of a work in which the user can directly influence the narrative arc. The interests professed in *Hot Pictures* included the dissolution of boundaries between the computer image, painting and photography, and the separation of artwork from the Russian gallery scene. As the 'first Russian electronic photo gallery', as Shulgin called it, *Hot Pictures* was novel by virtue of its self-styled context: a gallery space free from commercial, white cube constraints, accessible from home and office and amenable to both private reflection and public reaction.

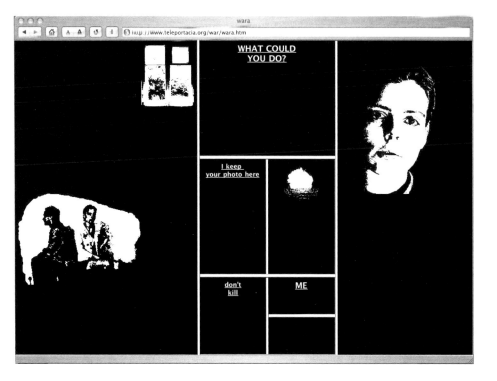

http://www.teleportacia.org/war/wara.htm

WHAT COULD
YOU DO?

I keep
your photo here

don't
kill

ME

20 **Olia Lialina**, *My Boyfriend Came Back From the War*, 1996. Lialina jettisoned the no-frills technical style then popular with net artists in favour of a more intimate, decorative, narrative, and, for that time, personal approach to web-based art. She later included the work as part of *The Last Real Net Art Museum*, which took the original *My Boyfriend Came Back From the War*, coupled with other artists' variations on it, to create an archive of work.

At this time, the internet's role in relation to art was by no means clear, and there were no authoritative or complete formulations on the subject. Shulgin notes some of the ambiguities of the medium, writing in his introduction to *Hot Pictures* : 'Photography for the long time seemed to be the only credible method for reality reflection. But the development of the computer technologies had put this postulate on trial. So photography which in its time had changed all fine arts now is changing itself. Electronic photo gallery is not only the presentation of specific artists and works, but also an attempt to research and visualize the described phenomena.' Shulgin's 'electronic photo gallery' extracts photography from the offline gallery context, depicting it as a broad medium that accommodates painterly, mechanized and documentary aspects. We see these themes reflected in the art in *Hot Pictures*, which covers a broad range of work from the politicized to the pictorial. One example is *Empty Icons* by the group Medical Hermeneutics (Sergei Anufriev, Vladimir Fiodorov and Pavel Pepperstein) – heavily Photoshopped photos of Russian religious icons. Another example is found in Evgeni Likhosherst's (also called Chumakov)

works that are about the 'impossibility of being an artist' and recall the concurrent work of British photographer Richard Billingham: tragicomic, touching and unsettling. They were, according to the information provided on *Hot Pictures*, Likhosherst's last works: 'The last evidence that he is an artist. He keeps silence since 1990. He is one of the most talented photographers in Russia.'

Certainly not the first artist to undertake building his own distribution and promotion mechanisms, Shulgin applied internet capabilities to his critiques of conservative art culture, publishing prescriptive declarations presented in Futurist-like, apocalyptic terms. In a 1996 manifesto, Shulgin identifies 'pure and genuine communication' as a tenable goal for the net artist:

Artists! Try to forget the very word and notion 'art'. Forget those silly fetishes – artefacts that are imposed [on] you by suppressive system[s] you were obliged to refer your creative activity to. Theorists! Stop pretending that you are not artists. Your will to obtain power [over] people [by] seducing them with intellectual speculations is very obvious (though understandable). But [a] realm of pure and genuine communication is much more appealing and is becoming very possible nowadays. Media artists! Stop manipulat[ing] people with your fake

21 **Alexei Shulgin**, *Hot Pictures: Evgeni Likhosherst*, 1994, from the series 'The Quiet', 1990. This project highlights how, as a medium for display and publication, the internet is able to host art and information that would otherwise remain lost or local.

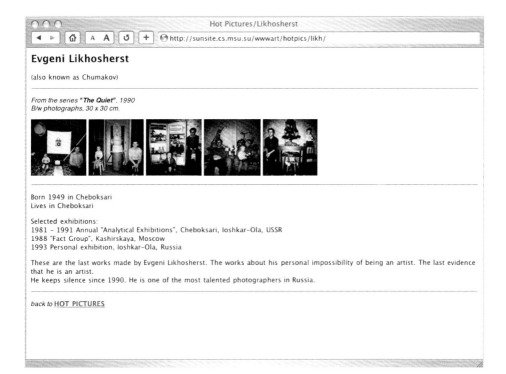

Hot Pictures / Likhosherst

http://sunsite.cs.msu.su/wwwart/hotpics/likh/

Evgeni Likhosherst

(also known as Chumakov)

From the series *"The Quiet"*, 1990
B/w photographs, 30 x 30 cm.

Born 1949 in Cheboksari
Lives in Cheboksari

Selected exhibitions:
1981 – 1991 Annual "Analytical Exhibitions", Cheboksari, Ioshkar-Ola, USSR
1988 "Fact Group", Kashirskaya, Moscow
1993 Personal exhibition, Ioshkar-Ola, Russia

These are the last works made by Evgeni Likhosherst. The works about his personal impossibility of being an artist. The last evidence that he is an artist.
He keeps silence since 1990. He is one of the most talented photographers in Russia.

back to **HOT PICTURES**

'interactive media installations' and 'intelligent interfaces'! You are very close to the idea of communication, closer than artists and theorists! Just get rid of your ambitions and don't regard people as idiots, [unfit] for creative communication. Today you can find those that can affiliate [with] you on [an] equal level. If you want of course.

Beyond his confessed aversion to gallery and museum culture, it seems apt that an artist who grew up under the Soviet Communist government would celebrate open realms for 'communication', and belittle art that depended upon 'official' art spaces or intellectual 'seductions'. Curiously, after *Hot Pictures* Shulgin did not make any more web work relating closely to the social and economic conditions around him. He would go on to focus on the formal and medium-related concerns that have guided both new media art discourse and the work of the next wave of net artists.

New Vocabularies

If disdain for the channels of the art world offered one route into web-based modes of art-making, another was provided by the constantly evolving vocabulary of internet protocols, or usage standards. Because of the net's casual climate of constant development, information sharing and communication, deriving in part from its use as an academic tool and large-scale message board in academic settings, new terms often sprung up in the vernacular. As a result, much internet formal rhetoric has a sociable, friendly tenor. The 'handshake', for example, is the noisy process that occurs when two modems interact; it establishes mutually beneficial transmission speeds and other related information exchange metrics. German artists Joachim Blank (b. 1963), Karl Heinz Jeron (b. 1962), Barbara Aselmeier and Armin Haase allude to this term with their 1993 web project *Handshake*. *Handshake* is a visually and organizationally basic work with a small inventory of low-fi images split up among sections called 'Rorschach Test', 'Symbols and Interpretation', 'Life and Work in Eastern Europe' and 'Electronic Art or Electronic Aided Art'. The combination of user-generated content, social commentary, discussion of conceptual and media art histories and awareness of their own artistically impure context (and consequently, what was at stake in claiming web territory for art) shows this group as both knowing heirs to art-historical traditions and forebears of online social spaces and art platforms like THE THING and Rhizome.org. And in light of the rigorous discussions about the cultural role of the internet that would later

take place across email lists and web communities, *Handshake* appears as a prescient example of net art's self-aware tendencies.

Tools servicing internet protocols provided inspiration for artists, propelling them towards more medium-specific work, work dependent on and inseparable from its location online. As site-specific sculpture operates vis-à-vis the particular components and ideologies of a place, so do many works of internet art derive in significant ways from their location within a networked public field of vision and consumption. Taken together with *Handshake*'s manifestation of its process of development and its tools, its site-specificity indicates a quality shared by some of the earliest web projects: the capacity to merge effectively with its discourse and self-awareness. Such works lack the nonchalance or sneakiness of Bunting's approach; instead they evoke minimalist ethics in which process is valued over product, and objects (here, the web site) are almost leftovers or 'leavings', as writer and photographer Max Kozloff (b. 1933) described them.

In contrast to works containing readable discursive content, there were also early projects that appeared muddled, impersonal and impenetrable. Through the collaborative Jodi.org (both a web address and the moniker by which its creators are known), Joan Heemskerk (b. 1968) and Dirk Paesmans (b. 1968) were among the first to venture fully into pure technological abstraction. Their experiments began in around 1994, while the couple were working and living near Xerox PARC's engineering-driven community in Palo Alto, California. During the first few years, across multiple projects, the duo created aggressively technical interfaces, ignoring coherent content in favour of desultory representations of code, protocols and operating system (a computer's central application, on which all other software runs) aesthetics turned inside out. Some of these intentions can be seen in *http://wwwwwwwww.jodi.org* (1995) [22]. The front page is confusing, repetitive, discordant and alphanumeric, but the compositional effects are not what they seem: for behind this web page lies source code (the statements written in a particular programming language, here the markup language HTML), which reveals a cascade of traditional images and diagrams that are almost scientific or astrological. (To view source code, look in the menu of most browser applications, select 'View' and then 'View Source'.) Hiding coherent images in source code seems playful and riddling, a means of separating instructions (the HTML) from the completed task (the front page). This surreptitious divide of the browser is accomplished by radicalizing the source

Right and below:
22 jodi.org,
http://wwwwwwwww.jodi.org, 1995

code into the pictorial, and radicalizing the executed task into the unreadable.

Jodi.org also made a web page – a profanity-riddled work which uses the English word 'fuck' as its background – for Alexei Shulgin's site, the Moscow WWWArt Centre. Introducing it in August 1996, Alexei Shulgin wrote: 'The creators are obviously bearers of cyberpunk ideology with rather good taste…. They have presented post-linguistic and post-visual research that reflects very well the state of contemporary culture and communication. It's very logical that they are using the English word "fuck" as a background – nowadays it has become a mere symbol that means nothing and everything at the same time – a synonym for all other words….' The invocation of 'fuck' could be seen as a juvenile anti-authoritarian gesture, but it also reveals the code's human authors, people who value experimental programming. Unlike many other projects from this time, this work is free-standing, full of internecine interactions for users to get caught up in, and independent of external links or other sites. The disinclination of Heemskerk and Paesmans to straightforward dialogue with writers and curators, and their persistent use of oblique and nonsensical communications, have ensured that their own motivations remain unarticulated, often even to those who can read their subtle, cunning code.

Both *Link X* (1996) [23] and *_readme.html* (1996) [24], by Alexei Shulgin and Heath Bunting respectively, rely on the web's protocol for dividing and organizing files into domains (domains are the readable names, such as www.art.net, linked to IP addresses) and URLs (Uniform Resource Locators or file addresses). Like land titles in unchartered territories, in the mid-1990s domain names were entirely up for grabs. On one level, domain names are the most rudimentary, elemental aspects of internet art. They are signifiers, fundamental to the functions of the web, though often obscured by what fills the browser's main screen. Often addresses reveal technical information about a site – for example, if a URL has '.jsp' in its address, one knows that it was likely programmed in Java, while '.asp' means an Active Server Page is in use. On another level, domain names and URLs can help define communities by designating certain parameters of authenticity, expertise, tenure or power. Domain names are limited. For example, at the time of writing it was difficult to buy titles for iconic URLs like http://www.art.com or http://www.sports.net – these would have been occupied long ago, possibly purchased for substantial sums. The inflection of expertise in a domain name can be understood by considering how an art enthusiast would receive a text residing in the artforum.com domain versus one residing on a GeoCities or AOL server.

Shulgin's *Link X* forces attention to domains by listing them in thematic groups – 'never, never, always, today, now, maybe' is one *King Lear*-esque section, for example. When one mouses over the links, one sees that repeated words indicate further variances within the name – one may end with '.com' (signifying a commercial enterprise), another '.org' (for organizations) or '.net' (a more neutral suffix, used in varied ways). The multiplicity of a concept like 'desire', all the ideas it represents, is paralleled by the diversity of references made – desire.org is an inter-European initiative (Development of a European Service for Information on Research and Education), while Desire.com is a porn site. The project demonstrates how swiftly expectations or associations can be undone with the click of a mouse. Who would imagine that sky.org would yield the Finnish Cannabis Association? Shulgin's arrangement of concepts into groups brings a modicum of poetic order to a chaotic space, while still effectively emphasizing some of the more surreal aspects of words and language. His use of English, not his native language, signals inter-cultural dimensions of both the work and the medium (which was at that time English-language dominated); the project's form, a list, emphasizes qualities of

graveyard
truth
lies
love
love
friendship
bad
bad
good
best
body
sex
penis
pornography
gay
lesbian
saint
bible
bible
religion
church
jesus

coherence and organization, even as the unpredictability and frequent strangeness of the linked sites suggest the net's organic aspects, creating an overall effect quite different from language-based work offline.

Heath Bunting's controlled and more cynical project on domain names, _readme.html (which is also entitled *Own, Be Owned or Remain Invisible*) takes its name from the instructions document that accompanies software installers. Inviting the viewer in fairly informal terms to engage with the project, the title also serves to unite several registers: personal, procedural (almost all software has a text file called 'read me' that users are meant to read before use), self-promotional, instructional and technical. Like *Link X*, _readme.html foregrounds the centrality of the link and the domain name: here, each word in the article links to its semantically equivalent domain (every.com word.com becomes.com a.com dot.com com.com). As in *Link X*, the links are discovered by mousing over the linked words on the web page. Unlike *Link X*, however, _readme.html's external links across the web are unified by a journalistic text, an article profiling Bunting by journalist James Flint from British paper *The Daily Telegraph*. An account of the artist's background, family and interests, the

THE TELEGRAPH WIRED 50

 is on a mission. But don't asking him to
define what it is. His CV: bored teen and home computer
hacker in 80s Stevenage, and
 in Bristol, organiser and
digital culture activist, or his phrase, artivist, in
London, is replete with the necessary qualifications for a
90s sub-culture citizen but what's interesting about
is that if you want to describe to someone what he actually
does there's simply no handy category that you can slot him
into.

If you had to classify him, you could do worse than call him
an organiser of art events. Some of these take place online,
some of them in RL, most of them have something to do with
technology, though not all. One early event that hit the
headlines was his 1994 when
distributed the numbers of the telephone kiosks around Kings
Cross station using the Internet and asked whoever found
them to choose one, call it at a specific time and chat with
whoever picked up the phone. The incident was a resounding
success: at 6 pm one August afternoon, the are was
transformed into a massive techno crowd dancing to the
sound of ringing telephones, according to

More recently, in collaboration with his an
ex-Greenham activist and bus driver he set up a
 which mimicked the real one and asked employees to
send in their pets for vivisection and experimentation.
Glaxo were alarmed enough to issue a public statement, and
have the offending site removed.

But why has this one-time graffiti artist and stained glass
window apprentice embraced the net. When I was on the street
I was always looking for new tools, and I was always looking
to do battle with the front-end though I hesitate to say the
front end of what, exactly. For me the real excitement of
the net was that it exposed many different types of people.
Also, the new medium gave someone like who had little
or no resources - the chance to engage head on with
large-scale organisations I've always attacked big things.
When I was a kid I always used to pick fights with people
that were bigger than me. I suppose I've carried on doing
it, though now I'm fighting multinationals, or large belief
systems. I grew up in Stevenage, too, which although it
seems very pleasant jobs, grass, good transport it is in
fact an incredibly violent place. It s to do with the
top-down plan of the whole place and all the areas are
designated, for example. I think that's where I got my
hatred of large forms. People think it's a shame that

article's re publishing and mapping onto the web is provocative. Does the artist approve of this profile? Is it press material or a subversion of it? With its faded palette, light grey on white, the colours are barely there, an invocation of melancholia. There are poetic strategies at work: the article's content speaks of an individual and his preoccupation with attacking 'big things', 'large ideal systems', and the text creates a tension between the artist and his invocation of eight hundred commercial domains (one for each word in the article). Users encounter a mode of displacement and decentralization as they interact with the project which makes critical and hypertextual links between artist and discourse.

_readme.html hints at a different operational relationship between artist and critic. Proficient in programming and adept at various tricks and short cuts, Bunting modifies the authority of Flint's article by appropriating it into his own set of concerns and idioms. Similarly, in 1997, Bunting was widely considered to be behind the counterfeiting of various critics' identities. Both Tim Druckrey, a prominent new media art curator and writer, and critic Joshua Decter were spoofed when texts about net art, bearing their email addresses and names, were posted to various mailing lists – the power of the critic subverted by some basic email software manipulations.

Travel and Documentary Modes
Many artists and curators involved in media art of the 1970s and 1980s extended their work and interests easily into the internet space. In Europe and Russia these sorts of transitions were enabled by the significant political and cultural changes taking place: agencies, governmental or NGO, that specialized in art, education and open-media initiatives were established and wired as network technologies became an increasingly significant part of the development booms taking place in the United States and Europe. Philanthropist George Soros, a consistent advocate of media literacy, was responsible for supporting centres in Moscow, Ljubljana, Budapest, Macedonia and other Eastern European regions, funding conferences, exhibitions and workshops. The artists, teachers, curators and critics who existed near or within these scenes often had different relationships to technology than many Americans who, in the midst of an economic boom, came to new media via consumer, entrepreneurial or academic pathways.

Many projects that emerged from these networks were highly accessible and well known to the small net art scene, publicized by

24 **Heath Bunting**, _readme.html
(Own, Be Owned or Remain Invisible),
1996

the media centres where the artists worked, or via technoart festivals like Ars Electronica (Linz, Austria) and Transmediale (Berlin, Germany). From the web's inception, HTML pages hosted text and images easily and, consequently, the format lent itself to the documentary. One of the earliest projects in this vein was *The Hiroshima Project* (1995) by Akke Wagenaar (b. 1958). Wagenaar, who had previously made interactive installations, used the web to aggregate and index various aspects of the legacy of the atomic bombing of Hiroshima. Shown at Ars Electronica in 1995, *The Hiroshima Project* brought together information about the bombing – including evidence of denial and ignorance of the event – by aggregating links. Employing sequences of data that were often contradictory, Wagenaar presented a broad spectrum of opinions. To understand the work as a whole required considering each element in juxtaposition; like Susan Hiller's celebrated project collecting diverse postcards all entitled 'Rough Sea', *Dedicated to the Unknown Artists* (1972), the paradigm of object or data-collections give the artist the role of curator and, as American critic Susan Stewart has commented, 'it comes to exist by means of its principle of organization'. Wagenaar's work was taken offline in around 1996 (it has just been relaunched) but, interestingly, American Joy Garnett began developing the very like-minded,

25 **Joy Garnett**,
The Bomb Project, 2000–present. Collecting diverse but thematically linked material, Garnett's open database on nuclear information exemplifies the manner in which new technologies can simultaneously decentralize and organize information. While much of the data and images provided are culled from political and governmental resources, *The Bomb Project* also includes artists' contributions on the topic.

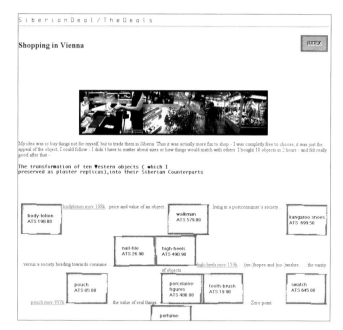

multimedia data-collection *The Bomb Project* [25] in 1997 (the web site was not launched until 2000) without any prior knowledge of *The Hiroshima Project*.

The role of the artist as transnational cultural documentarian or telepresent witness had as much to do with the web's plethora of information, and its ability to publish material straight away, as with the radically different kinds of access becoming available in the former Soviet Union and Eastern Europe. Accessing ex-Soviet territories provides the landscape for a project exploring new dimensions of global consciousness, *Siberian Deal* (1995) [26] by Eva Wohlgemuth (b. 1955) and Kathy Rae Huffman. *Siberian Deal* was conceived to 'realize the virtual and virtualize the real', in the words of the creators. This was accomplished by analysing trades and exchanges the pair made as they crossed Siberia. Items bought in the West (for example, Huffman and Wohlgemuth brought a Swatch watch, European perfume and high heels to trade) were exchanged for those local to Siberia. An emotional network evolved as the artists met, communicated and bartered with Siberians. Identifying geographical locations with a global positioning map, Huffman and Wohlgemuth transferred information about a largely unfamiliar realm via phone lines with poor reception and basic HTML, documenting the figures and scenes of their travels on choppy interfaces that feature text,

photos and animations of objects of exchange morphing into one another. The logging of encounters and travel demonstrates a net-based documentary mode that persists today, and in this case is focused on personalizing Siberia and its people by bringing together culturally disparate fields – net technologies, Siberian culture and relationship-based networking.

Huffman, an American who had been a curator at Boston's Institute of Contemporary Art, moved to Austria in the early 1990s and has since worked with a number of institutions and festivals focusing on media art in Europe, including the Soros Centers for Contemporary Art in Vienna and Moscow and Ars Electronica in Linz, Austria. Her involvement with these institutions as well as with such platforms as the Berlin-based *Telepolis*, the cyberfeminist email list Faces and the new media art organization Rhizome.org is in some ways emblematic of a particular moment in new media art's trajectory. In the mid-1990s, many artists, curators, activists and theorists focused on using the net to initiate international dialogues. At the same time, festivals and conferences offered participants venues at which to socialize and publicize their works and ideas. It was out of these projects and events that the seminal net.art scene and culture evolved.

The sensibility of that period, when there was new territory to explore online and geographically, had its analogue in a travel-

27 **Philip Pocock** and **Felix Stephan Huber**, *Arctic Circle Double Travel*, 1994–95

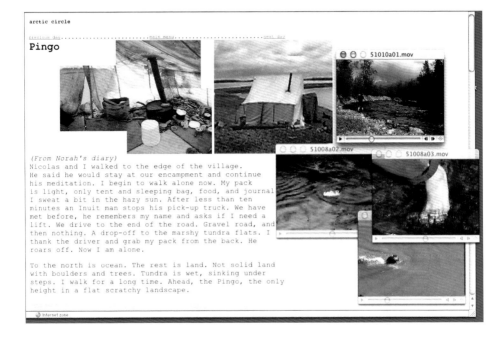

focused genre of works. Felix Stephan Huber (b. 1957) and Philip Pocock's (b. 1954) *Arctic Circle Double Travel* of 1994–95 [27] follows exploration and diary genres evinced by books from Daniel Defoe's *Robinson Crusoe* to Jack Kerouac's *On the Road.* Here, diary entries and photos are published from the fringes of the physical internet in Alaska. Rather than conducting commodity-based explorations as Wohlgemuth and Huffman had done, *Arctic Circle Double Travel* narrates personalities emerging out of isolated natural landscapes. It was more concerned with form than *Siberian Deal*, and has a sleeker design that emphasizes attractive graphics, photos and maps. Huber and Pocock's portrayal of the artist as explorer of pristine territories ably captures ambivalences felt by many net artists at that time: how to make the medium a respectable forum for art, even as it penetrated all territories, potentially flattening cultural differences and perpetuating problematic trends of capital and cultural flow from the West into less developed areas. These travel-based projects also break new ground by memorializing the drudgery and weight of the various equipment they used, documenting unreliability, crashes and irksome wires that characterized this time of pre-wireless networking, as well as fairly bulky CPUs. *Arctic Circle Double Travel* and *Siberian Deal* linked the net to less media-saturated environments, without suggesting alliances with or romanticizing either. Contrasting the connectedness of cyber life with Arctic travel, one sees in both an emphasis on process, chance, interaction and ongoing narrative – rather than on any particular final destination.

Remote locations were not the only objects of online documentation. Heath Bunting created two web sites relating to less extreme expeditions – *A Visitor's Guide to London* and *Communication Creates Conflict* (both 1995) – and featured them on his domain Irational.org, which hosts projects by a loose association of artists who share a subversive edge, low-fi aesthetics and situationist idioms. In his own work featured on the web site, Bunting follows an intuitive if sometimes cryptically simple approach. *A Visitor's Guide to London* represents the culmination of a year spent as a new resident of London, depicted through photos and observations. Black-and-white images of London streets are embedded with small buttons following north, south, east and west directions, offering the user choices that are vaguely cartographic. Other images include quotidian shots of skateboarders and corner shops, the artist's home (in which an old Mac Classic is visible on the table), along with photos of sites

@ message

i release !

```
peace and harmony vs destraction to destruction.
language from - mortality inspired fear,
creates desire for - unification via language.
'it good to talk' say british telecom,
but is futile as peace is expressionless;
attempted expression is conflict.

crypto conservative desire for breach of borders
(penetration, internal disruption, anarchy, pain, humour)
to relieve public embarassment of paradox;
for enhancement of self perception;
self define by external;
to relieve denied domination of
objective/language/structure

but the language rationale fights back,
until destruction through complexity / contradiction;
paradox attack; energy depleation.

oh dear ! what can we do ?

notes.
```

```
other stuff.

heath@cybercafe.org
```

@ message

tokyo notes

tokyo has a 'big trash' day,
but you can find stuff
lying around most of the time.

here are posters thanking the citizens
for their co-operation
in catching subway terrorists.

of interest (such as BBC headquarters and Covent Garden). In contrast to user-friendly travelogues by other artists, this project is image-driven. It is introduced by an index page (index pages are typically used to organize files within a web site and are not usually seen by the user) listing its contents in alphabetical order. Though one can navigate *A Visitor's Guide to London* using cartographic pointers, like a psychogeographical wander through the city, the index page provides a contrast between the hyper-rational order of alphabetical files and the artist's often hermetic relationships to London's buildings and roads.

Communication Creates Conflict [28] was commissioned by the arts initiative of Japanese telecom giant NTT. Like *A Visitor's Guide to London*, this project is quite literal. Its opening page features a poem outlining a more complex version of globalized communication. Within this lyrical, simple format, the artist addresses certain candid and uncomfortable aspects of

communication, including its promotion and attendant commodification by companies such as British Telecom. Rather than lauding 'communication' as a straightforward ethics unto itself, Bunting shows a sense of scepticism and curiosity throughout the project documenting a trip to Japan. The generalized scrutiny and tension of the poem heighten the level of consciousness in each of the work's various sub-pages. Subsequent pages explore themes of 'attempted expression' and 'humour' and use tech tools to add elements of time, space and presence to Bunting's Tokyo encounters. On one page users can submit text for placards that Bunting would distribute in metro stations, as per the Tokyo custom he had discovered. Some of the leaflets share a literal, simple sensibility with works by Fluxus artists Yoko Ono and George Maciunas (1931–78): 'Perpetuate your own myth', 'Emotional not rational computing', 'Cultivate your own weirdness'. A results page memorializes each placard and notes how many were distributed by Bunting. If the other travel projects mapped out terrain with IT tools and well-informed accounts and narratives, *Communication Creates Conflict* shifted the focus to interactions: web users' active and expressive roles in Bunting's encounters were important parts of the work.

Bunting's interpretations of communication practices dovetailed neatly with the ideas of many of the intellectuals coming to prominence on mailing lists like Nettime and Syndicate – figures such as Geert Lovink (b. 1959), who was a primary theorist of media pragmatism as a tool for social and political change and, with Anglo-Dutch writer David Garcia, of tactical

29 **Simon Biggs**, *Great Wall of China*, 1996. This work draws from a database of words from Franz Kafka's short story *The Great Wall of China* to produce dynamic texts. By using the navigational tropes of the Chinese landmark, Biggs directly alludes to the functions of place and language that form the basis of perception, unwittingly underlining a theme of much of this period's internet art.

media. Nettime, set up by Lovink, German Pit Schultz (b. 1965) and others in 1995 as a reaction against hyped, often American, press touting the internet as a utopian free-market platform, was small yet enormously influential in international media activism and theory circles until around 2000 and continues as an important, larger-scale discursive list. Australian critic and long-time Nettime participant McKenzie Wark notes that Nettime was 'a mailing list, but it was also a series of meetings, and publications in different formats.... It thrived on the positive confusion of the aims of its participants, all of whom could think of it in their own way and imagine everyone else concurred. [It] arose out of the discontents of critical theory. It found a negative semantic terrain in its hostility to *Wired* magazine, the *Rolling Stone* of new media sellouts, and positioned itself against the "unbearable lightness of *Wired*".' On an email list like Nettime, users subscribe by adding their email addresses to a list, and when an email ('post') is sent to the list's master address, it is automatically forwarded to all subscribers on the list.

While Nettime posts ranged wildly in style and topic – for example, reports on the status of Brazilian radio, writings on artificial life, complexity and art, musings on electronic music, essays on media consultants, French theorists Gilles Deleuze (1925–95) and Felix Guattari (1930–92), and announcements for projects or events – there were two strands of thought that connected them. One common theme was intellectual and critical scepticism of the 'Californian Ideology', a term referring to the utopian visions of the net, coined by Richard Barbrook and Andy Cameron in their highly influential 1996 essay of the same name. The other was that various aspects of technology culture and industry were discussed constantly, in great detail, and often in political terms. Though rarely focused on art, Nettime was an invaluable network for the emerging European net art community.

Net.art
Following the collapse of the Soviet Union, many artists working in Eastern Europe and Russia – cultures in which the promises of marketed 'democracy' and ideology were unwelcome – openly disavowed the consumerist, utopian and often apolitical content of dominant internet discourse. The social responsibility of this group of artists was salient, particularly at a time when many important cultural and political decisions regarding access to technology were taking place. This context encouraged a number

of artists to make polemical statements and gestures to attack norms of the art establishment. By the late 1990s this genre would involve subversive product design and hacking-related projects. Others made work that had a less practical reach, but that captured the spirit of the artist as a catalytic and social force. Many of the artists who espoused these attitudes remained less interested in art discourse by non-artists. They tended to write their own declarations and definitions, and remained out of the fray of art-related communities like THE THING and Rhizome.org. A seminal project that illustrates this position is Vuk Cosic's *Net.art per se*.

Vuk Cosic, born in Belgrade in 1966, has shown consistent interest in historical narrative (he worked as an archaeologist before becoming an artist) and variable ways to make ideas material (such as teaching, art and writing), but it was the reduced amount of time between publication and feedback that eventually led him to create internet-based art. Cosic, who had taught archaeology and been active with cultural initiatives through the Soros Foundation in Slovenia and Serbia, also had experience as an activist: 'My background includes several years in the ranks of what we called the Dissident movement. Most of my actions were part of the very general oppositional activism. Some of those were artistic, some journalistic and some were agitation. I felt very deeply an imperative to create a parallel system of values that would counter the dominant discourse in socialist Yugoslavia. The language that I used at the time was thus heavy on "us" vs. "them" both in social and artistic thinking. I believe that actually there is a bridge between that and what later became net.art.'

In 1994 Cosic came across the World Wide Web, which had a huge impact: 'I saw the web for the first time and dropped everything I was doing…. I immediately decided that I want to be involved. It was one of those situations when you are 100% confident at the very first moment…. I remember surfing for 18 hours for days. I believe I have clicked through the entire Yahoo! directory. By 1995 I was busy with the Ljubljana Digital Media Lab which was no more than a group of people talking. Luka Frelih and I started making sites for everybody that wanted them. For free. I was thinking of art in that context but very little was around that I liked. Then in March I somehow met Heath Bunting (first contact was via telephone) and found his web site was the best thing online. Then in June Geert Lovink and Pit Schultz invited me to Venice for the first Nettime meeting….'

At first, Cosic's art practice consisted of mailing images to other artists and like-minded peers. But as his affinity with Bunting and the Nettime crowd grew closer, and his mastery of HTML evolved, he began to present his own web-based artworks. *Net.art per se* (also known as *CNN Interactive*) [30] was his first project, a fake CNN site commemorating a meeting (called 'Net.art per se') of artists and theorists in Trieste, Italy, in May 1996, including Pit Schultz, Andreas Broeckmann, Igor Markovic, Alexei Shulgin, Walter van der Cruijsen and Adele Eisenstein. *Net.art per se* is a fairly comprehensive statement of the ideas that were critical at that stage of development in internet art: a serious engagement with popular media, a belief in parody and appropriation, a scepticism towards commodified media information and a sense of the interplay of art and life. At 'Net.art per se', meetings were held to consider how net artists should distribute and control work, how the 'modernist romantic perception of the "artwork"' applied to the internet, and how artists could deal with global audiences when topics and premises were not universal. *Net.art per se* is a replica of the concurrent CNN site of that time, complete with the multi-typeface logos for which the Atlanta company was famous, images of Pentagon staff and banal headlines about baseball and advertising promotions. This was the first internet art project to appropriate a mainstream web site, and Cosic created some of his own headlines. The main one blared 'Specific Net.art found possible', and the smaller headlines, which were buried under headers such as 'World', 'AllPolitics', 'Technology', 'Music' and 'Style', formed a poetic announcement.

Like pop art's early herald the British Independent Group, which affirmed the banality of photo-generated images and the

Below and opposite:
30 **Vuk Cosic**, *Net.art per se* (*CNN Interactive*), 1996. Part of the web site of the 'Net.art per se' conference.

influence of Hollywood, fashion and television, Cosic's *Net.art per se* takes materials from fields of mass media. By shuttling between CNN news and the findings of 'Net.art per se', Cosic equates both as ideological and contingent with a brazen sensibility. Indeed, CNN, which was for many synonymous with sinister aspects of ubiquitous American media and propaganda after the first Gulf War, functions here as a celebration of artistic potential. The subversion of corporate web sites shares a blurry border with hacking and agitprop practices that would become an important field of net art, often referred to as 'tactical media'. Located within a field of mass media, *Net.art per se* is absorbed by the system of communication and distribution through which it is published, and which it addresses. There is another echo of pop art and Andy Warhol in particular at work – *Net.art per se* follows his idioms of tabloid fetishizing and self-aggrandizement. Indeed, if Warhol's *Screen Tests* marked the onset of a paradigm in which media attention is a focus of social identification, a mirror for individual self-perception, as suggested by German critic Ursula Frohne, *Net.art per se* begins a campaign for artistic authentication on a stage stolen from the heart of American media.

Finally, 'net.art', a neologism conjoining artistic and internet communication fields, did more than suggest an art practice that was rooted in net culture. The name – which Cosic coined after coming across the conjoined phrases in an email bungled by a technical glitch (a morass of alphanumeric junk, its only legible term 'net.art') – would come to stand for the contributions of that first wave of people working during the 1990s, Cosic, Shulgin, Jodi.org, Bunting and Lialina chief among them.

31 **THE THING**, *c.* 1992–93. A screenshot of early versions of BBS THE THING as well as an image of some core participants. Founder Wolfgang Staehle is on the far left.

32 **Peter Halley**, *Superdream Mutation*, 1993. A signature configuration of electronic and architectural topographies, this digital image by Peter Halley was sold by Wolfgang Staehle via THE THING. The sale of Halley's images marks net art's earliest monetary transactions.

Net.art per se's headlining conclusion that a specific 'net.art' was possible galvanized discussions about internet art taking place online. In fact, nodes for discussion sprouted up internationally. One well-known Eastern European list was Syndicate, which started to connect media art practitioners in locations such as Sofia, Belgrade, Albania, Sarajevo and Estonia in 1995. Three other projects were based in New York: THE THING (1991) [31], which was launched as a BBS for artists and enthusiasts in New York and Cologne, äda'web (1994) and Rhizome.org (1996). THE THING was started by artist Wolfgang Staehle (b. 1950), originally from Germany, after a curiosity-driven impulse buy in a computer store led him to set up a large modem. After logging online, Staehle made the pleasant discovery that information-sharing and camaraderie were the dominant characteristics of most BBS exchanges, and he decided artists would benefit from their own version of an online communication channel. Staehle's reputation as an intellectual artist attracted an exceptionally gifted group of artists, curators, intellectuals and kindred spirits to post on THE THING's boards. During the mid-1990s, they would dial into the text-based hub to trade ideas on art, technology and politics. THE THING hosted discussions, reviews and art projects, and was for a long time a standard-bearer for many art platforms. Besides being the first to sell and distribute art online – Staehle put digital files by Peter Halley [32] up for sale and a year later published images and sound files by the likes of Japanese artist Mariko Mori [33] – THE THING was the internet service provider (ISP) of choice for many artists based in New York and Germany. Capitalizing on its strong European ties and Staehle's history on

the gallery scene, THE THING built itself into an innovative arts lab, sticking to the web as its basis through most of the 1990s (as opposed to email or print publication formats, for instance).

Rhizome.org, founded on Deleuze and Guattari's notion of a 'rhizome' as an anti-hierarchical, decentralized network, leveraged the archive model and email lists to form what its founder Mark Tribe has referred to as a social sculpture, an interconnected, collaborative platform run by new media artists, curators, critics and viewers. It is now commonplace to talk about networks and communities online, but Rhizome.org was singular for using models of free-form discussions as strategies for an art-focused public forum. An unmoderated email list hosted all kinds of discourse, from high-minded theoretical posts to patent self-promotion or friendly chatter. Criticized for being too 'American' in focus, or for lacking critical rigour, Rhizome.org as a venue for art discourse welcomed the changing conventions of electronic art criticism and consumption by refusing to be above its participants' preoccupations. At the time of its formation in Berlin (Tribe later relocated to New York), Rhizome.org intended to be a for-profit venture and started off as www.rhizome.com. Such was the mood in 1996 among Tribe and other new media visionaries, including those behind editorial ventures like *Telepolis* and *Word*, that they thought the 'new economy' taking shape would serve to value new kinds of content, like Rhizome.org's mix of chatter and theory. By 1998, it was clear that Rhizome.org had to become a non-profit organization to stay afloat.

33 **Mariko Mori**, *Angel Paint*, 1995. A number of well-known artists, such as Mori, worked with THE THING, using the web as a medium as well as a means of distribution for their work.

Curator Benjamin Weil was also interested in hybrid forms made possible by online formats. Weil had cut his internet teeth with THE THING, but was interested in working closely with artists to create online experiments that explored new territories of production and distribution in the tradition of the Bell Labs-sponsored EAT. In 1994, Weil teamed up with the arts-minded British businessman John Borthwick to found äda'web, an online art platform that complemented Borthwick's other web site, a guide to Manhattan called *Total New York*. Like New York's Dia Center for the Arts, which had a similar programme for collaborating with blue-chip artists on web-based projects, äda'web produced its first art site in 1995, Jenny Holzer's *Please Change Beliefs* [35]. The work divides itself into three parts, each named for one of the title words, *Please*, *Change* and *Beliefs*. *Please* refreshes unsettling aphorisms, such as 'Humanism is obsolete' and 'Murder has its sexual side' across a web page. *Change* allows users to modify these aphorisms, and *Beliefs* aggregates the now modified truisms. Occasionally one comes across a video-formatted version of an aphorism. Holzer's long-term interests in spatializing information in public spaces, using items such as T-shirts or more commercial formats including billboards, are well matched to the mixed context of the commercial and communitarian web.

Äda'web would develop around twenty other projects and collaborations before shutting down in early 1998 when parent company Digital Cities, owned largely by America Online (which acquired Digital Cities and äda'web in 1997), withdrew funding. While there is no way to group the wide-ranging projects undertaken at äda'web conveniently without seriously

34 **Group Z, Belgium** (hosted by äda'web), *Home*, 1995. A simple project that called attention to the variability of browser windows by proposing, pictorially, a specific width and height.

Opposite:
35 **Jenny Holzer**, two screenshots from *Please Change Beliefs*, 1995

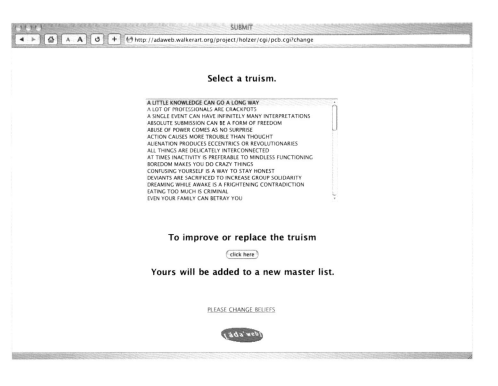

http://adaweb.walkerart.org/project/holzer/cgi/pcb.cgi?change

Select a truism.

A LITTLE KNOWLEDGE CAN GO A LONG WAY
A LOT OF PROFESSIONALS ARE CRACKPOTS
A SINGLE EVENT CAN HAVE INFINITELY MANY INTERPRETATIONS
ABSOLUTE SUBMISSION CAN BE A FORM OF FREEDOM
ABUSE OF POWER COMES AS NO SURPRISE
ACTION CAUSES MORE TROUBLE THAN THOUGHT
ALIENATION PRODUCES ECCENTRICS OR REVOLUTIONARIES
ALL THINGS ARE DELICATELY INTERCONNECTED
AT TIMES INACTIVITY IS PREFERABLE TO MINDLESS FUNCTIONING
BOREDOM MAKES YOU DO CRAZY THINGS
CONFUSING YOURSELF IS A WAY TO STAY HONEST
DEVIANTS ARE SACRIFICED TO INCREASE GROUP SOLIDARITY
DREAMING WHILE AWAKE IS A FRIGHTENING CONTRADICTION
EATING TOO MUCH IS CRIMINAL
EVEN YOUR FAMILY CAN BETRAY YOU

To improve or replace the truism

(click here)

Yours will be added to a new master list.

PLEASE CHANGE BELIEFS

(ada'web)

http://adaweb.walkerart.org/project/holzer/cgi/pcb.cgi

ABSOLUTE SUBMISSION CAN BE A FORM OF FREEDOM

ABSOLUTE SUBMISSION CAN BE A FORM OF FREEDOM

(ADD) (RESET)

PLEASE CHANGE BELIEFS

(ada'web)

undermining the artistic goals of Weil and his collaborators, many of the well-known artists with whom they worked, such as Holzer, Lawrence Weiner (b. 1942), Julia Scher and Doug Aitken (b. 1968), were able to explore their signature idioms or interests during their affiliation with the organization.

Online nodes like äda'web filled important gaps between artists and established institutions and audiences of art enthusiasts in a variety of ways. More than simply enabling the promotion and distribution of new media art projects, they gave users the means to communicate, develop critiques and amuse themselves. With online chat a persistent activity, these forums could often resemble variety-show stages or spoken-word performances. And, unlike the traditionally influential channels of art criticism – print magazines such as *Artforum*, *Flash Art* and *Art News* – mailing lists enabled artists, critics and enthusiasts to stand on an equal footing, with the email setting making an end to discussions virtually impossible. Furthermore, the small group of interested participants, numbering just a few thousand until 1999, contributed to an intimate and close-knit sensibility. Not that these communities or networks solved everything – internet artists still lacked inclusion in broader art discourse and, even if they considered institutional acknowledgment to be dubious, there were shared concerns about how artists could support themselves. Indeed, the net had many shortcomings.

36 **Vivian Selbo**, *Vertical Blanking Interval* (left) and *Consider Something Intangible* (right), from *Vertical Blanking Interval*, 1996. This äda'web project establishes hybridity between internet and television aesthetics by using the web as a framework for the presentation of televised commercial data. Featuring commercials emptied of their contents and reduced to obtuse communiqués, Selbo's screens might also be read as visualizations of what is normally hidden from the television viewer.

37 **Peter Halley**, *Exploding Cell*, 1997. The Museum of Modern Art in New York undertook a brief exploration of internet art, commissioning projects such as Halley's *Exploding Cell*. An online adjunct to the artist's offline exhibition, this collaboration and those like it were nonetheless significant and helped to introduce internet aesthetics to artists and art enthusiasts.

38 **Barbara London** for the Museum of Modern Art, illustration from *Stir-Fry: A Video Curator's Dispatches from China*, 1997. Media curator Barbara London used the net to document a curatorial research trip to China. Somewhere between a demystification of the curatorial process and an introduction to contemporary art in China, this mode of documentary has a hybrid nature.

ON THE WAY

We are the loyal sons of distance

Every morning we depart, the mind ablaze

The heart weighed down with care and bitterness

We go, according to the rhythmic love

While the songs escaped backward

Footfalls echo in the memory.

No privacy here, the installation **"Visible and Invisible Lives"** makes clear. Arrayed within a framed outline are a set of monitors, a window on one, a door on another, a foot entering on a third, all of which can be understood as details of a room.

The trio were thrilled that viewers took their room as something real, and acknowledged its implications.

Cyberfeminism

Among these discursive networks, the scrutinizing of politics and the analysis of how gender, race and class informed technoculture often took place. 'Cyberfeminism' was one of these fields of practice. With a decentralized, connection-dependent matrix as the crux of net culture, theorists like Sadie Plant (b. 1964), with whom the Australian collective VNS Matrix [39–40] coined the term 'cyberfeminist', found the net to be inherently female and feminizing. Other feminists, such as Faith Wilding (b. 1943), noted that feminism's migration into information-technology fields was part of 'Third Wave' feminism's occupation of diverse platforms for public action and rebellion. As well as supplying a term of identification (i.e. 'I am a cyberfeminist artist'), cyberfeminism covers three areas, generally speaking. It describes the position of women in technological disciplines and labour, including gender-based divisions of labour within these fields and industries. It also addresses women's experiences of technoculture, including its effects on work, domestic life, social life and leisure. And finally, it comments on the gendering of various technologies, possibly their feminization or eroticization.

VNS Matrix was formed in 1991 in Australia by members Josephine Starrs (b. 1955), Francesca da Rimini (b. 1966), Julianne Pierce (b. 1963) and Virginia Barratt (b.1959), who left the group in 1996, as a technoart group with the stated goals of using and manipulating technology to 'create digital spaces in which identity and sexual politics can be addressed'. In its communiqués, or the frequently referenced *A Cyberfeminist Manifesto for the 21st Century* [39], the Matrix flaunts strategically changing identities and spectrums of sexual power, as well as the combination of sexual and technical languages. The presence of its members at conferences and on email lists underscored how the intellectual, male-dominated net could be seen as just the latest in a fairly long history of male-dominated media. Where Nettime offered up versions of net users as dupes, often unknowingly deprived of various freedoms or lacking in critical ability, the VNS Matrix took a different approach – overriding accepted net behaviour with sexual and creative personalities, and searches for fun and knowledge.

Their *Cyberfeminist Manifesto* is at once sexual, graphical and technical and, with its explicit language, evokes the 'cunt art' of the 1970s. It can also be identified with 1980s French feminist concepts like *jouissance* and *écriture* which posit, respectively, pleasures and writing that exist beyond discourse and fixed

39 **VNS Matrix**, *A Cyberfeminist Manifesto for the 21st Century*, 1991

40 **VNS Matrix**, *Cortex Crones*, 1993. Still from All New Gen computer game. The post-binary gender cyborg was the central theme of this science-fiction-based game by the VNS Matrix. Never realized, it does predate the vogue for game art in the first few years of the twenty-first century.

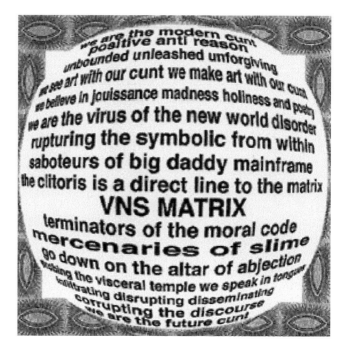

we are the modern cunt
positive anti reason
unbounded unleashed unforgiving
we see art with our cunt we make art with our cunt
we believe in jouissance madness holiness and poetry
we are the virus of the new world disorder
rupturing the symbolic from within
saboteurs of big daddy mainframe
the clitoris is a direct line to the matrix
VNS MATRIX
terminators of the moral code
mercenaries of slime
go down on the altar of abjection
infiltrating the visceral temple we speak in tongues
corrupting disrupting disseminating
corrupting the discourse
we are the future cunt

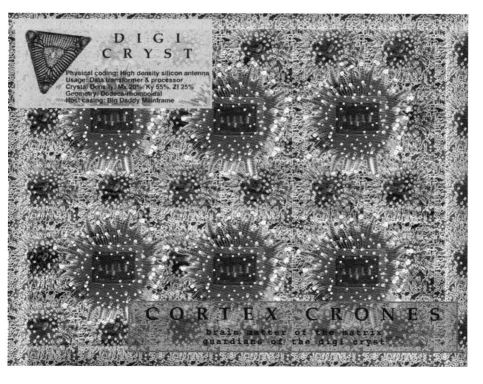

DIGI
CRYST

Physical coding: High density silicon antenna
Usage: Data transformer & processor
Crystal Density: Mx 20%, Ky 55%, Zf 25%
Geometry: Dodeca-rhomboidal
Host casing: Big Daddy Mainframe

CORTEX CRONES
brain matter of the matrix
guardians of the digi cryst

meaning (which was identified as male and bound by conventional language). Further establishing its historical weight, the manifesto itself travelled as a graphic, inscribed in a circle defying linear trajectory – an allusion to the argument posed by feminist Alice Jardine that masculine aesthetics privilege linearity. In an interview posted to Nettime, Josephine Starrs described the group's goals and methods to Dutch art critic Josephine Bosma: 'We started postering cities in Australia with that manifesto. We wanted to work with technology, we're all from different backgrounds: writer, performance artist, filmmaker. I was from a photography background. We didn't have access to any particular new technology, but we had access to a photocopier, so we just started writing about technology, because we were worried that it seemed such a boys' domain at that time, in the artworld and so on…. We had this agenda of encouraging women to get involved if they want to look at their relationship with technologies, to get the[ir] hands on the tools and to have fun with it. Part of the project was to use humour in this process…. We tried to make it like technology isn't intimidating, it's fun to use.'

Another reason the 'cyber', 'sexual' and 'feminist' seemed so compatible in the hands of the VNS Matrix is that the group made optimistic theorizations of network technology popular in the mid-1990s. One of these was the 'cyborg', which referred to a cultural dependence on technology. Cyborgs were a key concept of the time, deployed by the VNS Matrix and advocated as a politically potent feminist aesthetic by Donna Haraway in her 1985 canonical essay, 'A Cyborg Manifesto: Science, Technology, and Socialist-Feminism in the Late Twentieth Century'. One should also note that in virtual net environments like Palace, popular in the mid-1990s, graphical representations of self were often thought of as alternative personae, or 'avatars'. That people could be liberated from the standard descriptive qualities of the day-to-day world gave way to theories that the net heralded new kinds of fluid identities, complete with altered hierarchies and unprecedented interconnections. True, these relied on making a distinction between 'real life' and online life, but it was a popular assumption around the time of this manifesto. The projected image portrays the internet as a utopia of fresh social formations and individualities. For women artists in particular, these possibilities held a great deal of aesthetic potential and freedom.

Corporate Aesthetics

Critical consciousness of power imbalances took many forms in net art circles, and one persistent articulation of political frustration online has been anti-capitalist sentiment. One strand of these politics took to claiming that internet territory was artistic, and was bolstered by critiques of the intellectual, creative and moral inferiority of commercial ventures. Dotcoms were often the focal points for this anger, as they were taken to be emblematic of the market-driven, utopian 'Californian Ideology'. The term 'dotcom', of course, refers to the semantic suffixes of new media companies generally founded in the 1990s with the aim of capitalizing on the rise of internet usage and culture by providing specialized tools or content. As providers of solely online-based services, Amazon and Yahoo! are dotcoms, whereas companies like Apple and IBM are not, though they also maintain an online presence.

In art circles, the aversion to dotcom culture and ethos was often marked by expanded uses of satire and parody – employing the intriguing limits of these models to provoke critical consciousness. While a web site called ®TMark.com would become an epicentre for this activity in the late 1990s, etoy – created by a group of European artists then operating out of Zurich, Switzerland – was the first to use dotcom aesthetics to reposition art in relation to daily practices. Incorporated in 1994, etoy fuelled its self-styled hybrid of business practices, foolery and confusion with ambitious, though ambiguous, radicalism.

The plan, as articulated on the web site, was 'to establish a complex and self-generating art virus and e-brand which reflects and digitally infects the nature of today's life and business at large: an incubator that turns the essence of digital lifestyle, e-commerce and society into cultural value'. Via identical costumes and highly regimented behaviour, based on detailed research and exhaustive discussions, etoy members brought office aesthetics into the more marginal scenes they inhabited in Switzerland and Austria. Online, their antics included surreptitiously confusing web users about the content etoy offered, and in 1996 a search engine hack called *Digital Hijack*, which redirected thousands of search engine users to the etoy home page. In 1999, etoy became embroiled in a remarkably complicated fight with a dotcom named eToys that brought the spectre of corporate mockery into the scope of American financial markets (see Chapter 3).

Anti-commercial sentiments posing a relationship of binary opposition vis-à-vis the 'artistic', 'pure' and 'progressive' were

41 **Eva Grubinger**, *Netzbikini*, 1995. In this early work, participants download and print out a bikini pattern (a non-technological subject) and customize it for wear. As a result, Grubinger's web site hosts a profusion of hand-made, individualized swimsuits that make it difficult to focus on any one costume or participant. This project highlights an important aspect of the decentralized internet, through which a vast array of data travels easily to be recontextualized in subjective settings.

Above left:
42 **Ben Benjamin**, *Bingo skills-building seminar and strategy workshop*, 1995

Above right:
43 **Ben Benjamin**, *Earman*, 1997

hard to sustain in such a mixed environment as the net. Within the context of new media art, the topic of dotcoms could illuminate various corporate behaviour and allowed artists to manifest rejection of market strategies or objectives. Progressive projects were almost always fraught with paradoxes: at this time most net artists were dependent on commercially produced tools like those of Adobe, Netscape and Qualcomm (free-software tools would later diversify the field), and all of them found their work distributed via browsers – which were then standard commercial softwares distributed by new media giants such as Microsoft and America Online. Most artists, including Vuk Cosic with his *Net.art per se*, or Heath Bunting with *_readme.html*, sought to traffic in these very contradictions but with their own intentions made clear.

It must be added, though, that in net art circles the term 'commercial' was considered as both positive and negative, and much commercially minded work was thought to exhibit exciting and constructive artistic qualities. This was as much a philosophical position as it was a realistic one, because many internet artists supported themselves as professional designers, producers or programmers in the new media. Especially in America, where governmental support for artists is limited, new media artists could often be found at work in the private sector. Michaîl Samyn (b. 1968) [44], a Belgian artist, and Ben Benjamin (b. 1970) [42–43], an American based in San Francisco, were two such designers/artists who began working online in the mid-1990s and

launched web sites with similar names, *Zuper* and *Superbad* (1995) respectively, to showcase art and design work. Both seem to have thoroughly absorbed the playful and joyous aesthetic capabilities of HTML, and their works recover a sense of the fun, unfamiliarity and wonder of digital aesthetics. *Superbad* in its early iterations seemed to disregard programming limits and standard spatial deployment. Highly visual, and underpinned by rich syntheses of games, pop culture, advertising and signs, *Superbad* used a range of aesthetics practices in interfaces, suggesting that the web was a diverse and multivalent medium. The grand spectacles these artists created as experiments were unable to reconcile the tensions between the aesthetic and commercial, but they isolated some of the net's more desirable and glamorous possibilities.

Telepresence
A term derived from virtual reality describing the sensation of feeling in a different place or time by virtue of technologies of coordination, 'telepresence' is a characteristic of much internet behaviour, in the way that reading an email from an overseas friend produces a kind of intimacy that belies geographical distances. This sensibility has encouraged fantasies that internet industries and cultures are 'virtual', existing in ether or in an almost fantastic realm, with no impact on actual behaviour, natural resources, lands

44 **Michaïl Samyn**, *Zuper2: spring*, from *Zuper*, 1995

or existing systems. And to the extent that internet networks, especially amidst media and economic hype, seemed to occlude the realities of life offline, literally and figuratively, there were artists who immediately recognized the net as just one 'network' next to many others, such as those found among natural phenomena. Articulating a link between natural processes and communication networks in symbolic and mechanical terms is *The Telegarden* (1995–present) [45] by Ken Goldberg (b. 1961), Joseph Santarromana, George Bekey (b. 1928), Steven Gentner (b. 1972), Rosemary Morris, Carl Sutter, Jeff Wiegley and Erich Berger. In this installation work, internet users worldwide are able to tend a living garden (physically located in Linz, Austria) by giving commands to a robotic arm, which is controlled through *The Telegarden*'s web site. The project highlights a sense of community by getting visitors in dispersed locations to manage the garden (by watering it or planting new seeds, for example). Although viewer requests are carried out in turn, several users can care for the garden at one time, and it is also possible to see the identity of fellow-users along with their position in the garden. Interactivity between participants is further encouraged through the so-called 'village square', a public chat system.

The other side of 'telepresence', cannily alluded to by *The Telegarden*, is the physical, vital reality easily missed in the context of new media culture. The haze of press about the revolutionary capabilities of the net, and the relentless attention paid to the stock prices of internet-related businesses occluded, for a time, certain realities. In fact, most of the world's cargo continued to travel by sea (not high-speed internet access lines), packed and accompanied by people, and the production of computers and related equipment followed the same patterns as other electronics; the toxic materials that form these devices were moulded by factory workers in Third World countries. These issues underwrote the work of the artist group Bureau of Inverse Technology, which is headed by its engineer Natalie Jeremijenko (b. 1966) and, like etoy, set out to emulate the anonymous nature and brand ambition of companies trading on the stock market, bringing representations of less-visible information into artistic zones. *Live Wire* (1995–present) [46] was an early internet-related project set up by Jeremijenko, which elided the standard activities of the internet (browsing web sites, sending an email), making use of a local network to visualize activity with a string that wiggled according to local computer usage. The dangling sculpture increased the peripheral reach of

45 **Ken Goldberg**, **Joseph Santarromana**, **George Bekey**, **Steven Gentner**, **Rosemary Morris**, **Carl Sutter**, **Jeff Wiegley** and **Erich Berger**, *The Telegarden*, 1995–present

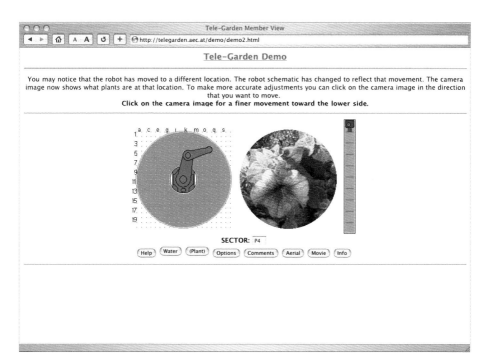

http://telegarden.aec.at/demo/demo2.html

Tele-Garden Demo

You may notice that the robot has moved to a different location. The robot schematic has changed to reflect that movement. The camera image now shows what plants are at that location. To make more accurate adjustments you can click on the camera image in the direction that you want to move.

Click on the camera image for a finer movement toward the lower side.

SECTOR: P4

Help Water (Plant) Options Comments Aerial Movie Info

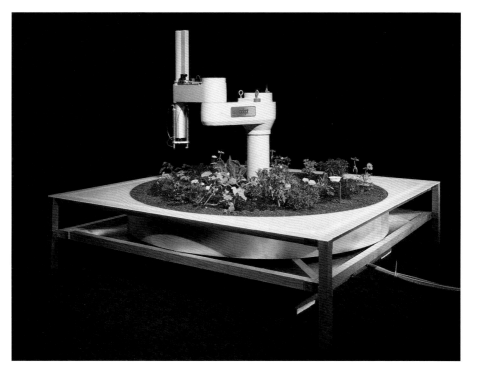

the formerly inaccessible and unarticulated network traffic. While screen displays of traffic are relatively common for practical purposes (e.g. air-traffic systems), their symbols usually require interpretation and attention, and the string, in part because of its very banality, was an unusual, sculptural and sensitive index for activity, allowing aural, spatial and visual impact. This piece was initially installed in the heart of Silicon Valley, Xerox PARC in Palo Alto, California, where its wiggles claimed attention for neglected information.

In *Live Wire*, a formal element is vitalized and composed by network activity, creating an association between minimalist sculpture and the internet. The work also signals, at the close of the earliest years of net art practice, an increasing focus on formal expression. In fact, many of the preoccupations of this chapter – online communication, the browser screen and documentary – were to be carried forward in years to come, explored and reconfigured using new means of production, collaboration and audience. With *Live Wire*, Jeremijenko is intent on emphasizing the representation of internet concepts (such as network traffic) just as much as functionality, and this interest would become the foundation of much net art that followed.

46 **Natalie Jeremijenko**, *Live Wire*, 1995–present. The more recent installations of *Live Wire* in offices and cafés are characteristic of Jeremijenko's interest in juxtaposing the formal functions of technology and its standards with everyday or natural settings and topics.

The NEW Java Flashes

Flash 1 Flash 2 Flash 3 Flash 4

STOP HOMEPAGE

© 1999 João Aires de Sousa

ATENTION !! THESE FLASHES MAY BE HARMFUL TO EPILEPTICS

WWWART AWARD: http://www.ips.be/_wbm/home.htm

Back Forward Stop Refresh Home History Larger Smaller Preferences Print Source

Address: http://www.easylife.org/award/fhome.htm go

Google

Men at Work in depth

It is probably more rewarding to visit the site countrywise

Argentina	Estonia		Jordan	Romania
Armenia	Finland		Lithuania	Russia
Australia	France		Madagascar	Slovakia
Austria	The Gambia		Mali	Slovenia
Belarus	Germany		Mauritius	South-Africa
Belgium	Great Britain		Mexico	Spain
Canada	Greece		Morocco	Spitsbergen
Chile	Hawaii		Namibia	Sweden
China	Hungary		The Netherlands	Switzerland
Croatia	Iceland		New Zealand	Tanzania
Cuba	Indonesia		Norway	Turkey
Cyprus	Iran		Peru	Trinidad & Tobago
Czechia	Ireland		Philippines	United States A.
Denmark	Italy		Poland	Vietnam
Egypt	Japan		Portugal	Zimbabwe
	Jersey		+ Madeira + Azores	

Path: Home / Countrylist / Men at work in depth e-mail: Bartolomeo

Internet zone

Chapter 2 Isolating the Elements

By 1997, net art had become an established pocket of relatively autonomous art-making, though it had not succeeded in reaching a wider public. Beyond the spheres of internet communities, media festivals and artists' immediate social and professional circles, there was little interest in and even less money for net artists' work. Since the launch of basic web browsers, many variations on HTML web pages had emerged. The tradition of using basic HTML and images to make art documentaries and straightforward web pages had fallen by the wayside, and parody, appropriation and formal explorations, as well as email, music and animation, came increasingly to the fore.

Email-Based Communities
Email, a system for sending and receiving messages electronically over a computer network, has changed the nature of work and communication in technologized cultures unequivocally since its widespread adoption during the 1990s. It was certainly the organizing medium for many in the cyber intelligentsia and art fields, analogous to the way in which Parisian cafés hosted the discussions of existentialist thinkers, and literary and art journals such as *Tel Quel* or *October* provided a forum for postmodern discourse. Though the email format initially limited users to texts and streamlined graphics (HTML and graphic emails did not become popular until around 2000), its advantages were its ease as a method for spontaneous and instantaneous expression and its international penetration. Mailing lists consist of email addresses organized under one name, such as softwareculture or Sarai, so that emails sent to this name are automatically forwarded to the list of subscribers, who can then respond accordingly. Curator and writer David Ross noted in a 1999 lecture entitled '21 Distinctive Qualities of Net.art' that forms of online discourse, such as

47 **Alexei Shulgin**, from the WWWART Award, *Java Flash* for 'Flashing', 1997. Shulgin founded the WWWArt award to acknowledge creative web sites that did not originate in an artistic context, creating prize categories such as 'Flashing'. By clicking on each of the new Java Flash options ('Flash 1', 'Flash 2', 'Flash 3' or 'Flash 4') the user is able to view four screens with different combinations of colourful, blinking boxes. This award celebrates the flashing image, which was a key element in the web's aesthetic development.

48 **Alexei Shulgin**, WWWArt Award for 'Research in Touristic Semiotics', 1997. Shulgin created the category 'Research in Touristic Semiotics' to award a concise guide to some common traffic signs around the world (organized by country). By awarding this web site, Shulgin alluded to an international, diverse, visual information system and highlighted the net's lack of such pointers at that time.

mailing lists, break down boundaries between critical and generative dialogues.

While email offered fairly immediate communication and expressive possibility regardless of physical location, for many net artists working in the 1990s actual meetings were vital. Spoken conversation allowed more nuance than electronic, and in-person discussions were less apt to produce the misunderstandings to which writing can lend itself, especially on international lists with mother-tongue language variations. Moreover, beyond the excitement of perennial email correspondents meeting 'f2f' (face to face), and the bonding over food, drink, dancing and travel that took place, events gave those involved the sense that they were taking part in meaningful and productive discussions about culture. Though the artists involved were by and large marginal in the contemporary art field, the scene's connections to respectable and engaged intelligentsia were a kind of compensation, a lifestyle

49 **Jodi.org**, *Yeeha*, 1996. With the direct force of an email and the visual economy of alphanumeric symbols or ASCII (the standard computer code for representing English characters as numbers), works such as this one were able to deliver both pictorial and text messages quickly and efficiently to large audiences.

50 **Heath Bunting** and **Natalie Bookchin**, *Criticism Curator Commodity Collector Disinformation*, 1999. Bunting considered the term 'net.art' to be 'a joke and a fake', precipitating a popular distraction from the chief aim of his work which was to build open, democratic systems and contexts. He collaborated with Bookchin to create this searing tutorial calling for the use of disinformation and counterfeited identities as a way of resisting the objectification and institutionalization of art.

offering a sense of shared artistic interests. Indeed, the infinitely expanded number of internet users active today should not obscure the extent to which travel and meeting 'f2f' were central to the early net art scene, especially in Europe. Despite the near absence of an art market for net art in the 1990s, new media art events were consistently well attended by significant artists in the field – for example, more than twenty-five per cent of Nettime's subscribers travelled to Ljubljana, Slovenia, in spring 1997 for the 'Beauty and the East' conference. The proliferation of meetings and festivals was necessary to sustain a culture made up of distributed pockets of excited, ambitious young artists and thinkers invigorated by technocultural possibilities. The result was a contingent of veritable nomads who hopped from Nettime meetings to Transmediale festivals, from Next 5 Minutes annuals to conferences organized by media centres such as T0 in Vienna, C3 in Budapest and many others.

nettime may meeting
Beauty and the East

welcome to the

Net Criticism Juke Box

hey kids, here are some clips:

?	RA stream	RA file	MPEG3 stream	MPEG3 file
1. E-lab in London	1Mb	1Mb	6Mb	6Mb
2. Cherie Matrix	1Mb	1Mb	6Mb	6Mb
3. Nick West	1Mb	1Mb	6Mb	6Mb
4. Survival in Bosnia	1Mb	1Mb	6Mb	6Mb
5. The VPRO "Paradise" show on Venice Nettime Conference	1Mb	1Mb	6Mb	6Mb
6. Digital Chaos	1Mb	1Mb	6Mb	6Mb
7. Net and Architecture	1Mb	1Mb	6Mb	6Mb
8. Orphan Drift	1Mb	1Mb	6Mb	6Mb
9. Pauline & Simon Mute	1Mb	1Mb	6Mb	6Mb
10. Julia Scherr	1Mb	1Mb	6Mb	6Mb
11. Zone	1Mb	1Mb	6Mb	6Mb

Thanx to Josephine Bosma, Michail Langer and Geert Lovink that gave us the tapes.

Even as these gatherings thrived, however, the fundamental limits of email-based communities were also becoming manifest. Josephine Bosma remembers that at the 'Beauty and the East' conference a clear disjuncture between many net artists and more hardcore activists was taking shape: 'At the event you could already see (in hindsight) how Nettime was going to change. The artists had their private meeting and did not interfere in the main meeting…. They were said to feel offended by some private mails by Nettime founder Pit Schultz who told them to keep the prank mails and other artistic intervention down a bit.'

An art project made for 'Beauty and the East', *Net Criticism Juke Box* (1997) [51], pokes fun at the endless streams of serious discourse circulating online and addresses these tensions. Put together by Vuk Cosic with material from interviews conducted by Bosma and Geert Lovink, the work uses a very simple interface to remodel and redistribute art discourse. Modelled after a jukebox but with selections of criticism rather than songs, the site has a friendly look (it is adorned by an image of Calvin and Hobbes, from the cartoon series *Calvin and Hobbes*, dancing to music) and, in terms of its interaction design, shares the notion of browsing and choice with the web. Like a mailing list, the *Juke Box*'s format prevents any one theme or opinion from dominating by relying on the scuttle of multiple viewpoints, and on subjective and responsive elements (interviews), which combine with electronic musical interludes. The inclusion of electronic music which, like

the internet, relies firmly on new technologies, invokes a novel music subculture that was very popular at the time in Berlin, London and elsewhere in Europe and also defied standard authorial conventions with its emphasis on remixing, shared authorship and group usage. The work concisely demonstrates how traditional boundaries separating visual art, music and criticism could be breached, as audio files are incorporated into another form, HTML, and broadcast almost as music. All data can be enmeshed together, recalling McLuhan's dictum that 'the content of any medium is always another medium'.

The artist-orientated mailing list 7-11 was founded in 1998 because, as Vuk Cosic recalls Heath Bunting once saying, 'We needed a forum that will be a context and not an audience.' Indeed, if Nettime moderators, in the name of discursive weight and email decorum, inhibited email art and pranks, 7-11, which Cosic, Bunting, Jodi.org and Alexei Shulgin formed together, established a new vein of creativity rooted in email. Its formation highlighted a conflict: if Bunting et al wanted freer improvisation and activity, they would have to overcome obstacles brought about not only by broadened use (more subscribers), but by the desire for permanence and a wider audience. For example, the

52 **Rachel Baker** and **Kass Schmitt**, Jury page from *Mr. Net.Art* competition, 1998

introduction of moderators (effectively editors who check emails for their relevance) and the establishment of web archives (which documented email posts by archiving them) were two such obstacles. It may have been largely due to the growth of email lists into more populous, archive-friendly forums that many major net artists abandoned them altogether.

On 7-11, to which some of those artists initially subscribed, jokes, innuendo, illustrations and fake personae abounded. Occupying a space between email and performance, the 7-11 list approximated a model of call and response, encouraging creative replies to posts, avatars, ASCII pictorials and technorubric. Some emails brought attention to the formal elements of the genre, like Jodi.org's messages, which put expanses of data in the subject line. Or, the contributions of the elusive artist m/e/t/a – these bore his personal mark, his email address, but otherwise contained huge data-collections, such as a post consisting of a long list of serial IP numbers and the web sites that occupied them.

Though the list managed to alienate some female artists – London-based Rachel Baker, for example, described it as littered with 'sexual, egotistical, politically incorrect posturing' – it was a pioneering effort in externalizing creativity and experimentation. Participants such as Baker, Cornelia Sollfrank and Josephine Bosma were shrewd observers of the workings of art-celebrity and discourse, and were sufficiently inspired and repulsed by 7-11 to parody it quickly with the *Mr. Net.Art* [52] competition of 1998. A playful art competition that used the terms of a beauty pageant to mock celebrity, Bosma describes *Mr. Net.Art* as 'really part of the experimental environment at the time. 1997 was the year of the first Cyberfeminist International and it was the year in which Faces, the mailing list for women in new media, started. I was looking for ways in which the main, mostly male discourse could be subverted to the advantage of women.' In *Mr. Net.Art*, the notion of the individual male artist-genius was exposed to ridicule. The eventual contest winner, *The Web Stalker* (1997) [60] by I/O/D 4, had not even been a contestant. This artist-created software indicated a horizon beyond the terms of the competition – beyond categories of gender and personal charisma. *Mr. Net.Art* challenged the claims that net art culture was enlightened, and created a *de facto* women's group out of its all-female jury.

Exhibition Formats and Collective Projects
The visibility and influence of international net art meetings and conferences such as 'Beauty and the East' coincided with large-

scale online exhibitions launched by individuals and a handful of curators associated with various international museums. Alongside these curators, universities from Colorado to São Paulo were expanding their research and teaching new media art and theory. Despite the small audiences attending these shows, and the occasional clumsiness with which some curators considered the internet, museum support provided exposure for many artists and gave interested viewers a focal point for discussion.

Offline galleries remained generally uninterested in internet art in the 1990s for a number of reasons. Like media art, performance or moving-image work, internet art was difficult to sell: it was ephemeral and prone to technical obsolescence, it had unfamiliar display aesthetics, and projects were technically complex. For many galleries, their own identity was associated with a physical location and actual artworks, and internet-based work simply did not make sense to them. One commercial gallery that integrated net art into its physical space and online presence from an early point as part of a roster of painting, sculpture and installation was New York's Postmasters Gallery. In 1996, Postmasters mounted 'Can You Digit?', which included a number of works that resided on the web or used new software like Director (a multimedia authoring tool that hosts audio and video)

53 **Kass Schmitt**, *Choose*, 1997. Winning entry, *Form Art* competition

In the window titled "Wrote":

prosaics

PROSAICS (rendered in a grid of squares/dots as large letters)

54 **Alexei Shulgin**, from *Form Art*
web site. On this page extending
the playful and formal themes of
the exhibition into an interactive
environment, users are expected
to enter text into an empty field
and then push a button. The result:
their words are transformed into
billboards of large letters with
strict forms. Having the capacity to
be highly experimental and open to
artists and amateurs alike is
a signature of many internet
art projects.

and were distributed online. Participants included Lev Manovich and Sawad Brooks (b. 1964). The following year, the gallery mounted 'MacClassics', in which artists made use of old Macintosh computers. As the driving force behind these two shows, Postmasters' curators Magda Sawon and Tamas Banovich did much to crystallize internet art for the New York and international art scene.

On the positive side, web-based expositions were extremely cheap to produce, as long as one had access to programming resources and server space. With little but a thematic premise and server space to host files, or even more minimally, with a web page programmed to link to other net art projects, one could build and host shows easily, assuming the role of curator and exhibition-space proprietor within a matter of hours. A key innovation was the reduced amount of time needed to mount and unmount an exhibition, with projects able to be linked to major art centres or other nodes in seconds. This made it possible for curators as well as consumers to view artwork without being restricted by geographical distance or gallery hours, while

exhibition spaces could be mobile and collapsible. This historical shift realigned the fixity of the gallery compared to the fluidity of art cycling through it – exhibition venues could now be as flexible as web sites. While in theory this development has the potential to affect the relationships between cities and the galleries that inhabit them, so far the impact on offline art spaces has been limited. Instead, a slew of net-based organizations and projects with missions to map online art have formed, enlarging the function of museums or galleries as filters and promoters of art.

Artists were among the earliest to aggregate artworks on web sites and develop exhibitions, and their curatorial practices were able to encourage new aesthetic experiments. Two playful online shows that turned the internet art community spotlight on previously unexamined formal ingredients were organized and produced by Alexei Shulgin in 1997. *Form Art* [53–54] and *Desktop Is* [55–58] take their subjects from elemental aspects of internet culture: the web form and the computer desktop. *Form Art*, commissioned by Hungarian arts organization C3, included works using 'forms' as a dominant motif. Forms are HTML conventions that appear in the guise of menus, checkboxes, radio buttons, dialogue boxes and labels; they are often used when filling out web-based applications, surveys or questionnaires. Small, interactive sections of web documents, forms have a conceptual appeal since their content is often submitted seemingly into the ether (though more likely to a mail server or web server). The range of projects in *Form Art* shows a varied exploration of the possibilities and properties of forms. For example, in *FormArt to*

55 **Alexei Shulgin**, Explanation page, *Desktop Is*, 1997

I IRI Art by Arvids Alksnis they are used to create figurative shapes, a flag, faces, a castle. Viewers input material where they can, click around and browse until, eventually, they are left with one small radio button, and there is nowhere to go. Kass Schmitt's *Choose* [53] uses forms to create shapes that stagger clumsily across the screen. By uniting artists under a formal constraint, the ensemble of works constituted a project of medium-defining value.

Desktop Is took the computer desktop as its central theme. Now common currency among computer users, 'desktop' requires some historicizing in order to recapture what made it an interesting premise for an art project. Desktops are the basic interfaces that exist on graphic computers (in other words, standard home or office computers) when the computer has completed turning on and no applications are running. Populated with files, aliases or shortcuts to applications and hard drive and folder icons, desktops are significant for their prevalence, even if they are often peripheral, and for their metaphorical value, normalizing the computer interface for technophobes. Described by writer Steven Johnson in his book *Interface Culture* as the 'cathedral' of the internet age, desktops are simultaneously architectural, artistic and semiotic. Nowadays, it seems apt that the 'desk' or 'office' connotations of desktops have been outpaced by the widespread use of graphic computers for entertainment and recreation. In Shulgin's project, the desktop is rendered the material of the exhibition and often its stage.

In *Desktop Is*, participants followed a doctrine of goal-directedness, each one using the desktop as a dominant feature in a work. Some submissions teased out issues of personalization and privacy, like Rachel Baker's desktop [56] with its coyly named folder 'Bakers Sexuality'. Others, like Garnet Hertz's [57] contribution, were chaotic and optical, with colourful icons, folders, applications and documents overwhelming and crowding one another. Overall, this project and *Form Art* find some of their meaning in-between the discrete works that comprise them, striking a balance between artists working in an individualist mode and within communities or networks.

Another important early collective project was *Female Extension* (1997) [59] by Cornelia Sollfrank, executed with a small team of programmers. A reaction to a 1997 net art competition called *Extension* mounted at the Galerie der Gegenwart of the Hamburger Kunsthalle, *Female Extension* set out to critique the criteria of judgment the museum put forth and address what Sollfrank identified as a 'lack of competence and…insecurity of

56 **Rachel Baker**, Desktop for *Desktop Is*, 1997

57 **Garnet Hertz**, Desktop for *Desktop Is*, 1997

58 **Natalie Bookchin**, Desktop for *Desktop Is*, 1997

those who show, curate, categorize and judge net art. To deal adequately with net art, those experts who are trained in traditional art, need an understanding of the new medium…based on practical experience. Without this understanding, the characteristics of net art fall victim to the aesthetic and economic considerations of the curators.' Sollfrank used a computer program to collect HTML material via search engines and recombine this data automatically into web sites. Over two hundred of these sites were uploaded to the museum's server and entered into the competition under fictional names claiming to be women artists from around the world. Calling attention to the gender imbalance among technoartists, which was at the time around 4:1 male to female, Sollfrank's project recalls, among others, Judy Chicago's legendary work *The Dinner Party* (1974–79), which also created a symbolic body of work and a legacy of female (albeit fictional) artists.

Browsers, ASCII, Automation and Error
Inspired by the free-software movement that had been operative since the early 1970s (its central activity was the distribution of software and its source code for adaptation purposes), critic Matthew Fuller, programmer Colin Green and artist Simon Pope started to develop an artistically orientated web browser in 1997, working under the name I/O/D 4. With the general premise that, as Fuller put it, 'technological innovation was class warfare', the British trio went on to create *The Web Stalker* [60]. At the time, almost all users viewed the web through Netscape Navigator or Internet Explorer, products designed according to corporate

60 **I/O/D 4**, *The Web Stalker*, 1997. Though *The Web Stalker* has many functions, these illustrations show the browser's capacity for revealing the architecture and information design of a selected web site. The small circles represent individual pages, while the interconnecting lines map the links between pages on the site.

interests as opposed to aesthetic, public or educational ones. *The Web Stalker* offered an alternative to conventional browsers and was designed to map data differently – explaining connections between web sites, for example, and offering views of web neighbourhoods. Instead of organizing Javascript or images as industry standards do, it produced readings of HTML limited to text and links, thus enabling the user to view web pages and content on an entirely different interface.

In 'A Means of Mutation', an essay accompanying the release of the software, Fuller alluded to Internet Explorer and Netscape Navigator, which were at that time engaged in the highly publicized 'browser wars' (a battle for market share), and suggested the opportunity for and potential power of alternative software: *Where do you want to go today? This echo of location is presumably designed to suggest to the user that they are not in fact sitting in front of a computer calling up files, but hurtling round an earth embedded into a gigantic trademark 'N' or 'e' with the power of some voracious cosmological force….It is the technical opportunity of finding other ways of developing and using this stream of data that provides a starting point for I/O/D 4:* The Web Stalker*….The material context of the web for this group is viewed mainly as an opportunity rather than as a history. As all HTML is received by the computer as a stream of data, there is nothing*

to force adherence to the design instructions written into it. These instructions are only followed by a device obedient to them….

In their work, Fuller and colleagues forced the seemingly generic and almost invisible presence of commercial browsers to stand as material itself to be reconsidered: not just a distribution technique or filter through which artworks could be viewed, but as content in the public sphere, fair game for perceptual and conceptual scrutiny. In his essay, Fuller also linked the software to what was being shown in museums and galleries:

At the same time as the project was situated within contemporary art, it is also widely operative outside of it. Most obviously it is at the very least, a piece of software. How can this multiple position be understood by an art-world that is still effectively in thrall to the notion of the autonomy of the object? Anti-art is always captured by its purposeful self-placement within a subordinate position to that which it simply opposes. Alternately, the deliberate production of non-art is always an option but not necessary in this context…. Instead, this project produces a relationship to art that at times works on a basis of infiltration or alliance, and at others simply refuses to be excluded by it and thus threatens to reconfigure entirely what it is part of. The Web Stalker *is art. Another possibility therefore emerges. Alongside the categories art, anti-art and non-art, something else spills over: not-just-art.*

61 **Jodi.org**, *http://wrongbrowser.jodi.org*, 2001. Jodi.org's browser regurgitates HTML into dynamic, incoherent hybrids of teletext and black-and-white abstractions. While its interfaces have a chaotic beauty that might best be experienced on a monitor turned on its side (as in the picture below), the disorientating software prompts questions about conditioned behaviour and functionality.

Influenced by theories of mass media, Fuller's proposition about 'not-just-art' is that The Web Stalker specifically, and software art more generally, should be used and assimilated into people's lives and behaviour: that they resemble both other forms of mass media, such as music or television, and tools, such as cellular phones.

The Web Stalker made a dramatic impact on its audience. As a fully functional project with a strong conceptual if not political agenda, it drove a wedge between passively consuming images or web content, and using them and their constituent text and HTML links to compose other kinds of visual structures. Besides opening up programming as an artistic practice, The Web Stalker was itself capable of both production (of images) and distribution. Indeed, the analogy the project makes between day-to-day reception of information and experimental composition brings a new perspective to other works in different media that sought to create apparatuses for production and reception, such as Stan VanDerBeek's Movie-Drome, or radio- and TV-based arts like John Cage's Imaginary Landscape Number 4 of the 1950s or Nam June Paik's Participation TV respectively. But unlike these other media-based works, The Web Stalker was able to proliferate – any

62 **Jonah Brucker-Cohen**, *Crank the Web*, 2001. The artist has rebuilt what is normally a digital application as an index of physical labour: *Crank the Web* is a browser that requires the turning of a handle to function. Brucker-Cohen physically grounds the internet, which is so often discussed without reference to the actual labour economies (such as computer manufacture) that make it possible.

63 **Kasselpunk**, *Samurai.remix*, 2002. Inevitably, after projects like *The Web Stalker*, advanced programmers such as Kasselpunk developed practices that isolated and experimented with the browser as a dynamic, almost sculptural, medium unto itself.

CRANK THE WEB
by Jonah Brucker-Cohen

individual with a computer and network connection could use it. I/O/D 4 took advantage of freeware mechanisms such as web sites to distribute its work, included it on discs attached to British magazines, and used stickers to increase awareness of the project beyond specialized art zones. *The Web Stalker* is seen as an historic work of two additional genres besides 'software art': 'browser art', a field devoted to the development of alternative forms and means of web browsing (examples include the 2001 project, *Crank the Web* [62], by Jonah Brucker-Cohen in which the browser becomes a mechanical, not virtual, tool); and 'data mapping', a genre that came to prominence in around 2001, comprising

projects in which the strategy of processing and placing information into new formal compositions is central (see Chapter 3). The Web Stalker, which had its release close to the first Annual Browser Day in 1998 – an event sponsored by the Waag Society in Amsterdam, devoted to browser art – aimed to provoke artists and programmers to create software, whether in the pursuit of functionality, aesthetic innovation or more socially engaged directives.

During the same period, a number of artists made important contributions to the field by isolating other pictorial or internet devices. ASCII (The American Standard Code for Information Interchange) – the standard computer code for representing English characters as numbers, with each letter assigned a number from 0 to 127 – is one of these forms. Computers often use ASCII codes to represent text, which makes it possible to transfer data from one computer to another. Vuk Cosic combined programming and formal analysis to create projects that elaborated the pictorial possibilities and aesthetics already established. He coded two freeware players that convert moving images into ASCII text and speech. The best-known application of its software was the conversion of the 1972 movie Deep Throat into an ASCII film, turning a legendary porn film into a large text file called Deep ASCII (1998) [65].

64 **Trina Mould** aka **Rachel Baker**, Dot2Dot Porn, 1997. An inventive feminist take on pornography that requires the 'male gaze' to be more intelligent and active in the way it constructs fantasy. This work also functions as a comment on piracy and censorship: those commercial search engines and firewalls that reject pornography would not, for example, be able to identify these images as such.

Opposite:
65 **Vuk Cosic**, Deep ASCII, 1998. Java movie player displaying the first online ASCII feature movie

Cosic, who worked with Luka Frelih and Walter van der Cruijsen on developing a display of *Deep ASCII* on a Pong video game console, explained their choice of materials to Josephine Bosma in a 1999 interview for ezine *Telepolis*:

We decided to work on a porno film because of the close ups....You can use an image with a lot of detail, but it will not render well in ASCII. Close ups in the porn industry are about 75 percent of the visual content.... They are good for ASCII. Then of course: which porn movie? That was pretty clear. First, Deep Throat *is the only really well-known porno movie. Second, it is a twenty-five-year-old film so it has a history....Then there is this whole thing about pornography being a hidden industry, nobody really talks about it, it is not for kids, it is not for decent people, but actually the economy of pornography is quite serious. Pornography makes up about 50 percent of internet contents and traffic.... I did some historical research and discovered a very beautiful coincidence. You probably know of the game Pong – the first computer game. Like* Deep Throat *in the porn industry, Pong was the first commercially successful mass product that triggered the entire industry. The game industry in America has earned more than the film industry, for three, four years in a row now. It just outgrew cinematography. Still, it is slightly hidden. It is out in the open, it is not immoral, but it is not treated as art or anything serious. Its economy makes it pretty serious in my opinion. Here comes the coincidence: those two things,* Deep Throat *and Pong were launched in the same month and year: June 1972. I put Pong hardware and* Deep ASCII *software together to underline the birth in June 1972 [of] a new civilisation.*

Beyond the choice of Pong as the project's hardware, *Deep ASCII*'s green-and-black, pixellated appearance recalls the game's graphic interface. The dominant pastimes and industries of gaming and porn are telescoped into one grainy filmic project, while at the same time denoting a structural component of net aesthetics, ASCII, as subject matter. Cosic translated a number of movies and art projects into ASCII, with formal strategies similar to those at work in artist Douglas Gordon's (b. 1966) projects using film, such as *24 Hour Psycho*. In *Deep ASCII* Cosic situates porn in the realm of art by calling attention to its particular filmic strategies, such as its emphasis on close-ups; it further removes *Deep Throat* from the ranks of mere smut by presenting it as raw data that allows for a rhetorical context far different from the cinematic original. In this way, the work also functions as a commentary on the circulation of cultural artefacts and forms of entertainment that is both encouraged and exacerbated by the net. In dramatizing his own careful consumption, the artist creates a work that calls for more

focused viewing strategies across the board, regardless of preconceived notions about a particular genre's aesthetic merit.

If Cosic used canonical films as sources for data and visual compositions, American artist John Simon Jr (b. 1963) takes the production of iconic images as his subject in *Every Icon* (1997) [66]. In a project requiring eons for full realization, Simon provided an image-making process automated by the algorithms of computer code. On a simple web page, he placed a grid of thirty-two by thirty-two squares. A code runs or 'executes', and the viewer sees a fluttering of black as the software begins its progression towards an all-black grid. Over time, the program displays all possible combinations. The artist estimates that across several hundred trillion years, the black-and-white elements will manifest every image (interested but less patient parties can manipulate their CPU's system clock for previews of what icons from the grid emerge in 2020). In a description of his work published in conjunction with the Walker Art Center's 'The Shock of the View' exhibition of 1998, Simon posed the question 'What are the limits of this kind of automation? Is it possible to practice image making by exploring all of image-space using a computer rather than by recording from the world around us? What does it mean that one may discover visual imagery so detached from "nature"?' The

66 John Simon Jr,
Every Icon, 1997

Given:
An Icon described
by a 32 X 32 Grid

Allowed:
Any element of the
grid to be colored
black or white.

Shown:
Every Icon

John F. Simon, Jr.

Edition Number:
Artist's Proof

Starting Time:
January 14, 1997, 9:00:00 pm

©1997 John F. Simon, Jr. www.numeral.com

work's strength lies in the tension between its automation and impossibly gradual results. The standard expectations of a computer – that while its programming is complex, results are delivered quickly – is inverted in *Every Icon*. Produced at a time when very few artists or gallerists could manage to sell net art, *Every Icon* was in fact marketable; it lent itself to the production of unique editions, each inscribed with its discrete starting-point and buyer's name, which were sold. This model of financial viability set an important precedent, offering net artists and consumers alike a desirable alternative to mainstream art markets.

Confusion and technical breakdown often characterize the experience of using computers and the net, and are addressed in several projects by Jodi.org from the late 1990s. One work, *http://404.jodi.org* (1997) [2], takes its name from 404, the status code for occasions when a server cannot find requested locations (usually web pages) or is unsure of their status. The project takes the notion of interactivity and creates futile exercises across three sections: 'Unread', 'Reply' and 'Unsent'. Each one frustrates attempts to interact by censoring the user's input. 'Unread' removes the vowels in data entered by the user, 'Reply' obscures communication in light of registered location (IP address) and 'Unsent' erases the consonants from text entered by a hopeful participant. Perhaps beyond the reading of this work as one about archiving complex memories of interaction, one can consider its descriptions of the relationship between computer and user – a relationship in which routines of misunderstanding, breakdown and disappointment are typical and standard.

Another Jodi.org work, *asdfg.jodi.org*, capitalizes on users' habits by taking the sequencing of files and directory structures, visible in the history window of the browser, as its hidden proscenium. Users are likely to look first at the flashing, changing windows and screens full of code fragments that defy ocular focus. The more cogent descriptive system, however, lies in the browser history, where one finds alphanumeric patterns made from file naming. Directory-structure data, akin to scripts and directions, are the backstage, repressed core of *asdfg.jodi.org*, memorialized in a more internal and restricted field.

Parody, Appropriation and Remixing

The collective ®TMark [68–69], legally a brokerage corporation, explains that it benefits from 'limited liability' just like any other company of its kind; using this principle, this team of artists, whose name is pronounced 'art mark', supports the sabotage

67 **Annie Abrahams**, *I Only Have My Name*, 1999. In this experiment, Abrahams tried to answer a number of questions, such as 'What's palpable of the personality behind the internet identity?', testing recognition and sincerity, what is real and what is not, in environments like IRC (Internet Relay Chat) channels. Using fifteen-minute question-and-answer sessions, she tried to establish if people could recognize her, out of four users all called Annie. The results suggest that normal aspects of subjectivity, such as personality and opinions, become neutralized in many online venues.

anniea

-hello everyannie
-4.3.2.1...
-top let's go....i'm the right one!
-you have to prove it
-i don't smile to my neighbours in the morning... do you?
-never had such an experience...
-sometimes it's a color given by the programm
-absolutely "javascript"
-i need respect
-deep relations in the network space
-c is not a bitch, i never said that!
-you hve to trust me
-i'm working on possible relations between people only with a kind of network existence
-the identity is what we can make with our presence on the network
-we have to build it
-and to do this.. we have to experiment the fragmentation
-of One identity... it's the purpose
-are u hungry?
-a kind of flux
-at this time we live in a window, a program
-shared by machines
-yes what coul'd be crucial when i'm the one people have to recognize?
-i loose myself now
-birth is a starting pointare they so many starting point?
-my paintings have become something else than paintings
-i know
-who should decide?
-I can decide
-god is a lucifer, on the other side
-so anniec you're not anniez
-my center?
-yes sweet one
-found may be
-i have to leave...a phone call...see you later-

anmeb

-hello
-hi
-i'am glad you join us
-missing one annie
-then, we can begin
-let's begin anyway
-yes, the one i asked to be annie
-all of you
-all annie are annies
-all one
-yes, it is the purpose
-ask my mother, jaceeee
-this one was not personal, was it ?
-to all or to one ? that is the point
-heelo annie
-no, javascript is not annie
-i try to be in control, in a biologic sense maybe ?
-not only my body
-but its relation to space and to others
-she lied
-not why, but who ?
-that's the purpose, confused identity
-we do are you, and we trust each others
-hello ee
-late, but thank you for coming
-no, we all did
-because i am it
-or me
-who am i ?
-are you alone ?
-do we live in the same world ?
-at birth time i supose
-birth is the first becoming
-the first before several
-name is a startig point too
-by writing a, b, c, d...
-pfff
-are you in trouble ?
-who is the real annie ?
-is there only one lucifer ?
-before every one become a lucifer, maybe
-who is nono
-time to vote now
-some annies have to leave soon
-frutja identity is in a foggy screen right now
-and nadja too
-no-one should be nadja
-or evryone
-anniea is nasty sometimes
-but she is a little bit intraverted

anniec

-hi frutja
-oeuhhh oeuhhh
-nerves
-I am at home
-two annies missing?
-hi anneb
-hello annea welcome
-we are complete
-allone
-go ahead fritja
-I am annie
-no one evreyone
-many just moving slowly
-I answered
-yes
-a javascript
-I hope all understands me
-I am rational with deep underground emotional streams
-I have to be alone to be in control
-héhéhé
-would have to think about it
-or why what?
-to find out if you are capable of finding out who is annie
-I am experiencing it
-because i made it
-no
-identity is multiple
-yes
-for each part of your personality
-when you pass borders
-i only have my name
-annie is
-impossible, annie is not a quality
-who's the real annie?
-I am
-who's the real annie?
-how many votes did i get?
-we cannot stay annie for ages
-Tell me if you think I am annie
-I feel dislocted
- lost
-How do you feel annies? lost or found?
-i will leave too
-will be back in half an hour too
-bye

annied

-thanks and hello everybody
-no i'm in bar
-welcome annieb
-go ! it's me
-me too
-please no personal question
-anarchy is a good friend of mine

-MOVING VERY QUICKLY YOU MEAN ?
-she is
-pffff...
-(don't trust her)
-because it's part of a project that i'm working on
-me neither
-it's part of my work on chaos
-and a mop
-dank je wel !
-hmmmm
-uuu
-hihi
-rubish
-nono
-irc misunderstanding
-so I would like to thank you for coming
-andré breton ?
-(must be from lorient _)
-lol !
-it's your problem man !!
- _)
- / perso annieb you can live now it's ok..
-ok
-I have to go...
-love and hate to you all...
-I'm living you to your search for anniesss

– or as they might put it, the informative alteration – of corporate products, from dolls and children's learning tools to electronic action games, by channelling funds from investors into 'mutual funds', set up to pay for the production of specific art projects by 'workers'. The group says its bottom line is 'to improve culture, rather than its own pocketbook; it seeks *cultural* profit, not financial'. While regular corporations function to increase wealth for shareholders, sometimes regardless of the cultural or social implications, ®TMark works towards improving its constituents' lives, sometimes at the expense of corporate practices.

®TMark projects frequently stake fresh ground for iconoclastic and anti-corporate activity, though they often exist as blueprints or instructions: 'Produce a documentary linking the increasingly harsh realities of the American workplace and economy to the rise in mental illness within the American population. Perhaps compare with European rates; perhaps also discuss "official" corporate solutions – Prozac etc. – within this

We're building
a better wrench.

Bringing IT to YOU!
www.rtmark.com

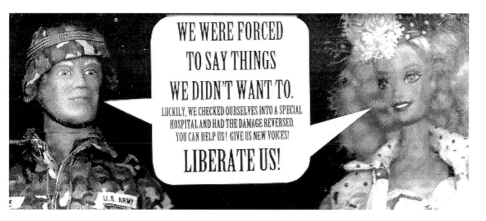

WE WERE FORCED TO SAY THINGS WE DIDN'T WANT TO. LUCKILY, WE CHECKED OURSELVES INTO A SPECIAL HOSPITAL AND HAD THE DAMAGE REVERSED. YOU CAN HELP US! GIVE US NEW VOICES!

LIBERATE US!

69 ®TMark/Barbie
Liberation Organization
(BLO), Media debris from Barbie
Liberation Army campaign, 1993.
In an early, far-reaching campaign,
®TMark transferred $8,000 from
a group of military veterans to the
Barbie Liberation Organization,
which used the money to switch
the voice boxes of three hundred
GI Joe figures with those of Barbie
dolls. Unsuspecting consumers
were understandably distressed to
find gender-variant toys when they
were expecting icons of American
masculinity and femininity, and the
prank was widely publicized.

context. Film must be scheduled as part of a major regional film festival.' Pivoting between idealistic and ridiculous, with their series of commands, ®TMark interventions approximate the instructional nature of code. Rather than allowing legality or practicality to cancel out their particular progressive visions of society, ®TMark projects occupy an intense space between political desire and action. Like works from the 1960s Fluxus group, such as Yoko Ono's instructions or La Monte Young's event scores, ®TMark action stipulations stand on their own, whether they are enacted or remain unrealized.

A signature tactic of ®TMark is that its representatives or artists present themselves in general with fake names and bureaucratic job titles. One reason for this practice, as David Ross explains, is 'to shift identities, [hide] their aesthetic practice as Duchamp did…declaring what they're doing as non art'. Beyond the framework of identity shifting, however, lies a more contextual motive: invoking anonymity is a way to underscore the protections accorded corporations. Since their own incorporation in the mid-1990s, ®TMark representatives have shown a genius for deploying graphics, publicity, parody and confusion by staging informal alliances with other artists and activists, and strategically wielding press releases, domain names and mailing lists in conjunction with those alliances. Their projects and those they co-produce are among the most publicized art pranks of the last decade: gwbush.com, a faux site for American presidential candidate George W. Bush during the 2000 election in the United States; Barbie Liberation Organization [69], an intervention that scrambled the genders of iconic American toys Barbie and GI Joe; SimCopter Hack (1997) [70] which inserted homoerotic visuals into the popular computer game The Sims;

70 ®**Tmark**, *SimCopter Hack*, 1997 (The Sims by **Maxis Inc**.). ®TMark channelled $5,000 from a New York shop keeper to a programmer for inserting his own erotic content into Maxis Inc.'s popular computer game The Sims. Whereas the 'contagious media' projects described in Chapter 4 stretch the outlines of parody, tactical media projects such as this one tend to be confrontational, direct interventions.

71 **Clover Leary**, *Gay Gamete*, 2000. Tactical media projects such as this apply many of the techniques associated with parody, performance and activist art. In this case, *Gay Gamete* demystifies egg and sperm donation industries and details how activists can intervene in procedures which in the United States exclude 'gay and lesbian DNA'.

and *Toywar* of 1999 (a grass-roots campaign responding to a legal dispute between art group etoy and dotcom eToys, described in Chapter 3).

Vuk Cosic had crafted his own CNN headlines in honour of the 'Net.art Per Se' conference, but his cloning of the 'Documenta X' web site in 1997 made many more headlines. The curators of this vanguard and prestigious exhibition of contemporary art, held every five years in Kassel, Germany, focused that year on the status of the object in art, had taken the daring step to include internet art both on their web site and in the actual exhibition. But the installation of internet terminals in Kassel was considered highly problematic by some net artists – the frustration was that festival organizers had created an office environment in which to show internet art, a stark contrast to the neutral spaces provided other artists for their installations, objects and canvases. To poach 'Documenta X', Cosic used a shareware program that copied almost every file from the official web site curated by Simon Lamunière (b. 1961). Like Sherrie Levine's photograph *After Walker Evans* and other appropriationist works, Cosic's clone of the site, called *Documenta Done* (1997) [72], articulates the technical capabilities of reproduction and raises questions about authorship. While Levine's work articulated feminist positioning in official art-historical canons by using the proposition 'after' to denote a hierarchical relationship, Cosic's clone seemed to denigrate the original by offering it a web address subservient to a Slovenian art lab and then the artist's domain: http://www.ljudmila.org/~vuk/dx/. Describing *Documenta Done* as a readymade, a manufactured, often prosaic object that becomes reassigned as art, Cosic announced that net artists were 'Duchamp's ideal children'. Cosic also cited archival and access concerns as well: 'Once upon a time, in September of 1997, the web manifestation of the "Documenta X" was taken off the web by the management. So, I did the copy that is still the only publically available one. This action speaks loud enough. My next idea in this department is to articulate a grassroots artists' initiative where as many as possible sets of complete works by net.artists would be toasted on DVDs and given away for web masters to make mirrors....' Drawing on the artistic inscription provided by 'Documenta X' to form his readymade, as he would with any other source, Cosic suggested that, online, all material was fair game.

Leveraging existing art as recyclable data was also an aesthetic strategy of Italian collective 0100101110101101.ORG (also known

72 **Vuk Cosic**, *Documenta Done*,
1997

as the O1s) [73–74], which in 1999 poached not only some of the most recognizable art sites online, including exhibition space Hell.com and Jodi.org, but also merged iconic graphics from well-known works by artists Alexei Shulgin and Olia Lialina. In the O1s' *Hybrids*, the use of material from the net.art oeuvre is itself reused, and copying is conjoined with making. Underlying this work and *Documenta Done* are the software concepts of 'cutting' and 'pasting', which are two of the most basic capabilities in computer operations, the ability to copy entire files or images with simple commands or keystrokes. In the book *The Language of New Media*, Lev Manovich notes that many artists – the DJ, for example – complicate the notions of 'cutting and pasting' by saying that their art is really in the 'mixing'.

This potential of new media operations comes to fruition in a series of works by American artist Mark Napier (b. 1961). Napier's *The Shredder* [76] and *Digital Landfill* (both 1998) [75] respectively tear up and aggregate web pages based on the URLs that users suggest. His intentions were not plagiaristic, unlike those of 010010111010110101.ORG, nor were they limited to the immediate net art circle. Instead he drew from the work of artists in other media, including Jackson Pollock and American minimalist

Below:
75 **Mark Napier**, *Digital Landfill*, 1998

Opposite above:
76 **Mark Napier**, *The Shredder*, 1998

Opposite below:
77 **Mark Napier**, *Riot*, 1999. This work of browser art, combining HTML, Javascript and Perl, enables social consumption of the web. Using this browser, participants do not surf alone or autonomously but see web pages featuring the debris (text and graphics) from previous users' destinations.

land artist Robert Smithson (1938–73), to call attention to the materiality of the web. A former painter, Napier cites Pollock's methods as his inspiration for *The Shredder*: 'I wanted to expose the raw material that make up the "design", "content" and "information" of the web and use that information directly. Of course, this material is a construct of software and the graphics display. It is "raw" only by virtue of the context *The Shredder* creates.' Though any web site can be 'shredded' and results will vary depending on how colourful or complex a site is, 'shredded' pages share a sensibility and evoke abstract expressionist painting in their redistribution of web elements and division of the screen.

Between 1997 and 1999, 0100101110101101.ORG and Luther Blissett (another Italy-based, anonymous art and activist collective) used appropriated materials to assert a dimension of social reality easily obscured by online culture. They aided in the exhibition and installation of work by Serbian artist Darko Maver [78], whom they would later reveal to be fictional. Maver's biography and CV, describing his attendance at art school in

Belgrade and Italy, were circulated online. His work, also available online, included photographs of staged 'violent aggressions' and murders in the former Yugoslavia. These staggering images quickly gained notoriety, and one was used as the cover photo for an album by a Spanish hard-core rock band. Maver was engaged both conceptually and politically, and his unforgettably graphic work was included in several group shows in Italy and Ljubljana. As media debris appeared documenting Maver's persecution by Yugoslavian authorities, a number of art magazines, including *Tema Celeste*, picked up on the story of artistic freedom amid repressive and violent rule. Maver and his work were held up as exemplars of free speech and expression. Meanwhile, the artist's conditions worsened: information circulated describing his arrest in connection with a series of murders, an acquittal and then another imprisonment. His death while in isolation in prison was reported in early 1999. On the web site that 010010111010110.ORG maintained for Darko Maver, the artists noted that it was a 'short step' to myth: the Venice Biennale that year included a tribute to Maver as a casualty of the Serbian crisis. It was not long after the Biennale events honouring Maver that 010010111010110.ORG and Luther Blissett revealed that the artist did not exist. The works attributed to him have a far more disturbing source: police files detailing actual murders, rapes and atrocities. The easy proliferation and duplication of data in works like *Documenta Done* and *The Shredder* were associated with an artistic and technical freedom. Seen in light of a related project such as *Darko Maver* (1998–99), however, these protocols create disembodied and extrinsic experiences. Indeed, the *Darko Maver* prank highlights the anarchic, impersonal aspects of the internet, and the difficulty of verifying any concrete truth in a sea of data.

78 **010010111010110.ORG**, *Darko Maver*, 1998–99. 010010111010110.ORG represented Darko Maver's life and career by releasing various images and documents online. The 01s claimed that this was a photo of Darko Maver and helped to structure the online fantasy of his life, prosecution and death. *Darko Maver* highlights the simultaneous persuasiveness and underlying contingency of online information and photos.

Mapping Authorship

Various attempts to assert authorship from the same period as *Darko Maver* suggest that the internet, in which images and text could be freely copied and proliferated, required new methods for describing authorship and separating information from misinformation. One innovative, medium-specific descriptive system is offered by the 1997 project *Agatha Appears* [79]. Created by Olia Lialina, *Agatha Appears* begins on the server of C3, a Hungarian media institute, but its narrative, about a country girl and a tech-savvy 'sys admin' (or 'system administrator', an employee responsible for configuring, administering and maintaining computers, networks and software systems), traverses different web pages hosted by a litany of international domains and servers. Often, the URLs themselves move the narrative along, as one notices when looking at them assembled:
http://www.here.ru/agatha/cant_stay_anymore.htm
http://www.altx.com/agatha/starts_new_life.html
http://www.distopia.com/agatha/travels.html
http://www2.arnes.si/~ljintima3/agatha/travels_a_lot.html
http://www.zuper.com/agatha/wants_home.html
http://www.ljudmila.org/~vuk/agatha/goes_on.html
 While files can be copied, their locations or addresses cannot, so Lialina juxtaposes the uniqueness of digital content – which, in fact, is not unique and always has the potential to be copied – with singular addresses. Other parts of her narrative are revealed in

80 **YOUNG-HAE CHANG
HEAVY INDUSTRIES**,
Rain on the Sea, 2001

Opposite:
81 **YOUNG-HAE CHANG
HEAVY INDUSTRIES**,
Half Breed Apache, 2001

error windows, or via floating text in the bottom of the browser frame, as well as through figurative graphics and block-like furniture and linear landscapes, adding up to what is more like a proscenium or operatic stage. When these are all linked, the project forms a unique work that is effectively protected from plagiarism, as British critic Josephine Berry points out in an essay posted to Nettime: 'Lialina is highly conscious of the location and names of digital files, seeing them as the only index of originality available. In the plagiaristic environment of the Net, where anyone can clone any web site, the artist's URL is the only guarantor that one is viewing the "original", most up-to-date and uncompromised version of the work. Her work also repeatedly reveals an interest in how the name of a file is its location and that, in this respect, language very literally controls the movement and behaviour of digital information – an example of the new performativity of words in the Net….' Extending the fiction into the address field and corners of the browser, Lialina invented an original narrative strategy, broadening the ways in which a web site could tell a story.

Hypertext and Textual Aesthetics
The narrative capabilities endowed by software and internet protocols underwrite many text-based works as well. The intersection of virtual and narrative dimensions can be articulated in a range of ways, and one salient strand relies on the interactive architectures of words, known as hypertext. Hypertext precedes the dawn of the web altogether, and is strongly linked to the historical evolution of electronic archives. American theorists, including Vannevar Bush in the 1940s and Theodor Nelson in the 1960s, suggested creating digital libraries of texts and took steps towards developing hypertext authoring tools based on the model of associative thinking. Hypertext works were described by Nelson as 'non-sequential writing', but on the web they are also often characterized by multimedia and narrative options. As we saw in the last chapter, Heath Bunting's _readme.html and Alexei Shulgin's *Link X* both pivoted on the overwhelming plethora of hypertext domain names. Typified by branching structures, hypertext works generally extend a narrative over multiple pages, spatializing the text by its irregularity and dispersal across web pages, and often transforming a text into something more filmic.

While many of the claims of literary avant-gardism that circulate in hypertext circles have precedents in historical uses of the codex (book) form – for example, the idea that early Modern Protestants tended rarely to read *The Bible* cover to cover, but used

it as a multiple entry-point text other claims that compare hypertext forms with cinematic ones are more intriguing. Indeed, well before the internet came into being, American writer Mark Amerika (b. 1960) had produced experimental fiction works that derived from screen aesthetics. He bounded onto the net art scene with *Grammatron* in 1997, a work that employs several strategies of narrative: first animation; then straightforward hypertext; then audio and animation formats, all with varied graphic layouts. As with most hypertext works, there is no clear linear trajectory to a text in *Grammatron*. Later works would include even more formats, such as music, as Amerika continued to broaden his technique using the circuitry of the web and other forms of mass media.

Feminist hypertext author and codex novelist Shelley Jackson (b. 1963) publishes many of her texts via Eastgate, a hypertext software and publishing company that delivers pages over the net to paying customers. One of her texts freely available on the web, an autobiographical work called *The Body* (1997), combines highly readable texts and clickable, low-fi images. It derives initially from a large map of her body, which lends itself well to the hypertext format – the layout informs the identity of the work culminating in a fragmented, multi-dimensional and often arresting read. YOUNG-HAE CHANG HEAVY INDUSTRIES, a Korea-based collective, has modelled a singular form of hypertext that is devoid of interactivity in the sense of clicking or moving a mouse and is closer to television and animation in format. Consisting of scored music and timed animation, YOUNG-HAE CHANG HEAVY INDUSTRIES' projects consistently use a clear, large typeface to jar the normal optical field of a screen into an articulation of the vector that can connect artist and viewer. Characterized by classical and jazz scores, and rushes of HTML and textual surfaces, YOUNG-HAE CHANG HEAVY INDUSTRIES' works explode the flatness of the web with literary propositions. The narratives of the twenty-one projects on its web site, some of which are available in Korean, Japanese and Spanish as well as English, vary in content. *Rain on the Sea* (2001) [80] narrates a dark personal reckoning, while *Half Breed Apache* (2001) [81] renders a lover's private language.

Other net artworks relied on using the simplicity of hypertext to emphasize relationships between sites, objects and people. Olia Lialina's early works *My Boyfriend Came Back From the War* [20] and *Agatha Appears* [79] made powerful identifications between narrative and the interactive screen, telling love stories while paying close attention to the scale of web pages and interactivity. *Will-N-Testament* (1997–present) [82], in which the artist bequeaths her

```
┌─────────────────────────── ◎ WIIL-N-TESTMENT by olia lialina ───────────────────┐

   ◀       ▷       ✕       ↻       ⌂       🕐    ┊   ✛        ━        ◉      ┊   🖨       ✳
  Back   Forward  Stop   Refresh  Home   History │  Larger  Smaller  Preferences │  Print   Source

  Address │ ◎ http://will.teleportacia.org/

  ◎ Google

  will-n-testament
  1. I revoke all former Wills and testamentary dispositions made by me and declare this to be my last Will.
  2. I appoint mike of www.design-staff.asts-www.dot-www.paranoia audio.msk.ru/mike to be the Executor and Trustee hereof.
  3. I give all my real and personal property whatsoever and wheresoever including any property over which
     I may have a general power of appointment or disposition by Will to my Trustee to pay thereout all my
     debts and funeral and testamentary expenses and subject thereto to give the following works to the
     persons named:

        a) My Boyfriend Came Back from the War and MBCBFTW Museum to my daughter Sofja Aleinikova
        b) Anna Karenin goes to paradise to Inna Kolosova
        c) Agatha Appears to MOMI, London Gleb Aleinikov
        d) CINE FANTOM online archives to CINE FANTOM Club
        d) Zombie&Mummy to Dragan Espenschied
        e) My files in Heaven&Hell to Michael Samyn's children
        f) The Great Gatsby to Alexei Shulgin
        g) If You Want to Clean Your Screen Some Universe to Diana McCartny
        h) Www.teleportacia.org to cross_the_border group
        i) Trust-n-dust Diary to Florian Schneider
        j) Trust-n-dust Diary page to Artemy Lebedev
        k) My articles in English to Josephine Bosma
        l) My articles in Russian to Tilman Baumgaertel
        m) Blinking table to Heath Bunting Elisabeth Timm
        n) Olia.htm to Igor Stromajer
        o) Olia.html to Vuk Cosic
        p) Lion/fresh.htm to Marko Peljhan
        q) Chat.jpg to Mr.net.art'98 Vadim Epstein
        r) will.jpg to Andreas Broeckmann
        s) Daisygif teaching page to Rachel Backer Greene
        t) This page to David Nicholson
        u) e-mail account olialia@sitylinov.ruteleportacia.org to Pit Schultz
        v) icq number 6239646 to Richard Barbrook
        w) Art.Teleportacia gallery to Rachel Backer
        x) olia_splash to Frederic Madre
        y) Identity Swap Database observation to Heath Bunting
        z) File Transfer Protocol and W to Konstantin Morshnev

  4. If any of the persons named in paragraph 3 predecease me leaving a child or children living at my death
     who reach the age of eightsixteen years then such child or children shall take absolutely and if more than onein
     equal shares the share in the artwork named above.
  5. My Trustee shall hold my Residuary Estate upon trust for such of my children as shall be living at my death
     and shall attain the age of 18 16 years and if more than one in equal shares absolutely Provided Always that if
  ◎ Internet zone
```

82 **Olia Lialina**, *Will-N-Testament*, 1997–present

online projects and possessions, reveals social and professional engagements using a single web page and hypertext. A document of approximately fifty-six lines, in which almost every letter loads as a separate file evincing a handmade, laboured project, *Will-N-Testament* memorializes both digital assets – from the account number of Lialina's ICQ (an instant messaging tool) to image files, to entire works – and the friend, family member or colleague who will keep the work upon the artist's death. The will operates on at least three levels. One is a traditional story of mortality and ageing. The second includes rhetoric of the law and property. The third explores the artistic use of language for conceptual ends, to vitalize or awaken a non-existent art economy: Lialina inscribes art objects with value derived from the social or intellectual capital her friends and colleagues bring to bear on her work.

Similarly, Israeli-born, New York-based artist Yael Kanarek (b. 1967) used the epistolary mode as the basis for her imagined

narrative *World of Awe* [83]. Launched in 1995, *World of Awe* mixes colourful, clean, well-executed futuristic landscapes with love letters full of imagined visual propositions and cyborg characters. Kanarek still publishes new parts of this immense work, texts and interfaces that vacillate between the fantastic and otherworldly and metaphors of the desktop, forging a hybrid, post-human vocabulary. For her mixture of rich, personally wrought mythology and networked platforms, she has earned the nickname of 'the internet's Matthew Barney', and *World of Awe* its *Cremaster*.

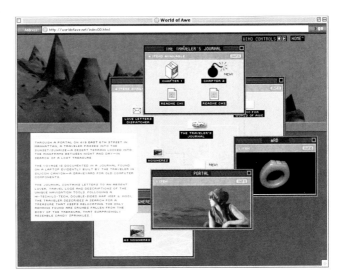

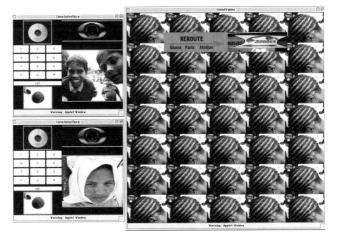

83 **Yael Kanarek**, *World of Awe*, 1995–present

84 **Shu Lea Cheang**, *Buy One Get One*, 1997. For this project, Cheang explored electronic and national borders with a laptop installed in a homemade 'bento digicase'. Complementing the images from Asian and African media centres that decorate the site, Cheang's work features an exaggerated cyber-persona to explode and engage myths about an international internet culture.

Remodelling Bodies

Bodies Inc. (1996) [85], a project by Victoria Vesna (b. 1959) in collaboration with Robert Nideffer (interface designer), Ken Fields (sound artist) and Nathan Freitas (programming), with sponsorship from Viewpoint Data Labs, a maker of 3D body models, sought to revalue and represent avatars by offering an online marketplace within a loosely corporate structure. The 'Inc.' in the title is a pun on the many definitions of incorporated – a company structure, without body or material substance, as well as united within one body. Here though, the form of economic incorporation is closer to a net community model of sharing and trading – nothing is really for sale, and capital is accumulated through usage. The web installation, with its chatrooms and showrooms, asks viewers to assemble a body from parts, choosing colours, textures and idealized body types. After launching their first version of the site in 1996, Vesna and her collaborators were inundated with requests from various people wanting to use the sleek bodies as avatars. *Bodies Inc.* suggests that the production of self and representation on the net can be closely linked to apparatuses of commerce and community.

Vesna's participatory corporation is a deliberate analogue both of corporate marketing and development of virtual bodies and of the mechanisms of online communities. *Biotech Hobbyist* (1998) [86] is a more minimal display of similar systems. Created by Heath Bunting and Natalie Jeremijenko, this perverse tribute to home pages and the net's manifestations of the weird and wonderful range of personal obsessions has a particular agenda in the demystification of biotechnology. The site's offerings – which include project guides for growing one's own skin and cloning – are meant to encourage the average hobbyist to engage with biotechnological debates, expanding the current set of participants in the field. In a manner typical of Jeremijenko's work, the webzine responds to the dominance of commercial and expert voices through a low-fi, tongue-in-cheek mirroring of their contents; it is also characteristic of Bunting's oeuvre in its redistribution of corporate intelligence through partisan intervention. With faux sponsorships from biotech companies, *Biotech Hobbyist* also offers a mailing list, a Q&A section, editorial and links. The project was never fully developed and has not been maintained, but it points towards the commercial interests leading debate and dialogue on biotechnology by incorporating industrial information with the artists' own idiomatic marks.

85 **Victoria Vesna** in collaboration with **Robert Nideffer**, **Ken Fields** and **Nathan Freitas**, *Bodies Inc.*, 1996

While *Biotech Hobbyist* took on the mild character of a curiosity-driven home page, other projects on the topic were less neutral. Bunting's *Superweed Project* (1999) [87] and Critical Art Ensemble's series of works on biotechnology address the invasion of farming, reproductive technologies and genetics by commercial interests. The highly charged materials of Critical Art Ensemble's *Society of Reproductive Anachronisms* and *BioCom* performances and web sites, two of their many artworks and texts on the biotech commercial complex which they call the *Flesh Machine*, employ misinformation and parody, calling attention to the dissemination of historical data about reproduction, fertility and its embrace by companies whose commercial interests are allied with eugenics. *Superweed Project* uses analogous tactics of hacking to perform an intervention in specific biotechnology projects. Reacting to agricultural company Monsanto's Roundup herbicide and its plans to develop genetically modified foods, Bunting and collaborator

86 **Heath Bunting** and **Natalie Jeremijenko**, *Biotech Hobbyist*, 1998

87 **Heath Bunting**, *Superweed Project*, 1999. This briefcase full of seeds, sold online, was intended to break down the 'illusion of science' and encourage popular participation in bio-scientific debates.

Rachel Baker held a launch at the London Institute of Contemporary Art in early 1999. Their press release included a dramatic quotation from American biotech activist Michael Boorman: 'Genetic hacker technology gives us the means to oppose this unsafe, unnecessary and unnatural technology. I hope that this SuperWeed Kit will empower others in their actions. We are engaged in a biological arms race with corporate monoculture.' The kit, which does actually exist, is pictured on the web site as an open briefcase full of different Brassica seeds (Oilseed Rape, Wild Radish, Yellow Mustard and Shepherd's Purse). While biotechnology generally remains in the hands of specialists, *Superweed Project* centres around the internet's capacity to share information and galvanize a particular lobby. In fact, *Superweed Project* is focused on publicizing and circulating data, citing polls which indicate that a large majority of British citizens are against genetically modified plants. The seemingly innocuous kit, sponsored by Irational.org's Cultural Terrorism Agency (one of Bunting's initiatives), belies a political belief that voices are not being heard or measured in existing democratic processes. The development of a functional product to counterbalance commercially produced herbicides was intended to dramatize the fact that corporate interests have lives of their own, often separate and immune from democratic processes, and that to stand up to them requires elaborate, if not material, platforms for both speech and feedback.

New Forms of Distribution
Other fragments of cultural data began to circulate in new ways courtesy of internet tools and applications. Between 1997 and 1998, music started to emerge in new online distribution channels and formats, dismantling boundaries between the internet and traditional broadcasting principles and platforms. Some of these developments related to various artistic practices and communities, such as those of experimental music or micro-radio that offered alternatives to larger-scale or even global music enterprises. Aside from content, would-be online broadcasters (called 'netcasters') really only needed encoders and servers to set up their own radio stations, so a proliferation of new stations soon energized the medium. On many early art radio sites from 1998 – including *Radio 90* initially run by Heath Bunting and colleagues at the Banff Center in Alberta, Canada, and Australian collective Radioqualia's *Frequency Clock* – the user took an active role in programming or customizing the media play list. The fast

pace of software development in this field, and the extraordinary adoption of MP3 as a compact, flexible format for mass dissemination of high-quality audio files, gave way to a number of exciting tools for sharing and modifying music files. The transformation of music files and their distribution on the net constituted large-scale acts of intervention in the permission-heavy corporate music and artistic property circuits which seek to regulate creative use and sharing. Not only were record sales hit significantly by internet music piracy, but communities of alternative radio practitioners and enthusiasts were able to grow to an extent previously impossible. As a result, a significant number of net artists have taken to creating aural analogues of the largely visually based experiences of the medium. One example is Alexei Shulgin's *386 DX* (1998–present) [88], a cyperpop project that raised questions about authorship in the digital environment and signalled Shulgin's departure from the classic net.art scene. Said to be the world's first cyperpunk rock band, *386 DX* is actually a computer, which plays songs by famous artists – including The Sex Pistols and John Lennon – using text-to-speech software.

Sexual Personae
BRANDON (1998) by Shu Lea Cheang (b. 1954) was the first web site to be commissioned by the Guggenheim Museum. Its title was

88 **Alexei Shulgin**, *386 DX*, 1998–present

Opposite above:
89 **Prema Murthy**, *Bindigirl*, 1999

Opposite below:
90 *Fakeshop*, another project in which Murthy participated, is an ongoing performance and installation series. Its web site both broadcasts live performances and serves as an exhibition platform for event and installation documentation. Jeff Gompertz, who co-founded the site with Murthy, describes the dynamic, multimedia site as 'a series of multimedia tableaux vivants'.

Right:
91 **Graham Crawford**, *Mirror Wound*, 1999. Many art-related collectives and communities have extended themselves online, taking advantage of the reach, ease and cost-effectiveness of developing web-based exhibitions. Although many of these venues stuck to documenting artwork in painterly or photographic formats, some, such as Queer Arts Resource, also took to exhibiting internet art like Crawford's *Mirror Wound*, a mythic, science-fiction narrative.

The immunological mechanism of the body is dependent on two major factors: (1) the inactivation and rejection of foreign substances and (2) the ability to differentiate between the body's own material (self) and that which is foreign (non-self).

inspired by Teena Brandon, genetically a woman, who was murdered by two local men in 1994 because she lived and loved as a man. Brandon's story was later portrayed in the 1999 American film *Boys Don't Cry*. Cheang's *BRANDON* explored issues of gender, identity, crime and punishment, challenging the viewer's ideas through multiple interfaces. Probing text, including question-and-answer sections and fictional narrative, was supported by various striking images, such as pierced nipples and tattoo-covered bodies. It was an ambitious and international project that included many live events and, though it is no longer available online, the Theatricum Anatomicum, the Amsterdam venue where some of the project's performances took place, does have documentation.

With its use of body parts, *BRANDON* shared strategies of repetition and disassembly of bodies across virtual surfaces with another important work of the late 1990s, *Bindigirl* [89]. Created in 1999 by American artist Prema Murthy (b. 1969), *Bindigirl* is premised on a literal pun on the notion of 'avatar'. In an interview published on Rhizome.org, Murthy explained: 'Bindi is my avatar. Not only is she my alias in the virtual world but a play on the word [avatar] which in India means an incarnation of a Hindu deity, the embodiment of an archetype. In this case she is the embodiment of the "goddess/whore" archetype which has historically been used to simplify the identity of women and their roles of power in

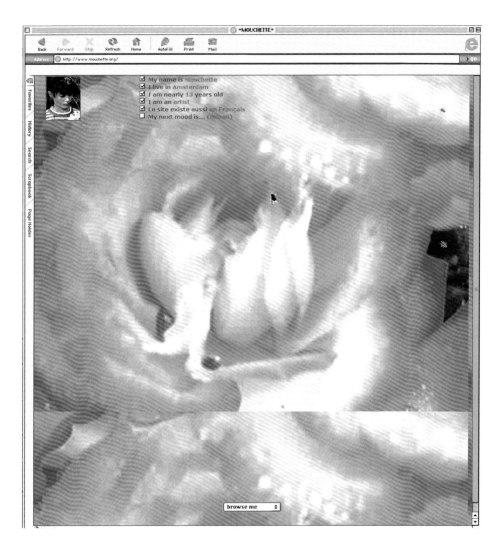

Back Forward Stop Refresh Home AutoFill Print Mail

Address http://www.mouchette.org/

☑ My name is Mouchette
☑ I live in Amsterdam
☑ I am nearly 13 years old
☑ I am an artist
☑ Le site existe aussi en Français
☐ My next mood is... (reload)

browse me

92 **Mouchette**, *Mouchette*, 1996–present

Opposite above:
93 **Candy Factory** and **YOUNG-HAE CHANG HEAVY INDUSTRIES**, *Halbeath*, 2002. The closing of a computer parts factory forms the desolate backdrop of this foreboding collaboration. YOUNG-HAE CHANG HEAVY INDUSTRIES brings its signature animation and fondness for classical music to bear on this glacial footage.

society.' *Bindigirl* consists of an array of photos of the artist and other South Asian women nude and in sexually provocative poses. In each, strategically placed bindis (traditionally, the decorative mark worn on the foreheads of Hindu women, symbolizing the spiritual eye) superimposed on the photos, mark the private parts of the bodies with taboo and external forms of Hindu observance. Murthy wrote in Bindi's online biography:'Why am I confined to this space? How and what do I need to get out of here – to go beyond my boundaries? At first I thought technology would save me, arm me with my weapons. Then I turned to religion. But both have let me down. They continue to keep me confined to my

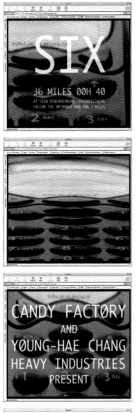

"proper" place.' The crossing of technical and religious failures in the feminist context helps to confront certain stereotypes.

An avatar derived from a film character, Mouchette has been evolving the web site of the same name since 1996 [92]. In the 1967 film directed by Robert Bresson, Mouchette is an angry adolescent in the French provinces, an outcast at school and a subject of town gossip. On the web site, the rebellious teen has been recast as a Dutch one and, in its earliest iterations, she was obsessed with suicide. Forever frozen as a sad-eyed thirteen-year-old, Mouchette's kitschy persona veers into the sensational, as suicide and child pornography are outlined with unsettling sound clips, innuendo and disturbing images. In this project, the field in which an image is mechanically reproduced is a psychologically fraught, unsettling one. Reviving a filmic personality on the web, the site's mysterious auteur, who only recently broke character to identify himself, gives the neo-Mouchette a memorable, problematic persona.

Japanese artist Takuji Kogo (b. 1965) was a collaborator on *Mouchette* and uses photography and video as the bases of his internet practice. His platform Candy Factory hosts a number of projects that often originate with physical locations. Kogo's photos and videos, such as *Joyful* (2000) [95] and *What an Interesting Finger Let Me Suck It* (2001) [97], have a degree of intensity per frame that renders them almost like slideshows. His presence as an

Right:
94 **Candy Factory** featuring **Gaku Tsutaya**, *Think The Same*, 2000. Moveable text snippets, a low-fi, Dada-esque sound collage of found audio and slightly disorientating navigation combine to provide an unsettling portrait of the home-page genre.

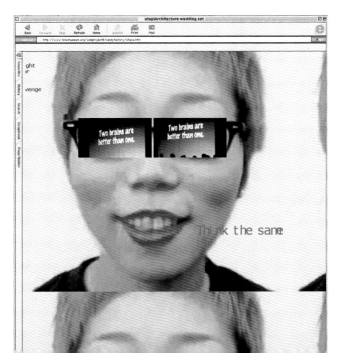

Above:

95 Candy Factory, *Joyful*, 2000. This project, taken from the book *Wake Up Time* by artists John Miller and Takuji Kogo, was shown as a digital projection at Japan's Soap Gallery (2000), as well as at the Photo Festival in Arles, France (also in 2000) through Candy Factory's project *On Air Remix*.

Opposite above:

96 Candy Factory, *Entangled Simile*, 1998. This is an installation view of Candy Factory's first exhibition, which was organized by Takuji Kogo in 1998 and took place in Japan. Works by John Miller (*Alive with Pleasure*) and Mouchette (*Fresh & Blood*) were also exhibited.

Opposite below:

97 Candy Factory and **Tetsu Takagi**, *What an Interesting Finger Let Me Suck It*, 2001. Virtuoso video and photographic tableaux are combined with unsophisticated internet forms. The combination of gorgeous, lush visuals with more homespun tools is a signature of Kogo's work.

internet artist derived from his interest in collaborating with other artists from around the world, and his projects are sometimes supplemented with transcripts of email or media exchanges. Accumulated, the images and videos, like the gorgeous and moody *Halbeath* (2002) [93], done with YOUNG-HAE CHANG HEAVY INDUSTRIES, testify to Kogo's exceptional talent for foreboding compositions and atmospheres.

In varying ways, the artists considered in this chapter drew distinctions between internet art and other practices by focusing on its defining materials and traits, from the web browser to the computer desktop, to the net's slippery authorial conventions. Kogo's photographic and filmic renderings expose the net in another way, as a delivery mechanism for rich media, a broadcast platform not dissimilar to television. Increasingly, art of the internet would derive from its ability, like television, to create a shared public space and cultural arena. Beyond the capabilities of TV, however, the net was highly decentralized, making many forms of interaction and intervention possible. As will be seen in the next chapter, these equivalences between the net and public space would motivate some of the most interesting and highest-profile internet art.

Takuji Kogo/ Entangled Simile

What an interesting finger Let me suck it

Chapter 3 Themes in Internet Art

Infowar and Tactical Media in Practice

The 1998 instalment of the international festival Ars Electronica revealed a truth at the heart of the internet – that beyond the rapid flow of information and increased ease of interaction and communication, the global economy, which was thriving in large part thanks to the boom in the technology sector, was now defined by information as much as if not more than by physical commodities. The internet's capabilities to produce, exchange and duplicate information in largely anarchic pockets put it at the centre of debates about economics, networks and information.

The festival, which took place in September at its usual location in Linz, Austria, represented the beginning of an intense period in internet art discourse and production. Every year, Ars Electronica chooses a theme around which to organize its symposia, installations and related events. Whereas previous years had memorialized the expansion of net culture with optimistic themes like 'Welcome to the Wired World', 'Endo Nano' and 'Intelligente Ambiente', 1998's theme was the more ominous and belligerent 'Infowar'. There were a number of spectacular, high-profile installations and interventions presented at the festival, and their examples deliberately blurred lines between art, activism, parody and politics. While the 'Infowar' symposia had been concluded by mid-September, its participants would find themselves embroiled in a number of far-reaching events and campaigns during the following year. These would culminate with *Toywar*, which Wolfgang Staehle called one of the 'greatest works of the 20th century'.

'Infowar' examined how informational, social and political phenomena interact. Gerfried Stocker, the festival's creative director, described the title's significance in an introduction to the 'Infowar' mailing list:

98 **Carlo Zanni**, *Landscape, Untitled Napster (alias)*, 2001. Napster, the well-publicized file-sharing service started by an American college dropout in 1999, is rendered iconic in this oil painting. This brand functions as a matrix in which values and desire intersect: Napster is an emblem of internet innovation and peer-to-peer ideology.

Increasingly the vital significance of the global information infrastructure for the functioning of the international finance markets compels the establishment of new strategic objectives: not obliteration, but manipulation, not destruction, but infiltration and assimilation. 'Netwar' as the tactical deployment of information and disinformation, targeted the human mind. These new forms of post-territorial conflicts, however, have for some time now ceased to be the preserve of governments and their ministers of war. NGOs, hackers, computer freaks in the service of organised crime, and terrorist organisations with high-tech expertise are now the chief actors in the cyberguerilla nightmares of national security services and defence ministries.

'Infowar' had its counterpart at the grass-roots level in the influential term 'tactical media', articulated by Geert Lovink and David Garcia in 1994, frequently used on mailing lists like Nettime, memorialized in essays such as 'The ABC of Tactical Media' and 'The DEF of Tactical Media', and expanded upon at the Next 5 Minutes conferences in Amsterdam. 'Tactical media' was inspired by 1970s 'tactical television' practices, and in particular by French theoretician Michel de Certeau (1925–86), who famously used 'tactical' to describe the invisible practices of consumers in the course of everyday life. Garcia explains: 'We theorised that the revolution in consumer electronics had transformed these tactics from invisible into visible practices. Turning tactical media into one of the primary ways in which people were becoming the subjects rather than simply the objects of modernity.' 'Tactical media' was an individual-centred approach to critical intervention that utilized the capabilities of consumer devices; and it had enormous resonance for many artists working with emergent technologies.

99 Electronic Disturbance Theater, *FloodNet,* 1998. *FloodNet* differed from many of ®TMark's anti-corporate campaigns in its engagement with government-specific targets. Part conceptual art and part performance art, *FloodNet* protests reclaimed internet space with acts of 'electronic civil disobedience'. It also contributed to *The Twelve Days of Christmas* campaign, which helped etoy to win its battle with dotcom eToys (see p. 126).

One tactical technique manifest at Ars Electronica was hacking. Hackers were set up with equipment in tents on the lawns outside Brucknerhaus, a festival hall in Linz, where they chatted with visitors about their ethics of anonymity, collaboration, evolving programming standards and open-software libraries. Chiefly expert computer and programming enthusiasts, hackers gained a sinister reputation after several high-profile cases in which they gained unauthorized access to systems for the purposes of corrupting data or stealing information (these kinds of hackers are called 'crackers'). While the general population may have been wary of how hackers wielded their powers to program across and beyond standard security measures, no one expected that an internet artist, Ricardo Dominguez (b. 1959), would receive death threats for his Ars Electronica project. Indeed, far more shocking than the ability to crack certain kinds of programs were the terrifying messages left for Dominguez in anticipation of his planned performance with the Electronic Disturbance Theater [99].

Dominguez, who founded the Electronic Disturbance Theater with Stefan Wray, Brett Stalbaum and Carmin Karasic, designed the performance group as an heir to activist and theatre traditions like those of collective Gran Fury and playwright Bertolt Brecht respectively. Like many works of net-based performance, the Electronic Disturbance Theater uses internet functionality to extend the body's field of action. Part of a widespread online campaign often referred to as 'Digital Zapatismo', Dominguez's project, called SWARM, developed the activist vocabulary of dissent by interfering with the web sites of Mexican President Ernest Zedillo, the Pentagon and the Frankfurt Stock Exchange. During SWARM's designated timeframe, a broad base of net users occupied some of the targeted sites' resources. Not only did Dominguez receive a menacing phone call in his Linz hotel room warning him to stop the performance, but the Pentagon took his project seriously, to the extent that the US government agency released a counter-applet (applets are small applications that run off other software, often used in conjunction with web browsers) to neuter SWARM. However rhetorical Stocker's premise of 'Infowar' may have seemed in writing, in practice governments and military reacted to disruptions in their online analogues with force. Whether the Electronic Disturbance Theater considered the project 'art' was irrelevant. An action in the field of mass media could not rely on the ethics of more open or more specialized zones, like art festivals.

®TMark, in attendance to judge the prestigious InfoWeapon award that year, used its extensive mailing lists and spotlight to raise awareness of the campaigns and counter-strikes against the Electronic

Disturbance Theater. This alliance was followed by another surprising gesture: the awarding of the InfoWeapon cash monies and honours to the small Mexican town of Popotla. Twentieth Century Fox had filmed some scenes of the blockbuster film *Titanic* in Popotla, building a giant cement wall that cut the village off from its beach, and chlorinating the crop of sea urchins that Popotla had fished for decades. In reaction, Popotla villagers decorated the wall with rubbish and made a media spectacle out of it. While Ars Electronica awarded *Titanic* a prize for its special-effect techniques in the film, ®TMark honoured Popotla for its 'symbolic low-tech resistance to real high-tech destruction'. The two strategies at play in this decision characterize the work of ®TMark as a whole: institutional and corporate workings are cracked open, and issues of capitalist ideology are addressed.

Also in attendance was Mongrel, a Britain-based collective comprising individuals of diverse ethnic and racial backgrounds who effectively combine these tactics to expose dynamics of race and class. Mongrel had already gained an international reputation from its award-winning CD-ROM of 1996 *Rehearsal of Memory*. For this project Graham Harwood (b. 1960), a member of the group, collaborated with the inmates of Ashworth Mental Hospital to create a work about patient life using hypermedia, in which a map of patients' skin is linked to documentation of their lives as residents at the maximum-security hospital. The work, as described by Harwood in the CD's liner notes, challenged 'assumptions of normality and at the same time [confronted] us with a clean comfortable machine filled with filth, the forbidden and the demented, its hygienic procedures contaminated with the effort of excluded human relations'. CD-ROMs, compact and inexpensive, are easily distributed and straightforward to use. This choice of format underlined Mongrel's deliberate use of 'machines'; in *Rehearsal of Memory*, computer technology and production opened the doors and windows of a maximum-security hospital.

Mongrel's work took an important turn when the group began to make software and web sites, debuting *Heritage Gold* [100] freeware in 1998. *Heritage Gold*, part of Mongrel's Ars Electronica installation, *National Heritage*, found inspiration in Adobe Photoshop and questioned the supposedly neutral operations of graphics tools by creating an image-manipulation tool rich with class and race mechanisms. Instead of choosing colours from a palette – blue, green or cyan, for example – users would select from categories such as Caucasian, Black and Japanese. The

100 **Mongrel**, *Heritage Gold*, 1998

◄ ► | 🏠 | A A | ↻ | + | 🌐 http://www.mongrel.org.uk/Natural/HeritageGold/activities.ht

MongrelSoft™ 💀 Think different.

[Activities ▲▼] (Go!)

Make the Most of a Great Moment
With HeritageGold 1.0 software you can quickly and easily modify your looks. What's more, follow any combination of more than 50 step-by-step Guided Activities and you can even change your roots. Powerful features (such as the Clone Tool, MongrelSoftŽª Social filters, One-Click Brown skin Removal, and dozens of Specialy Effect family history clean up techniques) let you edit and transform you Heritage into personal works of art.

What's more, with the pre-set customisations offered by our Heritage Templates you'll be having fun with your heritage in ways you never imagined possible! Download HeritageGold with free Heritage Templates.

Photo-Compositing
Cut and paste from any number of photos to compose your idea of the perfect photo Heritage moment. Add a greeting, too. HeritageGold provides the tools and guidance to make it easy and fun.

In picture number one we have Prince Charles aged five. He had begun daily lessons with Miss Katherine Peebles, his governess, who reported at the time he was making good progress.

Picture number two is a funny postcard.

Compositing these images using the simple-but-powerful tools in HeritageGold gives us our picture. The Heritage Templates really made us think: "What would the world be like today if we in England had a black Monarch?" Just maybe, there wouldn't be so many wars... You and your family can ponder these questions together using HeritageGold.

Create Calendars, Sports Cards, and More
Turn calendars, sports cards, greeting cards, and lots more into unique gifts

commands of Photoshop had themselves been Photoshopped, cosmetically changed to reveal an ideological basis for image production and manipulation. *National Heritage* consisted of a gallery installation of faces of varied ethnicities, sewn masks and appendages called *Colour Separation*, street posters and a newspaper. In an interview with Matthew Fuller, London-based Mongrel member Richard Pierre-Davis (b. 1965) explained his view of the confrontational mask images: 'I believe the mask to be one of the most defining aspect[s] of the whole project in more ways than one; the masks represent the mask that I always have to wear at the point of entry into Britain, it represents the mask that I wear repeatedly as I go about my everyday activities in this lovely multicultural state…. And then it also represent[s] the mask that a mongrel has to wear in sourcing resources for this project. So you see the whole *National Heritage* project is a constitution of the mask.' Mongrel's Matsuko Yokokoji (b. 1960) and Graham Harwood noted that the presentation of distinct and more racially ambiguous visages in *Colour Separation* shows how easily *Heritage Gold*'s mixing capabilities could suspend distinct racial categories into malleable data. Predicting – in tongue-in-cheek tone – a 'huge demand in the West for this software', they described *Heritage Gold* as part of a '[struggle] to find images that deal with the complexities of the kind of lives we are living now. There is no longer black or white….'

Harwood did more than extend the lineage of identity art politics into the net art sphere. He also described the philosophical stakes of technoart festivals and discourse: *Now, dominant racial and cultural groups in society act as audience to their own techno-cultural-media product. Bleached images of self-congratulatory ritualised distancing, symbolically install these groups as the right people to control, restrict, and censor Cyberland. Digital cloning has helped call into question accepted notions of originality and genius, allowing a re-evaluation of the codes of cultural production – just so long as this does not include the filth of uncomfortable social relations. Given the racialisation and elitism of most electronic art events, attendees might still think that underneath they're all still loveable. The multicultural lets-get-on-with-each-other-and-get-happy number has for a long time been one of the main tactics for hiding hard, difficult debate under a sixties-style love-in. Mongrel cultures have come too long a way in intellectual rigour to be fobbed off with a flower pushed up the barrel of their gun. This is as the 'Infowar' leaflet says 'a battle in which the power of knowledge is managed as a profitable monopoly'. Societies seem to have learnt nothing from the tragedies of this century*

[the twentieth century] that have been co-founded by the military technologies from which new media rises. Are we about to remake the cultural spaces for the arms dealer class that profited before from war, slavery, migrant-labour, poverty, death, and disease? Or are we to dirty up their future and complicate their desires with filth?

In conjunction with the storm of events around the Electronic Disturbance Theater, the impact of Mongrel's installation and the declarations of its members heightened the sense that new technologies provided strategies for realizing agitational goals.

Over the next fifteen months, the face-to-face encounter at Ars Electronica 1998 between ®TMark and etoy, the largely Swiss

troupe that parodied dotcom brands, would prove central to the high-profile tactical media event known as *Toywar* [102]. *Toywar* was the web site headquarters for a defensive campaign resulting from a legal dispute between etoy, which had been online since 1995, and eToys, a relatively new dotcom business, which aimed to dominate the online children's toy market. The latter used its substantial financial resources to sue etoy for its domain name, alleging that etoy's site contained 'pornographic and anarchic' content that threatened its business. The lawyers of eToys were successful in this regard, and at one point a court injunction shut down the etoy web site. Etoy solicited the support of ®TMark, THE THING, Rhizome.org and other lists: ®TMark assumed a leadership role and, following the call issued by etoy's Reinhold Grether for a 'new toy' to fight eToys, designed a game-esque campaign called *The Twelve Days of Christmas*. Gameplay included Electronic Disturbance Theater's *FloodNet* [99] applet, as well as emails, postings on the financial message boards about the debacle, all seeking to interrupt the toy-seller's web site and reputation during the busiest sales period of the year. The results,

102 **etoy**, *Toywar*, 1999–2000. *TOYWAR.battlefield* on the internet: showing some of the 2,500 TOYWAR.agents in January 2000, two weeks before eToys signed a settlement and dropped its lawsuit against etoy.

though it would be specious to ascribe them solely to the blitz of *The Twelve Days of Christmas*, were dramatic: following the involvement of thousands of outraged participants, the inflated price of eToys' stock fell by more than forty per cent, its web site was slowed for a time, and *Toywar* received enormous publicity from around the world. The bubble of the internet market was collapsing, and eToys declared bankruptcy after the lawsuit against etoy was resolved.

Of course, by posturing as corporations, sending out press releases and courting media attention, etoy and ®TMark were using some of the very material they wished to critique, and *Toywar* highlighted some of the paradoxes of politically progressive, parodic work. Acknowledging these paradoxes, focusing on the often hilarious transgressions and interchanges made possible by such positions, is part of their works' appeal. It seemed that while eToys exercised the legal rights granted to corporations in the United States, artists and like-minded people were also capable of media manipulation or the tactical use of media to create self-conscious, grass-roots, multi-faceted analogues of corporate power. That *Toywar*, despite its very real legal stakes and the substantial monies involved, was called a 'game' by its producers suggests a new dimension to art practices brought on by internet technologies. Using the premise of fighting against an enemy and defending space, as well as the *FloodNet* applet, and an element of performance, tactical media asserted itself as a method for seizing or reclaiming public space.

Toywar was an exhilarating and empowering struggle, but net art communities had been devastated by a more serious conflict in the spring of 1999: the NATO bombing of Kosovo. The notable absence of Yugoslavia-based participants on lists such as Nettime and especially Syndicate (its focus was on Eastern Europe) was accompanied by emails from those who still had internet access, full of desperation, fear and anger, as well as by documentation of the damage to infrastructure and civilian targets. While concern for friends and colleagues was paramount, the negative effect of the NATO campaigns on internet capabilities and independent media also became a topic for discussion. As Geert Lovink wrote about the silenced voices from Southeast Europe: 'Small media may be "tactical", but they are also easy to shut down.' Though the initial response among most communities was to share information and create possibilities for independent reporting, like the hosting of the B92 Radio Station (based in the former Yugoslavia) on Real Audio servers, artists also began to make

103 **Trebor Scholz**, *79 Days*, 2003

works in response. Net projects about the 1999 bombing varied from theatrical works like Teo Spiller's *I Was a Soldier on Kosovo* to historically based works such as Miklos Legrady's *Krematorium*. German artist Trebor Scholz's *79 Days* (started in 2001, although the web site was not launched until 2003) [103] consists of photos and videos of Yugoslavians presented without descriptive context, with hyperlinks conducting live image searches relating to various aspects of war. The artwork compares media debris about the war, likely culled from news sites, with Scholz's beautifully shot, high-resolution documentation of post-1999 Kosovo.

The reactions to the bombing of Kosovo and to *Toywar* were not the only efforts to make use of the mechanisms of new media forms. Many protestors, including those who participated in the 1999 Battle of Seattle (part of a protest against the World Trade Organization), mobilized via the internet to oppose International Monetary Fund and World Bank policies towards the debts of struggling countries. This widescale mobilization online for offline protests, of which *Toywar* was one example, set leftist advocates against stalwarts of the established marketplace and world order. These conflicts were elaborated in several instances as infowars.

Turn of the Millennium, War and the Dotcom Crash
In previous chapters we saw the emergence of discursive models, such as mailing lists, bulletin board systems and conferences that helped internet artists to build and sustain vital networks outside the art world and to generate fruitful relationships with both audiences and each other. A sense of autonomy or 'productive marginality', as Rhizome.org founder Mark Tribe called it, and the

practice of 'dialogue through work, as well as through communication', were central to the classical net.art scene, evident in *Net Criticism Juke Box* [51] or the *Mr. Net.Art* competition [52]. The net.art community had maintained a general sense of intimacy and trust for several years. Vuk Cosic knew critic Josephine Bosma; Bosma knew Olia Lialina; Lialina knew and had collaborated with Heath Bunting. Colleagues, regardless of their opinions or behaviour, were just an email away, and likely to be seen at a festival in the near future. But as the internet expanded exponentially, and as participants found themselves in different places in their lives, perhaps with children, consumed by other events, as many were by the war in Yugoslavia, or by more demanding personal responsibilities offline, this sense of community began to give way. In an essay 'net.art Year in Review: State of net.art 99' for the net culture journal *Switch*, artist and programmer Alexander Galloway noted formal shifts, writing that 'net.art', the genre best known by the work of Vuk Cosic, Heath Bunting and Olia Lialina, was dead. Endorsing this view was a quotation from German net art historian Tilman Baumgärtel, who had written as early as 1998 that 'the first formative period of net culture seems to be over'.

As the millennium came to a close, many levels of change were afoot. For a start, there was evidence of growing institutional interest in net art. In 1999 the ZKM mounted its substantial 'net_condition' show, and Tate Britain and Tate Modern began commissioning net art. New York's Whitney Museum of American Art hired digital culture magazine *Intelligent Agent* founder Christiane Paul as an adjunct new media art curator, and announced that net art would be in the 2000 Biennial. '010101: Art in Technological Times' was scheduled by the San Francisco Museum of Modern Art to open in 2001. The Guggenheim Museum also commissioned online art and began its valuable 'variable media initiative', in which curator Jon Ippolito considered how to preserve and conserve ephemeral and contingent new media and conceptual artworks. Vuk Cosic, practically a folk hero in Slovenia, was selected as the country's representative at the Venice Biennale. Meanwhile, several years of optimistic internet culture had produced another kind of aura for net-based art. Dotcom design shops seeking to create more sophisticated or innovative sites for clients, began to support 'research and development' projects that were also considered art. As demand for web sites on the part of most businesses increased, so did the status of interactive design. At the same time, production tools

and coding standards became more sophisticated. While not everyone embraced high-production-value aesthetics, internet art's formal scope benefited from the new levels of expertise and decor. Finally, internet traffic and popularity were clearly on the rise: data at statistics web site Zakon.org maintains that the web hosted five million sites in 1998 and, by the end of 2000, there were more than six times that number, over thirty million registered web sites. There were simply a lot more people online interested in new media art, from college graduates who had studied new media art at programmes started in the mid-1990s, to computer-engineering professionals, who decided to bring their methodologies and skills in art production to legions of self-taught 'netheads'.

Still, even such expansive usage did not make it easier for independent new media organizations to succeed financially in America. They consistently struggled to develop viable economic models, and äda'web, which eventually came into the America Online portfolio, was shut down in 1998. Early portal projects like artnetweb, which had gone online in 1995, ran out of gas in around 1999. Non-profit platforms Rhizome.org and Turbulence.org struggled to secure funding from granting institutions. During the same period, in parts of Europe and Asia, new organizations received governmental support, and platforms multiplied. *CRUMB* and *Cream* were two new, European publications about internet art. In Delhi, India, a new media centre called Sarai, operating with the Waag Society and the Australian Network for Art and Technology, launched in 2001. Founded by a number of filmmakers and researchers, the centre hosts events and classes, publishes books of research, and runs a number of email lists focused on new technologies, images, radio and ethnographic topics.

Responses to the broadened climate varied. While some critics and artists would argue that the tightly knit communities of the 1990s had disappeared, leaving watered-down versions in their stead, others embraced more expansive and developed forms of programming, along with the challenges of maintaining and nurturing more diverse and populous communities. Not only had the audiences increased exponentially, but more sophisticated methods and resources for programming had evolved too. In 'net.art Year in Review: State of net.art 99', Galloway observed:
People want more than email. They want new interfaces. They want killer apps [an application superior to others in its genre]. They want to escape the offline. All art media involve constraints, and through these constraints creativity is born. Net.art (the jodi-vuk-shulgin-bunting style)

104 **Maciej Wisniewski**,
Instant Places, 2002

was the product of a particular technological constraint: low bandwidth. *Net.art is low bandwidth through and through. We see it in ASCII art, form art, HTML conceptualism – anything that can fit easily through a modem. As computers and bandwidth improve, the primary physical reality that governed the aesthetic space of net.art begins to fall away. Today, plug-ins and Java are good. And software trumps them both.*

Galloway's analysis was borne out in the work produced by a new wave of net artists who drew from software engineering, game design and the free-software movement. Skilled programmer Maciej Wisniewski has taken the legacy of browser art such as *The Web Stalker* into multiple dimensions. One of the artist's projects in this vein was *Netomat*, which debuted in an early form at Postmasters Gallery in 1999. *Netomat* took words typed by the viewer and searched the internet for relevant text, images and audio, flowing the results onto the screen without any adherence to traditional page format. While *The Web Stalker* is typically considered to have changed the way users looked at browsers and web sites as whole entities, *Netomat* treated the internet as a highly visual and multimedia economy from which one could gather elements and reorganize them independently. *Instant Places* (2002) [104], which is akin to a game-cum

-communication platform, is another project by Wisniewski. It worked by connecting dispersed so-called 'data places' (different computers connected to the network) to form a matrix that was free from the constraints of geography, time and place. *Instant Places* featured predators (hawks) and prey (mice), which were able to move between different data places and communicated via instant messaging – enabling them to recognize each other and gauge movement, distance and shape.

Data Visualization and Databases
Scrutinizing access and gathering of materials was one dimension of an important work called *Life_Sharing* (2001) [105] created by 0100101110101101.ORG and commissioned by new media curator Steve Dietz at the Walker Art Center's Gallery 9 in Minneapolis, Minnesota. Its title is a play on the term 'file sharing', in which parts of a hard drive are made available over an internet connection (many music-sharing applications rely on this technology). The project turned 0100101110101101.ORG's shared computers into an open 'server', or a computer accessible across the internet with no passwords or verifications needed. Circumventing the entrenched protocols of navigating a web site (and not engaging directly with its raw contents and the authors behind it), the collective adopted an aesthetic that left far less to the imagination, stating that 'the idea of privacy is obsolete'. A novel format for psychic autobiography (the project derives from the personal indexes of 0100101110101101.ORG's participants), *Life_Sharing* made available all kinds of computer data and documentation, from their net artworks to personal forms and email. In *Life_Sharing*, the artists designate the ever-replenishing documents and data as reflections of self and as art objects:
With a computer one shares time, one's space, one's memory, and one's projects, but most of all one shares personal relationships.... Getting free access to someone's computer is the same as getting access to his or her culture. We are not interested in the fact that a user can 'study 0100101110101101.ORG's personality'; rather, in the sharing of resources, it's a matter of politics more than of 'psychology'.... It is not only a show. It's not like looking at Jennicam [a well-known web site, started in 1996, in which a young American woman lets a web cam record her every domestic action]. The user can utilize what he finds in our computer. Not only documents and software, but also the mechanisms that rule and maintain 0100101110101101.ORG: the relations with the Net; the strategies; the tactics and the tricks; the contacts with institutions; access to funds; the flow of money that comes

in and goes out. All must be shared so that the user has a precedent to study. From this learning, concrete knowledge – that is normally considered 'private' – can be transformed into a weapon, a tool that can be reused.

010010111010101010.ORG's supposition that its computers' contents, framed by ideological intent, could be viewed, reused and deployed suggests that, for its members, human psyches, experiences and bodies can be reflected at least in part in data, and that they are indeed themselves aggregations of data. The theatricalization of a private computer's contents and workings is one example of a wider phenomenon – the theatricalization of all spaces, which has been developing via the rise of entertainment culture and the expansion of television media over the last forty years. Since the 1960s, a significant body of artwork in which media attention is a focus has elaborated on these themes. In fact, 010010111010101101.ORG's contention that 'privacy is obsolete' has an analogue in Valie Export's *Touch Cinema* (1968) [106], in which the artist walked around Vienna with curtains covering her breasts and encouraged passers-by to reach in and touch them. Export, who called *Touch Cinema* 'an expanded movie', sought to question the boundary between public and private space, as well

HTTP://010010111010101101.ORG

106 **Valie Export**, *Touch Cinema*, 1968. By using her breasts and a simple curtain to personify, dramatically, the dynamics of film consumption, Export also alludes to the functions of identification and self-expression. In a contemporary project that also creates an equivalence between media and self, 010010111010101.ORG makes its hard drive, replete with email and private files, accessible to all users.

as the one-way structure of film. In *Life_Sharing*, this boundary is replaced with communication technologies, as file sharing and email both become entry-points into the work.

Self-reflection through the aesthetics of a medium à la Export is now well known via the contemporary popularity of reality television around the world. In *Life_Sharing*, a work in the reality-internet genre, the vérité of everyday functions (email, file organization and documents) gives birth to a new form of medial recording and what Ursula Frohne calls the 'media *mise en scène*'. Indeed, for those who understand the premise of *Life_Sharing*, the notion of voyeurism conditions many of the interactions one has while perusing the 010010111010101.ORG web site. Granted, 010010111010101.ORG is not conducting the kind of behaviour seen on most reality TV shows, nor is the user seeing televised images. However, the group's dissolution of the lines between colleague and spectator, participant and monitor, and public and private activity (such as email) in the name of transparency, is a politicized strategy, one akin to the open-source aversion to users' privately owned locked software. Those who do not want to comply with the stage that is the 010010111010101.ORG site have no choice, however, although they are given oblique warnings in pop-up windows that preface the site. 010010111010101.ORG members might argue that the internalization and permanence of observation now native to their web site is in line with standard security and dataveillance conditions on the internet.

Mediated information's porous, reflective and abstract qualities, and its role in shaping the subjective experience, forms a field of internet art loosely know as 'data visualization'. The reshaping of Information has been a motif for many decades in advanced art-making. Artists such as Hans Haacke, Lynda Benglis (b. 1941), Richard Serra (b. 1939) and Martha Rosler (b. 1943) offer rich legacies in this regard. While Haacke made work pointing to the interrelations of matter, social relations and technology, Serra and Benglis communicated the processional, flawed and transitory aspects of changes in form in works such as Serra's *Props* series of the late 1960s or Benglis's *For Carl Andre* of 1970. Rosler's work is particularly relevant in the ways it manifests the dubious nature of any given medium's 'truth value'. *The Bowery in Two Inadequate Descriptive Systems*, an important project by Rosler from 1974–75, used photos and text to point out and elide stereotypes of documenting the economically disenfranchised. The codes of documentary, text and image in that work are themselves subject to broader power imbalances. The areas of interest of these artists have countless online analogues, and one of the dominant concerns for many new media artists was how new technologies might commodify or neutralize various diversities of information.

In early 1997, artist and engineer Natalie Jeremijenko asserted the connection between technology and the body politic in a lecture called 'Database Politics' at the Museum of Modern Art in New York:

Technologies are tangible social relations.That said, technologies can therefore be used to make social relations tangible.Technologies create

107 **Amy Alexander**, *b0timati0n*, 2001. Net art seemed to move outside of the monitor after 2000, as evidenced by the 'show' put on by this artist using search engines. Results from the search engine's 'bot' (a computer program that runs automatically) are displayed in continuously animating patterns. Akin to a 'light and sound' interpretation of a quotidian online search, Alexander's work used humour and spectacle to bring net practices to life.

108 **Coco Fusco** and **Ricardo Dominguez**, *Dolores from 10 to 10*, 2001. This net performance was inspired by a real-life incident in which a Tijuana worker was locked in a room for twelve hours on suspicion that she was trying to unionize fellow-workers. Fusco and Dominguez webcast fictionalized surveillance tapes of her internment. The voyeuristic dimension of webcasting co-exists with an equally powerful critique of widespread apathy to the labour conditions in poor countries.

the material conditions within which we work, and imagine ourselves and our identities. I am concerned with how technology is developed within a context where overarching priority is given to formal systems over content, and where the complicating and politicizing projects of postmodernity are marginalized. I am interested in the epistemological work of current technologies. This includes what gets technological attention and what does not, what gets counted, and what gets left out. What is the political fabric of the information age? And what interventions can be made in a place where economics gets equated with politics, where diversity is rendered in homogeneous database fields, and where consumption forms identity?

Jeremijenko's observations that most of the applied organizational systems of the information age involve databases or structures contingent on broader political and social codes is often made evident in works of data visualization. Some of the best new media work in this vein calls attention to the non-neutrality and often arbitrary nature of information.

In the same way that an installation creates a particular context for reflection, the internet's limits construct relationships between users and the medium. Mongrel's *Natural Selection*, a search tool, storyboards these constructed relationships. The project evolved out of the group's observations that the net, with its unrestricted access and capacity for self-publishing, was a magnet for propaganda, in particular material promoting racial stereotypes and other offensive race-related texts and images. Mongrel members Graham Harwood and Matthew Fuller set out to smash this trend. In Matthew Fuller's words, the project offers a fresh

approach to tackling one of the net's most notorious scourges: 'Along with porn, one of the twin spectres of "evil" on the internet is access to neo-Nazi and racist material on the web. Successive governments have tried censorship and failed. This is another approach – ridicule.' If one uses *Natural Selection* to perform a web search, entering words without racial inflections like 'spaceship' or 'doughnut', one gets standard search engine results of web pages. If one enters a racially charged word like 'Nazi' the results appear standard, but if users click onto one of these pages, they will be confronted with very different and unexpected materials, such as web sites on sexual fetishes. Mongrel's mockery of racist publications dramatizes three kinds of web failures: that of the net as a utopian zone; that of search engines as consistent and neutral tools; and that of the internet's (often unwitting) hosting of the language of racial stereotypes.

New Zealander-born artist Josh On (b. 1972) and San Francisco design shop Futurefarmers render visible several usually mystified and invisible relationships between power and information in the project *They Rule* (2001) [109]. Opening with a simple animation, *They Rule* allows users to see the names of members of the boards of some of the world's biggest companies, and creates diagrams of their interrelationships – showing, for example, that former American senator Sam Nunn sits on the boards of Texaco, Dell and Coca Cola. Links to additional databases on the web reveal the political donations Nunn has made over the past years, and maps reveal his web of social and professional relationships. Another diagram from *They Rule* called *Pharm & Finances* reveals that pharmaceutical giant Merck and investment bank JP Morgan Chase share two board members. The rigorous, specialized diagramming and quantification executed in a palette of soft greys, incorporating small icons like office chairs and briefcases, bear a strong resemblance in scale and style to drawings by American artist Mark Lombardi (1951–2000), who chartered suspicious ties connecting scandals, government officials and big business. They are also reminiscent of corporate diagrams or flowcharts – precisely the kind of imperatives that are designed to effect change, reshape experiences and control representation. Underwriting On's work technically was a database of information about corporate board members. A 'database' is a program, usually searchable, that allows users to mix and match information from different categories called 'fields', and a number of artists have produced work using databases as either a metaphor, subject or medium.

Lev Manovich has argued in *The Language of New Media* that the database is a dominant new media form: *The most obvious examples are popular multimedia encyclopedias, collections by definition, as well as other commercial CD-ROM (or DVD) that feature collections of recipes, quotations, photographs, and so on…. As defined by original HTML, a Web page is a sequential list of separate elements – text blocks, images, digital video clips, and links to other*

109 **Josh On** and
Futurefarmers, *They Rule*, 2001

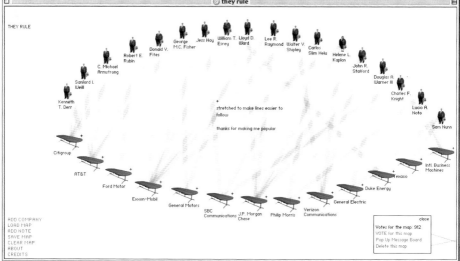

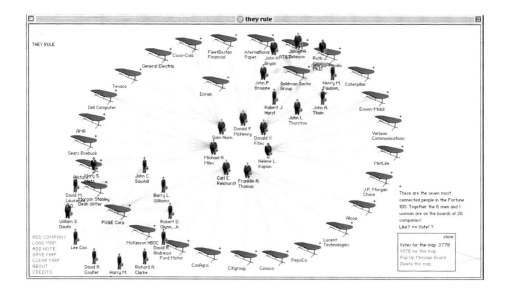

Chapters

Internment
camps in

The Dress of Mrs. Terwen-de Loos

People
Mrs. Terwen-de Loos
Jan Willem Terwen
Pier Terwen

Places
--

Years
2000 >

Keywords
Biography
Silk
The Silk Kimono

all items
viewed items
index

110 **De Geuzen (Riek Sijbring, Renee Turner, Femke Snelting)** in collaboration with **Michael Murtaugh**, *Unravelling Histories*, 2002. This beautifully designed database, revealing interlocking themes in Dutch colonial history, was inspired by the innovation of a Dutch art historian who, with fabric in short supply after World War II, used military maps to make her dresses. De Geuzen's installation of 1940s dresses and an online database is a feminist attempt at identifying and reclaiming female historical figures.

pages....As a result, most Web pages are collections of separate elements....A site of a major search engine is a collection of numerous links to other sites (along with a search function of course). A site of a Web-based TV or radio station offers a collection of video or audio programs along with the option to listen to the current broadcast, but this current program is just one choice among many other programs stored on the site. Thus the traditional broadcasting experience, which consists solely of a real-time transmission, becomes just one element in a collection of options.

Manovich adds that, because the web is always changing, diminishing and growing, its capability as a database far outweighs its narrative-orientated qualities. The net's rate of change, growth and depletion forms the basis of *1:1 (2)* (1999/2001) [111–113], a work of data visualization by Swedish-born artist Lisa Jevbratt (b. 1967). *1:1 (2)* pictorializes sections of the internet by using IP numbers, the unique numerical addresses given to registered computers connected to the net. The work comprises five iterations – 'Migration', 'Hierarchical', 'Random', 'Every' and 'Excursion' – and every visualization contains thousands of data points, in which each registered computer is represented by one such element. Jevbratt explains how she used software programs called 'crawlers' to aggregate the data and compose the interface:

Right:
III Lisa Jevbratt, *1:1 (2) –*
Interface: 'Every', 1999/2001. There
are two versions of this project
– one dating from 1999 and another
from 2001 – both of which can now
be viewed simultaneously on split
screens (as in this illustration). All
web sites have an Internet Protocol
(IP) address, consisting of several
numbers, which together make up
the web's numerical space. Using a
database of IP addresses compiled by
research group C5, member Jevbratt
has created five visualizations of the
web's entire numerical territory.
The pictures work by using
colour-coded pixels to represent IP
addresses, which a user can then
access by clicking.

Below:
II2 Lisa Jevbratt, *1:1 (2) –*
Interface: 'Hierarchical', 1999/2001

'The crawlers don't start on the first address going to the end; instead they search selected samples of all the numbers, slowly zooming in on the numerical spectrum. Because of the interlaced nature of the search, the database could in itself at any given point be considered a snapshot or portrait of the web, revealing not a slice but an image of the web, with increasing resolution.' There is an impossible quality to this affecting work, akin to the futility with which John Simon's *Every Icon* inches towards the wholeness of manifesting every imaginable icon only to be constantly marked by incompletion. In the case of Jevbratt's work, the interface to the internet becomes the internet itself. The ratio indicated by the title, a pixel for each web address, results in a highly dense field, yielding somewhat insoluble results. The scale of the web and the pixel are balanced in an uncomfortable tension. In the 'Every' iteration of *1:1 (2)*, a landscape emerges and the work tends towards the imagistic and representational. According to Jevbratt: 'The variations in the complexity of the striation patterns are indicative of the numerical distribution of web sites over the available spectrum. Larger gaps in the numerical space indicate an uneven and varied topography, while smoother color transitions and more consistent layers are indicative of "alluvial", or sedimentary, flat-lands in the web's IP space.'

In the work *Anemone* (1999) [115], artist Benjamin Fry (b. 1975) uses organic visual metaphors to represent web traffic on a given hub, creating an analogy between natural systems and online information sets. A similar work by Fry is *Valence* (1999) [116], which takes information-rich objects, such as books or web sites,

114 Erik Adigard/m.a.d.
(with **Dave Thau**), *Timelocator*,
2001. Though ostensibly a clock
interface, *Timelocator* contains
a great deal of information and
links. The somewhat basic premise
belies the sophistication of the
programming, an economy not
uncommon to this period of
net art.

Opposite above:
115 Benjamin Fry, *Anemone*,
1999. *Anemone* both visualizes
a web site's complicated and
changeable structure and maps
its usage patterns. The project
investigates a site's structure
by using a tree-like diagram to
represent its individual pages,
which are displayed as nodes at the
tip of each branch (clicking on
a node reveals which web page it
represents). The more frequently
an individual page is visited, the
thicker its respective node
becomes (up to a certain
threshold), while pages that
draw in no visitors eventually
lose their branch.

Opposite below:
116 Benjamin Fry, *Valence*, 1999

117 **MTAA** (**Mark River** and **Tim Whidden**), *website unseen #001: Random Access Mortality*, 2002

and visualizes individual pieces of information, based on how they interact with each other. The data-visualization software reads a text and connects each word by lines in a three-dimensional format. The more often a word appears, the further away it is placed from the diagram's centre. In this way, *Valence* is able to provide a general overview of the structure of information in any given text, highlighting, as Christiane Paul points out, 'relationships between data elements that might not be immediately obvious, and that exist beneath the surface of what we usually perceive'.

Other database-driven compositions are based on chance. In a work indebted to John Cage's scores of random sounds, *Random Access Mortality* (2002) [117] by American duo Mark River and Tim Whidden (who work under the name MTAA), songs by the band The White Stripes are divided into samples equal to one revolution of a 45 RPM record. These 1.33-second clips can be listened to individually, or every sample from the song can be heard in a random sequence, so that what was once a fairly harmonious and cogent narrative is synthesized to become something that seems full of more diverse and unrelated contents. The reverberations between the musical scraps and the original song suggest a stifling of a media form (music) by database means.

Games

Though few other projects shared the high economic stakes of 1999's *Toywar* campaign, gaming has developed into a lively and varied field of artistic practice. Besides their potential for fun,

games had attractive, colourful surfaces, offered role-playing opportunities and dramatic narrative possibilities, and also boasted show-stopping architectural spaces, the cutting edge of three-dimensional digital design. Game environments in fact crystallize some of internet art's most distinctive characteristics, chief among them interactivity: a game literally depends on a player. Creativity is also vital, as the hacks and additions players make and share within their communities comprise a significant part of game culture. In these open games, participants' own innovation is encouraged, and users are expected to come to their own conclusions about a game's successes and failures. These ideas exist within both the open-software movement and new media art communities that encourage feedback and popular, critical discourse. Finally, game art explains a mode of spatially based narrative that inflects many online experiences. As Lev Manovich writes in *The Language of New Media*, 'In most games, narrative and time are equated with movement through 3-D space, progression through rooms, levels or words. In contrast to modern literature, theater and cinema, which are built around psychological tensions between characters and movement in psychological space, these computer games return us to ancient forms of narrative in which the plot is driven by the spatial movement of the main hero, traveling through distant lands to save the princess, to find the treasure, to defeat the dragon, and so on.' Internet artists often deployed these forms and internal strategies of games to disseminate images or ideas.

In Natalie Bookchin's *The Intruder* (1999) [118], a story by Argentinian writer Jorge Luis Borges is propelled by the playing of various seminal game models, from Pong to war simulations. The user listening to the audio file that narrates the short story

118 **Natalie Bookchin**,
The Intruder, 1999

must be an active participant, catching, shooting and so on, in order to hear the next instalment of the story of two brothers who love the same woman. Part game history, part experiment in applying physical relationships to words, *The Intruder* enriches the communication and literary palettes of games.

Commercial games, such as those for Sony Playstation or Microsoft X-Box, rely on teams of programmers, designers and producers, and require significant investment to be developed. Artists and gamers began to explore and domesticate their often astonishing formal backdrops and internal contents in a field of activity called modification, or 'mods'. Visible forms of intervention include the patch, in which one can change the appearance of a game's character and its texture maps (or backgrounds). These and other mods sometimes acted as forms of critique, material methods for diversifying a game's politics or its visual aspects. American artist, curator, writer and gamer Anne-Marie Schleiner (b. 1970) described these possibilities in an interview in 1999: 'I am interested in the notion of art as culture hacking, art with a critical agenda that seeps outside the boundaries of prescribed art audiences and engages itself with a broader public (i.e. the gaming public). Art that finds cracks in the code and hacks into foreign systems. I also want to invite a cross-pollination of gaming and art strategies by providing artists with tools and techniques developed by game hackers and exhibiting game patches created by gamers as art.'

119 **Paul Johnson**, *Green v2.0*, 2002. This piece, which includes artist-created games and artfully presented hardware, is not internet art per se, but nonetheless exemplifies the growing acceptance of technoart and gaming in the art world.

Above left:
120 **Brody Condon**, *love_2.wad* (*Velvet-Strike* spray), 2002. *Velvet-Strike* is a collective effort by Anne-Marie Schleiner, Joan Leandre and Brody Condon to deposit politically progressive content in military-fantasy game Counter-Strike. Created as a response to Bush's 'War on Terror', it allows users to spray anti-war graffiti onto walls in the game environment.

Above right:
121 **Brody Condon**, *Adam Killer*, 2000–2. *Adam Killer* comprises a number of modifications of the shooter game Half-Life. In this picture, multiple copies of a character create a disorientating and bloody environment when they are attacked with weapons.

Right:
122 Documentation of the online exhibition 'Cracking the Maze', 1999. The text-heavy interface for this important exhibition of game patches deliberately resembles the source code of Doom. A popular, open, commercial game, Doom allows players to modify and customize its aesthetics. Makers of open games like Doom pay attention to mods and patches, sometimes adjusting later versions of their products to align with what players want.

Indeed, on Schleiner's web site her own work and curatorial projects are creative engagements with typical gender ideologies and xenophobia of games. Her *Anime Noir-Playskins* (2002), developed with Melinda Klayman, embraces the hybrid forms and characters of Japanese *anime* and rewards players for flirtation and mutual sex-positive interactions, assailing the sexism or homogeneous narratives of standard gaming fare. In 'Cracking the Maze' [122], an exhibition organized by Schleiner, artist Sonya Roberts made Quake players into buff, tough 'frag' queens (a play on drag queens), who seem sufficiently physically endowed to prevail in any match. Also in the exhibition was Parangari Cutiri's *Epileptic Virus Patch* for Marathon Infinity, a shooter game; in the altered version, fluorescent pulsating pixels and strobe lights reflect a player weakened by overload and exhaustion. Because gaming culture has thriving subcultures in the exchange of patches, textures and other graphics, the works enter into wider populations and discourses, and do not remain ironic or stagnant displays. On a more recent exhibition exploring erotic games and digital art, 'Snow Blossom House', Schleiner notes: 'I included screenshots of gay and lesbian movies made with nude Sims Skins. Gaming has become a digital folk art medium. Within their online communities, gamers play the roles of critics, curators, and artists, distributing their own game mods and collecting and reviewing others.'

Los Angeles-based artist Eddo Stern (b. 1972) endowed game narratives with political realism in his digital video *Sheik Attack* (2000) [124], in which gaming's shared edges with desktop violence and combat coexist in a work based on documented events from

123 **Melinda Klayman**, *Sushi Fight*, 2001. Part of the exhibition 'Snow Blossom House', curated by Anne-Marie Schleiner, *Sushi Fight* charts a sushi girl's increasingly difficult battle against various sea creatures with a magic flower as her only weapon. The player makes the girl grow if he or she attacks the opponent at the right time by clicking on the flower, but losing a point makes the sea creature increase in size.

124 **Eddo Stern**, *Sheik Attack*, 2000. Stern's digital videos are assembled from computer games such as Nuclear Strike, Delta Force and Settlers, and are significant in internet art history for their preoccupation with recreational, media-based and historical foundations of selfhood – concerns that intersect and reflect one another in contemporary technoart.

the Israeli–Palestinian conflict. Stern's *Summons to Surrender* (2000) is an experiment in narrative intervention. Using the online communities of three medieval-themed games, Sony's EverQuest, Microsoft's Asheron's Call and Electronic Arts' Ultima Online, Stern inserted computer-controlled game characters, using the game world as a live performance space, streaming the game actions online, and offering 'free' use of shared characters. Stern says this 'may appear like quixotic pleas for agency from an enthralled fan.... But these actions also serve to hijack the game's space and context and assert a newfound public space for street performance.' A cyberpunk-inspired project, *Summons to Surrender* introduces sci-fi allusions, alternative interactions and a model of resistance into the nostalgically medieval and homogeneous utopian backdrop of those games.

Enemy encounters take a more theoretical turn in *Trigger Happy* (1998) [125] by British duo Thomson & Craighead. Jon Thomson (b. 1969) and Alison Craighead (b. 1971) developed a version of the 1978 Space Invaders, a classic among video games, in which the invading enemy is not an alien force, but rather quotations from Michel Foucault's essay 'What is an Author?' from 1969. The game challenges the players' attention spans by forcing a dilemma between reading the quotes and preserving one's safety amid dropping bombs while shooting at them (it proves very hard to do both). Hypertext links deriving from the quotations at the top of the screen distract even further. British writer J. J. King wrote about this frenzied environment as a comment on the attention strategies required by contemporary technologies: '*Trigger Happy* is

125 **Thomson & Craighead**, *Trigger Happy*, 1998

gesturing towards the basis of a future information economy, where attention, precisely because of its scarcity, may become a central commodity. The most successful constructions, we're left thinking, may be those which in generating attention and catching the gaze, can take the reader's finger off the trigger.' The player must destroy a quotation from Foucault's text about subject positions among writers, texts and readers, or face destruction by that text. Indeed, by configuring the game in this way, the artists establish an homologous relationship between the fictional opponents of gaming, and the tensile relationships of artist and viewer, or artist and player, to which Foucault's essay alludes. In *Trigger Happy*, resolution between these subject positions seems impossible: the most appealing possibility is to play another round.

Mongrel's *BlackLash* (1998) [126], which also appeared in the 'Cracking the Maze' exhibition, was a web-based game in which a player chose from four stereotyped black fighting characters, then slew his or her way to freedom by killing police and fascist characters. One of the creators, Richard Pierre-Davis, explained how the game deploys stereotypes: '*BlackLash* is based on a combination of stereotypical half truths and hardcore reality

coming from the point of view of a young black male trying to survive inner city life in the nineties, hence the name…. You choose one of the stereotyped characters, after which you proceed to battle the forces of evil that plot to convict or eliminate you from the streets. It also aims to encourage the black community through game culture that it is possible to break into different areas apart from music, and create games that have got some thing to say.' If many games rely on stereotypes and exemplary historical conflicts for their premise, as *BlackLash* did, Jodi.org's *SOD* (1999) radically modified the classic computer game Castle Wolfenstein, establishing abstracted spaces for gaming. With a jaunty score and limited palette of grey, black and white, the game space at first appears approachable. However, within the minimal environment it is difficult to ascertain the targets one is supposed to shoot, and easy to get lost in its disorientating, Kafka-esque space. Combining confusion, interactivity and a simple graphic environment, *SOD* hints at private emotions, all the while taking gaming back to its more primitive, computerized core. The ways in which artists have worked with games – creating new material for free widescale distribution into communities with feedback channels, and inflecting existing games with more personal and political and less homogenized content – have helped to produce a new dimension to an existing entertainment sector.

126 **Mongrel**, *BlackLash*, 1998

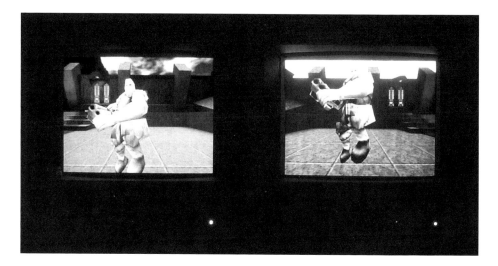

127 **Victor Liu**, *Children of the Bureaucrats of the Revolution*, 2002. Quake, an open-source game that encourages participation and creative use, offers the setting and 3D environment for this dance piece. Liu gives an insider's perspective of the dances by recording the viewpoints of the dancers themselves, simultaneously displaying them on adjacent monitors. Games have become regularly used software repositories from which artists create works of dance, performance, sculpture, music and video.

Generative and Software Art

Generative art, according to American artist and teacher Philip Galanter, is 'art practice where the artist creates a process, such as a set of natural language rules, a computer program, a machine, or other procedural invention, which is then set into motion with some degree of autonomy contributing to or resulting in a completed work of art'. Fluxus projects and Happenings, which relied on scores or instructions, have been recognized as historical precursors to new media-based forms of generative art. As with software art, many Fluxus projects problematized the role of the artist by removing his or her physical index from the production of the artwork. Art generated by software can lack the physical, improvisational latitude of a Happening, but can vary according to external data conditions or user input. In addition, if a project of software art is open (that is, its code is available or open to editing), it can be modified, adjusted and refined by another user. Some online software art is premised on the endurance of mechanized algorithms, such as John Simon Jr's *Every Icon*. Others draw attention to certain mechanized or routine behaviour among users, programmers or designers, or rely on varied input from users.

British writer Saul Albert described the term 'software art' as applicable to 'art that is made from, uses, or interrogates software as a cultural form and context'. One important influence encouraging the development of software and generative art is the free-software movement. Often identified with the rubric 'open source', free software and its communities organize around

libraries of code or particular projects. In these collaborations, the revisions and modifications by varied programmers are incorporated. With the success of Linux as a popular open-source operating system (an operating system is the central application of a computer, on which all other programs run), the economic and authorship paradigms of the free-software movement encouraged innovation, diversity and collaboration. The awarding of the prestigious Golden Nica Award to Linux at Ars Electronica in 1999 testifies to its importance as a model matrix for creative collaboration. Proprietary software, in comparison – for example, Adobe Photoshop and Microsoft Word, Excel and PowerPoint – is closed to modification and expensive to purchase. As German critic Dieter Daniels explains, open-source software is a 'bottom-up' system, while proprietary ware is 'a "top-down" structure as represented by the precise notation of a classical composition as well as the proprietary software developed by Bill Gates's Microsoft Corporation, for which the secrecy of the source code is the basis of a capitalist monopoly'. Beyond the ideology and cost of buying commercial software lie concerns, raised early on in *The Web Stalker*, that with its limited sets of commands and functions designed for use across a wide scale, commercial software inhibits experimentation and autonomy. Matthew Fuller, who has published extensively on how 'software forges modalities of experience', a topic sometimes known as 'software culture', writes of the need for collective activity among software engineers, artists and computer users. These teams, suggests Fuller, besides nurturing a diversity of tools, could also draw inspiration from the successful organizational structures of the free-software community, such as their repositories for distribution and collaboration.

Runme.org [128], which Fuller helped organize, is such a work, inspired as it was by the distribution databases common among free-software initiatives. Developed by a team of artists, programmers and writers – Amy Alexander, Florian Cramer, Matthew Fuller, Olga Goriunova, Thomax Kaulmann, Alex McLean, Pit Schultz, Alexei Shulgin and The Yes Men – the web-based repository for software art foregrounds several interlocking paradigms of the open-software nodes: downloads, feedback and keyword indexing. In contrast to a traditional exhibition or gallery, *Runme.org* shares art within an artist-driven discursive context. While the projects included are diverse, enabling various forms of sound, image and textual creation, together they suggest a growing dominance of functionality, shareware and programming

128 *Runme.org* software art repository, 2003

as an art genre. With the model of web-based discussion and distribution, *Runme.org* offers an alternative to other art discourse and archival models, such as Rhizome.org or THE THING. Like many works in this field, software art's proximity to free-software methods creates an important foundation.

Alphabet Synthesis Machine (2002) [130], made for American television network PBS by Golan Levin (b. 1972) with Jonathan Feinberg and Cassidy Curtis, allows users to consider certain dimensions of typography and handwriting by developing a typeface based on a direct mark (made with the mouse). Levin, despite his prowess as a programmer, understands that aesthetic activities online need not be devoid of handmade, direct, unmediated line creation and experimentation. The manual gesture of creating a letter, while subject to the rules of code that turn it into an alphabet, suggests a different set of possibilities, unlimited by proprietary word processor typefaces. Working in film and TV as well as software, American artist Barbara Lattanzi (b. 1950) began to develop software that would help her improvise with film and video, citing existing resources as inadequate: 'I would rather make my own software (what I term "idiomorphic software"), because the commercial software that I use comes at a price. That price has less to do with money and more to do with a different process of abstraction: the active framing of my work within considerations dictated by irrelevant practices of Design.'

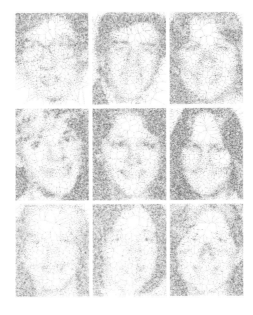

Above:
129 **Golan Levin**, *Yearbook Pictures*, 2000. A virtuoso programmer, Levin's intricate portraits are composed by software that converts images into delicate line formations. This series of photographs of teenagers is uniformly treated with the same application, yet each image is endowed with a particular, subjective gravity.

Below:
130 **Golan Levin, Jonathan Feinberg** and **Cassidy Curtis**, *Alphabet Synthesis Machine*, 2002

Lattanzi's software *HF Critical Mass* [131], one of almost ten pieces of freeware on her site, is based on the cinematic techniques of Hollis Frampton (1936–84) in his 1971 film *Critical Mass* and noteworthy for its particularity. Available for use at no charge by anyone who might want to adopt his or her QuickTime files using the film's idiomatic style, the work undoes the gestalt relationship between software and mass functionality that characterizes most applications. As Matthew Fuller notes, 'Software is reduced too often into being simply a tool for the achievement of pre-existing neutrally formulated tasks.'

Tom Betts (b. 1973) of the British group Nullpointer has developed software for composing music, as well as *QQQ* (2002) [132], a networked installation-cum-performance based on the online game Quake. The actions of the geographically dispersed players are perverted in such a way that they appear in the installation as colourful painterly gestures amidst abstracted architectural spaces. Whereas the actual Quake players are involved in murderous exploits, *QQQ* presents the game as a performance space for image production. The beautiful and invented mutations of Quake position the work on an artistic borderline between gestural painting and gaming.

In the 2002 exhibition 'CODeDOC' for the Whitney Artport, a site that promotes and commissions internet art at the Whitney Museum of American Art, curator Christiane Paul sought to represent how different processes of coding conditioned the experience and expression of one idea. Commissioning twelve artists to submit code that 'should move and connect three points

131 **Barbara Lattanzi**,
HF Critical Mass software applied to
The Zapruder Film, 2002

132 **Tom Betts**, *QQQ*, 2002

in space', Paul stipulated that the code should be the 'object', as opposed to 'what it produces'. By thus reverse-engineering the usual focus in software circles on functional works, this group exhibition encouraged users to examine source code itself before experiencing its expression; on the 'CODeDOC' web site, the former was a prologue to the latter. In her introduction to the project, Paul linked code with aesthetics and themes evident in art of the 1960s: 'Even if the physical and visual manifestations of digital art distract from the layer of data and code, any "digital image" has ultimately been produced by instructions and the software that was used to create or manipulate it. It is precisely this layer of "code" and instructions that constitutes a conceptual level which connects to previous artistic work such as Dada's experiments with formal variations and the conceptual pieces by Marcel Duchamp, John Cage and Sol LeWitt (b. 1928) that are based on the execution of instructions.' As a form, source code is revealed as a highly malleable instrument, and artists' interpretations are varied permutations using different languages

```perl
#!/usr/bin/perl

# title: global city ( for saskia sassen ), 2002
# author: sawad brooks
# created: august 15, 2002
# program creates on your computer an HTML file named "global.html"
# - a "globalcity" newspaper front page, viewable using a Web browser

use Socket;

@space = ( "www.nytimes.com" ,"www.guardian.co.uk" ,"www.asahi.com" );

open ( FILE, ">global.html" ) || die ( "Cannot Open File" );
select ( FILE ); $| = 1; select ( STDOUT );

srand;
$cityindex = int ( rand 3 );

print FILE "<div style=\"position: absolute; left: 0px; top: 0px\">" ;
print "connecting $space [ $cityindex ] ..." ;
# call function GetHTTP to fetch URL
@stream = &GetHTTP ( $space [ $cityindex ], "/" );
foreach $s ( @stream ) { print FILE $s ; print "." ; }
print FILE "<\div>" ;

$cityindex ++; if ( $cityindex > 2 ) { $cityindex = 0; }

print FILE "<div style=\"position: absolute; left: 200px; top: 0px\">" ;
print "connecting $space [ $cityindex ] ..." ;
# call function GetHTTP to fetch URL
@stream = &GetHTTP ( $space [ $cityindex ], "/" );
foreach $s ( @stream ) { print FILE $s ; print "." ; }
print FILE "<\div>" ;

$cityindex ++; if ( $cityindex > 2 ) { $cityindex = 0; }

print FILE "<div style=\"position: absolute; left: 400px; top: 0px\">" ;
print "connecting $space [ $cityindex ] ..." ;
# call function GetHTTP to fetch URL
@stream = &GetHTTP ( $space [ $cityindex ], "/" );
foreach $s ( @stream ) { print FILE $s ; print "." ; }
print FILE "<\div>" ;

# Done
exit ;

# Note: You can copy or download the script above and run it locally on your computer.
# What you need:
# Perl for Macintosh OS 9 or older
# http://www.macperl.com/
# http://www.perl.com/CPAN/ports/mac/MacPerl-5.6.1r1_full.bin
# Perl for Windows
# http://www.activestate.com/
# http://www.activestate.com/Products/Download/Register.plex?id=ASPNPerl&a=e
# Linux | MacOSX | Unix systems have Perl already installed
```

Programmer-defined variables
String constants
Non-executing comments
Perl keywords

133 **Sawad Brooks**, the code for
Global City, for Saskia Sassen, 2002
(from the 'CODeDOC' exhibition
at the Whitney Museum of
American Art). Using programming
language Perl, Brooks displays
pages of the online versions of
three newspapers. Highlighting
Brooks's interest in digital
technologies – and the social,
political and philosophical issues
they raise – this project questions
the relative autonomy of each
newspaper and the way in which
such publications are displayed.

```perl
# Function fetches a URLs

sub GetHTTP {
        local ( $hostname , $doc ) = @_;
        local ( $port , $iaddr , $paddr , $proto , $line , @output );

        # ignore the "host:port" notation, and assume http = 80 everytime.
        socket ( SOCK, PF_INET, SOCK_STREAM, getprotobyname ( 'tcp' )) || die "socket (): $!\n" ;
        $paddr = sockaddr_in ( 80 , inet_aton ( $hostname ));
        connect ( SOCK, $paddr ) || die "connect(): $!\n" ;
        select ( SOCK ); $| = 1; select ( STDOUT );

        # send the HTTP-Request
        print SOCK "GET $doc HTTP/1.0\n\n" ;

        # now read the entire response:
        do { $line = <SOCK> } until ( $line =~ /^\r\n/);
        @output = <SOCK>;
        close ( SOCK );
        return @output;
}
```

134 **Sawad Brooks**,
Global City, for Saskia Sassen, 2002
(from the 'CODeDOC' exhibition
at the Whitney Museum of
American Art)

```
WHAT:

    This program moves and connects 3 dots.

    Each of the 3 dots animates around it's own rectangle.

    The 3 dots are connected in their current location by a translucent white triangle.

    My program keeps track of former dot locations, and draws blue triangles connecting
    the 3 dots in places they used to be.

    Like most (all?) things, the traces of where the dots have been fade over time.

    You can change the rectangles,

           and therefore the trajectories of the dots,

                 and therefore the patterns created over time,

    by clicking anywhere on the screen.

    A random corner of one of the 3 rectangles will relocate to the spot you clicked.

    The dot controlled by that rectangle will move back onto it's trajectory around the
    new triangle (most of the time - sometimes it doesn't quite get back 'on track' but
    that was a mistake I liked so I left it.)

    To quit the program, hit ENTER on your keyboard.

WHY:

      This was apparently a very simple assignment: 'move and connect 3 dots'.

      But all motion implies time.

      Time and motion can create complexity out of very simple things.

      This is especially the case when a simple shape (a triangle) repeated over
      and over again, following another simple shape (a rectangle) creates a complicated
      network of lines.
```

including C, Perl, Java or Lingo. While Sawad Brooks uses Perl in *Global City for Saskia Sassen* [133–134] and Camille Utterback (b. 1970) works with C in *Linescape.cpp* [135], Golan Levin's *Axis* [137] and Martin Wattenberg's *Connection Study* [136] reveal code with Java. Far from dehumanizing texts, code shows its latitude for intention and personality: it is political in the hands of Levin, elegant and terse when written by Wattenberg, and hyperrational in Utterback's contribution.

Finally, not all software art exists in a functional state; some of it remains purely propositional. Moving away from the explorations of functionality and visualization in the previously discussed works, Graham Harwood's *London.pl* (2001) [138] exists in an even less objectified form than an application: it is simply a script in Perl (a language designed for processing text). *London.pl* consists of a program that calculates the collective lung capacity of children in London who have been, in the artist's words, 'beaten, enslaved, fucked, and exploited to death' since 1792 (at the time of

135 **Camille Utterback**, *Linescape.cpp*, 2002 (from the 'CODeDOC' exhibition at the Whitney Museum of American Art)

```
import java.awt.*;

import java.applet.*;

public class ConnectApplet extends Applet

    implements Runnable {

  Point current;

  Point[] p=new Point[3];

  Thread animation;

  int w,h;

  Image pictureImage;

  Graphics picture;

  public void init() {

    w=size().width; h=size().height;

    pictureImage=createImage(w,h);

    picture=pictureImage.getGraphics();

    p[0]=new Point(w/2,100);

    p[1]=new Point(w/2+70,170);

    p[2]=new Point(w/2-70,170);

    current=p[0];

  }

  public void start() {

    animation=new Thread(this);

    animation.start();

  }
```

```
// key: code in gray makes the program run.

//      code in black draws the picture.

public boolean mouseDown(Event e, int x, int y) {

  int shortest=Integer.MAX_VALUE;

  for (int i=0; i<p.length; i++) {

    int d2=(p[i].x-x)*(p[i].x-x)+

          (p[i].y-y)*(p[i].y-y);

    if (d2<=shortest) {

      current=p[i];

      shortest=d2;

    }

  }

  return mouseDrag(e,x,y);

}

public boolean mouseDrag(Event e, int x, int y) {

  current.x=x; current.y=y; return true;

}

synchronized void updatePicture() {

  for (int i=0; i<5000; i++) {

    int x=(int)(w*Math.random());

    int y=(int)(h*Math.random());

    long a1=f(p[0],p[1],x,y),
```

136 **Martin Wattenberg**,
Connection Study, 2002 (from the
'CODeDOC' exhibition at the
Whitney Museum of American Art)

the designations used in *Axis* do not imply the expression of any opinion
whatsoever on the part of the author or publisher concerning the legal
status of any country or territory of its authorities, or concerning the
delimitation of its frontiers or boundaries.

Although we have tried our best to document all possible Axes, our data
indicates that not all threesomes of countries have yet completed their
Axis registration form. Thus only approximately half of the 6 million
possible Axes are displayable at this time.
*/

```java
import java.awt.*;
import java.applet.*;
import java.awt.image.*;

public class AxisApplet extends Applet implements Runnable {

    //-----------------
    // Declaration of variables.
    // See end of document for inlined database.
    Thread   appletThread = null;
    boolean stopThreadP  = false;
    int      csrX, csrY;
    int      iter = 0;
```

137 **Golan Levin**, *Axis*, 2002.
Online Java applet (from the
'CODeDOC' exhibition at the
Whitney Museum of American Art)

138 Graham Harwood,

London.pl, 2001. Like Yoko Ono's instruction works, *London.pl* (written chiefly in the programming language Perl) may or may not be executed. Unlike most software art, this work introduces poetry and historical references into the algorithms of code.

```
foreach my $Class ($SocialClasses){
        #Add the contents of this $Class to
$DeadChildIndex->{$Index}
        # Class attribute
        if( $Class eq $DeadChildIndex->{$index}->{Class}){
                $DeadChildIndex->{$Index}->{Class} =
X{$Class} ;
        }else{
                warn
"$DeadChildIndex->{$Index}->{Name} is not a member of = $Class\n";
        }
        $DeadChildIndex->{$Index}->{Class} =
X{UncategorisedVictim} if ! $DeadChildIndex->{$Index}->{Class};
        #  The averedge daily scream output of fear for
the period 1792-2002 is 5.
        my $TotalDaysLived =
($DeadChildIndex->{$Index}->{Class}->{LifeExpectancy} * 365)
        #  Calculate the gross $Lung Capcity for
Screaming for this child
        my $LungCapcityForScreaming =
&Get_VitalLungCapcity(\%{$DeadChildIndex->{$index}}) *
$TotalDaysLived;
        # assign to $DeadChildIndex->{$Index}->{ScreamInFear}
        $DeadChildIndex->{$Index}->{ScreamInFear} =
$LungCapcityForScreaming;
}

#  The Get_VitalLungCapcity routine uses the Age and
Height entry of the DeadChildIndex.
        #  to calculate the Lung-Capcity of the dead child. This
is then used to calculate the
        #  volume and capacity of screams when terrified.
        sub Get_VitalLungCapcity{
        my $DeadChild = shift;
        my (
                $VitalLungCapcity,   #  vital lung
capacity in liters of air
                $Height,             #  is height
in centimeters
                $Age,                #  is age in years
        );

        $Height = $DeadChild->{Height}  unless ! defined
$DeadChild->{Height};
        $Age   = $DeadChild->{Age}   unless !
defined $DeadChild->{Age};

        if ($Height && $Age){
                #  Basically your vital lung capacity
gets bigger as you get taller,
                #  but it gets smaller as you get
```

Britain's Industrial Revolution). The vital statistic is used to time a scream – the collective scream of these children – to be broadcast in London in the hope of redressing what the artist cites as an 'imbalance of imagination and innocence'. The consequences of the Industrial Revolution are also alluded to in quotations from William Blake's *Songs of Innocence and Experience*, which are remixed in the code along with the artist's premise and the Perl commands. In this work, code calculates the formal consequences of the artist's prescription for England. Engineering and functionality are designed but sidelined, and the work instead draws attention to its socially inspired internal content. It is the concept that gives the work its strength, not its materiality.

As Christiane Paul noted, there are parallels to be drawn between this form of generative art, software art and earlier art practices that changed the relationships between the artist and his or her work of art, like those by John Cage or Sol LeWitt. They, like other conceptual artists, opened up spaces between symbolic representation and enactment. Software projects such as *London.pl* are akin to works from the 1960s that emphasized proposition and intention via text-based projects. However, the circulation of *London.pl* and many other works of software art within free-software contexts as well as art zones gives them economic, technical and sociological values different from art

objects or events. Perhaps the most apt metaphor is that *London.pl*, and software art like it, can function like a musical property in the public domain, without copyright: it travels easily, and is free to sample and build upon.

Open Works

In their own ways, *London.pl* and 'CODeDOC' represent the model of open software in which users with programming knowledge can modify or participate as author, audience and critic. Building on the general knowledge of internet users, who are likely familiar with online communication and basic functions like uploading and downloading data, some artists sought to dissolve boundaries between art production and audience. Like Mark Napier's *Digital Landfill* [75], which explored the formal material of the web by having visitors chuck web sites in a metaphorical 'trash heap', or Nam June Paik's *Participation TV*, in which users could evolve complex visual structures, these works rely on essential contributions from their audience. Some are akin to the surrealist text-and-image collage technique, the 'exquisite corpse' so named after a fragment from one of the collaboratively formed sentences. In *Glyphiti* (2001) [139], Andy Deck (b. 1968) developed an interface in which any viewer can modify or change

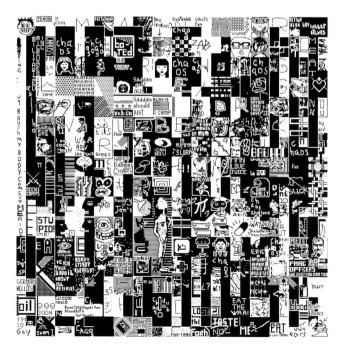

139 **Andy Deck**, *Glyphiti*, 2001. Although certain elements in this project have been fixed by Deck, including colour (black and white only) and size, users have the freedom to change the individual glyphs that make up the site and leave their own mark. Designed to function across most firewalls, *Glyphiti* bears similarities to graffiti in its appropriation of private space for fun.

140 **Mongrel**, *Linker*, 1999.
A prototype for *Nine(9)*, *Linker* aimed to enable sophisticated visual self-expression to those not exhaustively versed in graphics software. Similar to an application like Adobe Director but smaller and scrappier, this free software employed 'drag-and-drop' functionality to create rich multimedia maps.

visual elements. Its collaborative edge is that it is designed to function across most firewalls (hardware or software lines of defence, used by institutions or companies to protect private data or prevent employees from partaking in leisure activities). A similar work is *communimage* [141], launched in 1999 by programmers c a l c and Johannes Gees. A democratic collage of graphics uploaded by visitors, as well as communication tools for people to form relationships around their participation, *communimage* offers large-scale, eccentric, visual juxtapositions.

If internet technologies allow for friendly encounters around image maps, the rhetoric of social and creative processes can also drain collaborations of their critical potency, rendering them highly documentary or formal. An important work of collective software, *Nine(9)* (2003) [143–144], created by Mongrel's Graham Harwood and commissioned by the Waag Society in Amsterdam, inscribes collaboration into a social context by allowing users to create simple multimedia 'knowledge maps' that can be linked to

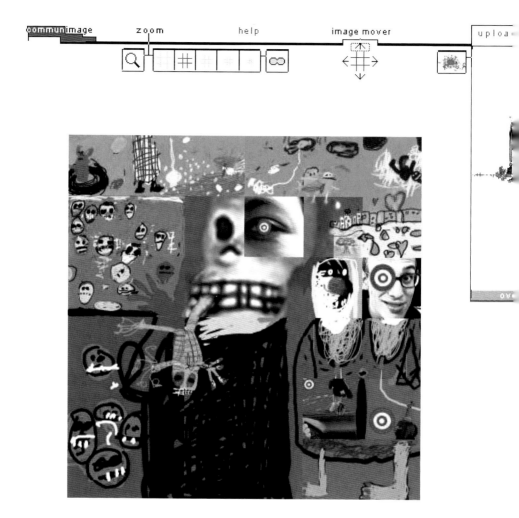

Above left and opposite above right:
141 c a l c (Teresa Alonso Novo,
Looks Brunner, tOmi
Scheiderbauer, Malex Spiegel,
Silke Sporn) and **Johannes Gees**,
communimage, 1999

Below right:
142 **Josh On**, **Amy Franceschini** and **Brian
Won** of **Futurefarmers**, *Communiculture*, 2001.
Like other software projects described in this
chapter, *Communiculture* is geared towards group
use, valuing the relational, interactive expression
of ideas. In the section entitled 'what can we do
about art on computer?', for example, one could
place an avatar between a participant who notes
that 'computer art allows people to share and
communicate' and another whose forthright
belief is that 'art is art. Computers are tools.'

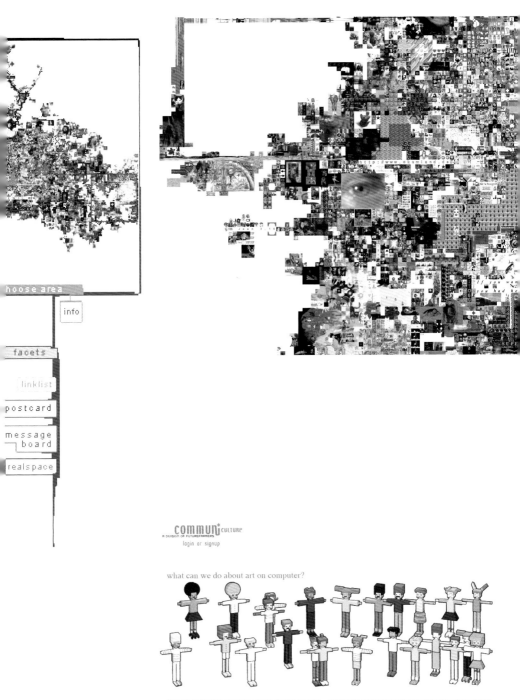

hoose area

info

facets

linklist

postcard

message
board

realspace

COMMUNі*CULTURE
A DIVISION OF FUTUREFARMERS
login or signup

what can we do about art on computer?

◄◄◄◄◄◄◄◄◄◄◄◄◄◄◄◄◄◄◄ ►►►►►►►►►►►►►►►►►►►►►►►►►►
visit the persons website who made this continuum

those made by other participants. The links of *Nine(9)* maps are accompanied by automatically generated emails that aim to create connections between users; at the same time, Perl scripts search out other shared features across maps. Named after the difference in years between female life expectancies in Jamaica and Sweden, the project was developed in reaction to another social imbalance: most graphics and media production software, such as Director or Photoshop, are designed almost exclusively for experts. Like *communimage*, the project is somewhat crowded and disorientating to the eye: since users have published medleys of snapshots and other media, *Nine(9)* has the tempo, scale and visual diversity of a scrolling view of a city street or crowded park. That all its borders meet, and not one knowledge map takes precedence over another, puts a political aesthetic of equality at the centre of the work. And like all the software works previously discussed, *Nine(9)* suggests that the community of the internet can and should be democratized by expanding the ranks of who can use it, and how.

The Crash of 2000
By 2000, an emergence of a number of books and academic courses on net culture and related subjects indicated that online art forms were considered an instructive and vigorous intellectual force. The increase in international museum and festival commitments to online art, the ongoing support from media centres, and the formation of new forums in South Asia and South America registered widespread recognition and relevance. Many curators eagerly took on internet-based work and found ways to execute exhibitions in educational contexts and a slew of smaller venues, such as Eyebeam in New York, the C-Level in Los Angeles and Cornerhouse in Manchester, England. Museums and galleries also sought to keep up, their staff struggling to deal with the technical issues related to curating, hosting, displaying and archiving internet art, even as many of their work routines were becoming dependent on tools like email and web servers. By 2000, it had become more customary to peruse the photographs or documentation of an artist via his or her web site, but the prospect of maintaining emulators needed to preserve software from the mid-1990s was a much more specialized, expensive and technical enterprise.

At the same time, however, net art suffered palpable losses in prestige and funding alike. The collapse of the American stock market in spring 2000, after years of prosperity driven by information technology (since 1995, more than a third of American

Opposite above:
143 **Mongrel**, *Nine(9)*, 2003. This collaborative software project enables nine groups or individuals to share texts, images and sound and explore the social make-up of their communities through so-called 'maps'. Tracking word frequency in order to represent the content of archives and find links between users, *Nine(9)* is able to accommodate 729 knowledge maps in total (nine groups, each containing nine archives, with nine maps per archive).

Opposite below:
144 **Mongrel**, two images from *Nine(9)*, 2003. The images on the left and right are taken from the maps 'Killing Snails' and 'No Camping' respectively.

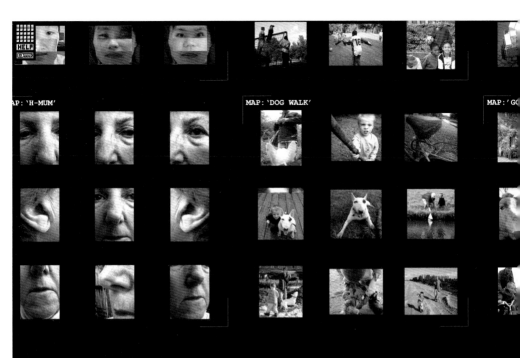

economic growth had resulted from information technology enterprises), brought with it a sense of cynicism about the internet. The market's breakdown led to major cutbacks in endowments in the United States and resulted in a more conservative climate in museums and funding sources nationally (these would only be exacerbated by the Republican policies in subsequent years). Unlike television and film, which shared a more consistent trajectory of success as forms of mass media, the net was tainted by economic failure, demystified hype and market-less ideas. As internet-related businesses shut down in waves, 'gold rush' days were proclaimed over and 'paper millionaires' (those whose wealth relied on unrealistic company valuations, stock options or securities) were dismissed as greedy and opportunistic entrepreneurs. Television news specials seemed to match critical assessments of net art when they pronounced the internet 'dead'.

In the first few years of the twenty-first century, these deaths would become manifest as the earliest notions of the autonomy and distinctiveness of the internet began to weaken and fade, and net art practices moved closer to other cultural fields such as tactical media, free software and film (i.e. rich media formats, such as animation and video). In the hands of artists, the net would often approximate a black market, suggesting a panoply of responses to the legacy of the dotcoms and net.art.

145 **Harwood/Mongrel**, *Uncomfortable Proximity*, 2000. In one of the first commissions of the Tate's net art initiative, Tate Online, Harwood copied large sections of the real Tate web site, incorporating text and images that dramatized the exclusivity and myopia of the 'British social elite' who have historically controlled and used the museum. Text on the site reads: 'The construction of the collection…is a construction of the British social imagination…an example of economic power organising itself around the politics of the aesthetic.'

146 **Wolfgang Staehle**,
Untitled, 2001

Chapter 4 Art for Networks

Voyeurism, Surveillance and Borders

Telepresence, surveillance, voyeurism and live broadcast were motifs of Wolfgang Staehle's installation at Postmasters Gallery in September 2001. Staehle had hooked up three video cameras to film a castle in Bavaria, the TV Tower in Berlin and the skyline of Lower Manhattan, creating lyrical, idyllic, still images that seemed liberated from time and daily life, even as they were refreshed every four seconds. These three video streams were transmitted via the internet for broadcast onto the gallery walls, constituting an ongoing pictorial meditation on media voyeurism. On 11 September 2001, when it documented the terrorist attacks on Lower Manhattan, the installation suddenly became a clear, if unintentional, articulation of the role mass media images could potentially take on. Originally titled *To the People of New York* and now known as *Untitled* [146], the work (inadvertently) doubled as journalism and shared qualities ascribed to that genre (instantaneous, mediated), an uncanny combination of art and life intensified by the decision of Magda Sawon (Staehle's dealer) and the artist to let the streams continue to document each stage of the tragedy and its aftermath until the show closed in October. As Staehle told *Artforum*, his 'landscape painting became a history painting'.

This combination of real world events and online surveillance mechanisms should not be taken as relevant or singular only in light of tragic, public occasions, such as the events of 11 September. But the attacks on New York City and Washington DC did usher in an era in which surveillance, controlled media environments and individual freedoms became heightened topics for debate. While many artists had struggled with the autonomy and privacy of internet spaces during the 1990s, as countries responded to the US-led post-11 September 'War on Terror' by

147 **Jonah Brucker-Cohen** and **RSG**, *PoliceState*, from *Carnivore*, 2003. In the *PoliceState* client by Brucker-Cohen (using Radical Software Group's *Carnivore* software), information about US terrorism activates radio-controlled police cars. This project is based on FBI surveillance software, which is used to monitor network traffic for terrorist activitities.

148 **Yucef Merhi**, *Maximum Security*, 2002. Venezuelan-born Merhi has been hacking into the email account of Venezuelan President Hugo Chávez since 1998, installing the intercepted messages as wallpaper.

passing more stringent surveillance and dataveillance laws, security and privacy re-emerged in cultural spheres as salient issues. The specialization of governmental surveillance technologies is parodied in a work by the international collective Radical Software Group (RSG) called *Carnivore* (2001–present). There are two parts to *Carnivore*: the first, the Carnivore Server, monitors internet traffic (email, instant messaging, web surfing, etc.) in a specific local network and provides the data results; the second is made up of client applications by other artists who visualize the data, such as Jonah Brucker-Cohen [147] with *PoliceState*. Inspired by the FBI dataveillance software DCS1000 (nicknamed Carnivore), *Carnivore* is explained by new media art curator Benjamin Weil as demonstrating 'how difficult and arbitrary the fielding and representation of information can be, thus making a derisive comment on the official endeavor to monitor information exchanges'. Like other works in the data-visualization mode, *Carnivore* software suggests that there is no necessary congruence between information and its interpretation.

In 1997, Slovenian artist Marko Peljhan (b. 1969) debuted his research station *Makrolab* at 'Documenta X' in Kassel. He has since brought the structure to a number of nations, including Scotland and Australia, and plans to end up in Antarctica by 2007. A travelling lab for telecommunications and natural phenomena

149 Alex Jarrett, *Confluence*, 1996–present. The medialization of every inch of the globe, *de rigueur* in the satellite age, finds a homespun corollary in this collective effort to photograph every latitude and longitude degree intersection. The work pivots on an issue crucial to assessing the role of the internet in our media-saturated lives – namely, the relation between a person and the documentation of his or her actions.

research, *Makrolab* hosts artists, scientists and tactical media workers whose projects focus on the abstract and intangible qualities of digital and satellite culture, including radio waves, atmospheric properties and the electromagnetic spectrum. Peljhan contends that these are the invisible but actual materials of global social and political mechanisms, and that following these fields requires specialized knowledge and research. The roaming research station and its expansive body of data on the workings of invisible spectra, stored and conveyed on its globally accessible web site, accord this project boundaryless status. The dispersal of *Makrolab* findings marks a new dimension of specialized artistic activity and stands as a small-scale and pervious analogue of forms of governmental and military research and surveillance.

150 **tsunamii.net** (**Charles Lim Yi Yong** and **Woon Tien Wei**), *alpha 3.3* (detail of the walk), 2001. This project, which preceded *alpha 3.4*, charted a walk from Singapore to Malaysia.

Peljhan's long-term research on borderless systems such as radio waves and the electromagnetic spectrum has coincided with explorations of other borders using the net as a basis or point of comparison. Tsunamii.net [150], a duo made up of Singaporean-born artists Charles Lim Yi Yong (b. 1973) and Woon Tien Wei (b. 1975), explores boundaries between internet space and geographical organization, mapping their divergences into a narrative. For *alpha 3.4* (2002), created for 'Documenta XI', the duo used a Global Positioning System, or GPS (a system supported by a range of military, commercial and consumer

151 **James Buckhouse**, *Tap*, 2002. *Tap*, which is downloadable onto Palm Pilots, enables users to strengthen the dance skills of animated characters – by making them practise certain dance moves, for example. Users can choreograph dances, watch the finished performance on their Palm Pilots or send sequences to other people. Far from devotion to the web or email as formats, the uses of the net envisioned by artists like Buckhouse are local, enabling creative social interactions that take technology as a point of departure.

152 **Heath Bunting**,
from *BorderXing*, 2002

applications that determines an individual's or object's time, location and velocity based on radio waves). As they walked from Kiel (the location of the web server of 'Documenta') to Kassel (the physical location of the 'Documenta' show) in Germany, the GPS and a mobile phone registered their changed locations on a web site installed in the 'Documenta' space in Kassel. An earlier work, *alpha 3.0*, consisted of a web walk-about in a housing estate in Singapore. There, a GPS triggered various web sites to load according to the walker's particular position. In an ongoing performance series called *34 NORTH 118 WEST*, the artists and performers use GPS as the prerequisite for a theatrical show-cum-local exploration of a Los Angeles neighbourhood. Like earlier web-based travelogues, tsunamii.net's work addresses the net as an index of location, comparing its ability to confer location with the actual activity of walking through various territories. *34 NORTH 118 WEST* is explicit in its exploration of physical landscapes via computer tablets and satellite technologies.

Heath Bunting questioned the relevance of international borders in *BorderXing* [152], commissioned by Tate Modern in Britain in 2002. In a stunning inversion of the traditional

assumption that web sites are open and democratic forms, Bunting restricts access to *BorderXing* (an easy technical feat, but highly unusual for net art sites) according to certain criteria: visitors from public venues such as universities and cyber-cafés were admitted, as well as inhabitants of entire nations whose people are marginalized (such as Afghanistan and Iraq). Bunting's access policy showed bias against private consumption by users outside social spaces or oppressed political contexts. On the web site, the artist has documented his routes and strategies for crossing about twenty international borders. The travelogue includes a helpful web-based tool for plotting the easiest way from one point to another, and offers suggestions on how to execute a journey, avoid guard dogs at borders, jump trains and traverse freight tunnels; it also demystifies international boundaries by pointing out various geographical realities (e.g. 'the border is just a shallow stream, easy to cross'). While there are many supposed liberties associated with the consumption of the internet and its various communication devices, in *BorderXing* the net becomes inseparable from national boundaries and borders.

let's warchalk..!

Print out this card - it should fit in your wallet as it is based on a standard business card size. When you find a wireless access node in your town, then leave a chalk symbol for others to find.

Please let me know if you have suggestions or changes to the warchalking symbol language, have an alternative version you have made or pictures of warchalking you've come across to
warchalking@blackbeltjones.com
[send URLs of pictures and symbol design please]

let's warchalk..!		notes
KEY	SYMBOL	
OPEN NODE	ssid)(bandwidth	
CLOSED NODE	ssid O	
WEP NODE	ssid access contact (W) bandwidth	
blackbeltjones.com/warchalking		blackbeltjones.com/warchalking

153 **warchalking.org**, *Warchalking Pocket Card*, 2001–present. A practical folk art sprung from internet culture, 'warchalking' is a D.I.Y. international movement that identifies wireless access zones using elaborate visual symbols derived from hobo communiqués of the Great Depression. Markers on walls, sidewalks or storefronts specify the kind of access provided as a means of providing more open gates to telecommunications. Illustrated here is a pocket-reference of warchalking icons, designed to be downloaded, printed and used.

24.6.2002 warchalking pocketcard v0.9
version history
draft version - looking for comments and suggestions - MJ

Above:
154 **Bureau d'Etudes**,
Lagardère, Chroniques de guerre,
2003

Right:
155 **Yuri Gitman** and
Carlos Gomez de Llarena,
Noderunner, 2002. *Noderunner* is
a team-based wireless game that
transforms a city into a playing
board. Against the clock, players
must log into as many nodes as
possible, uploading photographic
proof of their location as they go.

Wireless

In 2001, the use of wireless networks as access points for computers to connect to the net began to increase. Relying on high-frequency radio waves to communicate between nodes, wireless networks are another step in the domestication of computers: from massive devices that filled entire rooms and required enormous amounts of electrical power to portable machines that fit in a bag and operate without much equipment. Wireless networks can be private or public, and for artists they have become an organizing principle for collective action, since they open up net access to more users and thus impact the corporate hegemonies that currently control internet access. Secondary waves of collaborators have taken up initiatives to demarcate free wireless zones and target technological know-how into community initiatives. One visual-based offshoot of the free wireless movement is the practice of 'warchalking' [153]: practioners mark buildings with elaborate 'warchalking' symbols to indicate free access points or, as *Consume.net*'s James Stevens calls

ꟽVC®PRODUCTS

You can order any of this products for free (one at the time), just send us an e-mail with the name of the product and your postal address.

them, 'wireless clouds'. Stevens, who founded Backspace, an open-media lab in London that hosted many important net art events until its closure in 1999, set up Consume.net in 2000 as a tool kit and resource for various British wireless community projects.

Most technologized cities have wireless community initiatives. In New York, the technoart museum Eyebeam organized a series of events in August 2002 to generate a new kind of map of the city. Artists and participants from NYC Wireless, The Institute for Applied Autonomy, Sumant Jayakrishnan and the Surveillance Camera Players collaborated on a colourful, textured map of Manhattan that included wireless nodes and surveillance points. The power of media access to direct new considerations of physical spaces and diagrams was manifest in the Eyebeam program, as well as in *BorderXing*, *Consume.net* and 'warchalking' initiatives. Contextual maps of borders, 'wireless clouds' and other kinds of networks form three recent European collaboratives: The University of Openness, Bureau d'Etudes [154] and *Mapping Contemporary Capitalism*. The University of Openness, a 'self-institution for independent research, collaboration and learning' operates a Faculty of Cartography that advances experimental map-making through research and events. Bureau d'Etudes is a French artists' group that uses a larger association of media artists known as the Tangential University to distribute its maps, including charts entitled *Media Skills*, *European Norms*, *MONOTHEISM, Inc.* and *Lagardère, Chroniques de guerre*. Topics of these 'maps' include EU bureaucracy, networks and government. A dense black-and-white, downloadable map with blurbs of data and icons, *MONOTHEISM, Inc.* (2003) documents relationships between various financial powerhouses (both individual and corporate), and world religions. *Lagardère, Chroniques de guerre* (2003) [154] visualizes the power networks of media company Lagardère through graphic files. Bureau d'Etudes' visualizations suggest that networks of power are permeable, as well as being open to interpretation and inquiry. *Mapping Contemporary Capitalism* is a London-based, long-term, open-source project aimed at 'creating a tool for collaborative mapping of power relations'.

As British critics Brian Holmes and Howard Slater have noted, the refusal of specialized art zones and the use of ephemera have extensive art-historical roots. Those behind *Mapping Contemporary Capitalism*, The University of Openness and Bureau d'Etudes are indebted to practices such as land art, mail art and Happenings, all of which expanded the fields and materials of art-making. Indeed, the contemporary proliferation of experimental mapping can be

156 **Minerva Cuevas**, *Mejor Vida Corporation*, 1999. One e-commerce-related project took to reversing the basic standards of corporate aesthetics. MVC, operated out of Mexico City by Mexican artist Minerva Cuevas, gave away free products designed to improve quality of life and assumed full accountability for its practices.

seen as a convergence of several factors: an interest in engaging particular institutions and phenomena; the development of sophisticated data-processing tools that make these engagements possible; a trajectory away from the internet medium as a focus, towards tactics; and a desire to create representations that can shape and visualize emergent collectivities and territories, since, as Jean Baudrillard suggested, 'the map precedes the territory'. Brian Holmes writes that the maps of Bureau d'Etudes 'aspire to be cognitive tools, distributing as broadly as possible the kind of specialized information that was formerly confined to technical publications. Yet on another level they are meant to act as subjective shocks, energy potentials, informing the protest-performances as they are passed from hand to hand, deepening the resolve to resist as they are utilized in common or alone. In this sense it is the very closure of their intellectual discipline, the rigour of their conceptual effort to depict a totally administered world that makes them *maps for the outside*, signs pointing to a territory that cannot yet be fully signified, and that will never be represented in the traditional ways.' These alternative universities and cartography experiments are artworks positioned on a kind of borderline – in terms of genre – between self-education and data processing, or research and tactical media.

157 **John D. Freyer**, *All My Life for Sale*, 2001

Opposite:
158 **AKSHUN** (artists' group), *73,440 Minutes Of Fame Available Now On eBay*, 1999. A complex nod to Warholian notions of fame, democracy and commodification, a group of artists studying at Cal Arts auctioned its allotted gallery time on eBay. A dissident group from North Korea hoped to win the bidding, but American trade law forbade a transaction, and the students chose not to take the case to court.

E-commerce

In the course of this book we have encountered different artistic practices addressing and intervening in the commercialization and commodification of internet space. The previous section surveyed practices using the net to contest dimensions of physical property, organizations, land and airwaves. One strategy involved the adoption of corporate structures, legal status or 'official' business interfaces, as in the work of ®TMark and etoy, or the Bureau of Inverse Technology. Concurrent with these corporate activities,

159 **Michael Mandiberg**,
Shop Mandiberg, 2000–1

Description

This heirloom has been in the possession of the seller for twenty-eight years. Mr. Obadike's Blackness has been used primarily in the United States and its functionality outside of the US cannot be guaranteed. Buyer will receive a certificate of authenticity. Benefits and Warnings Benefits: 1. This Blackness may be used for creating black art. 2. This Blackness may be used for writing critical essays or scholarship about other blacks. 3. This Blackness may be used for making jokes about black people and/or laughing at black humor comfortably. (Option#3 may overlap with option#2) 4. This Blackness may be used for accessing some affirmative action benefits. (Limited time offer. May already be prohibited in some areas.) 5. This Blackness may be used for dating a black person without fear of public scrutiny. 6. This Blackness may be used for gaining access to exclusive, "high risk" neighborhoods. 7. This Blackness may be used for securing the right to use the terms 'sista', 'brotha', or 'nigga' in reference to black people. (Be sure to have certificate of authenticity on hand when using option 7). 8. This Blackness may be used for instilling fear. 9. This Blackness may be used to augment the blackness of those already black, especially for purposes of playing 'blacker-than-thou'. 10. This Blackness may be used by blacks as a spare (in case your original Blackness is whupped off you.) Warnings: 1. The Seller does not recommend that this Blackness be used during legal proceedings of any sort. 2. The Seller does not recommend that this Blackness be used while seeking employment. 3. The Seller does not recommend that this Blackness be used in the process of making or selling 'serious' art. 4. The Seller does not recommend that this Blackness be used while shopping or writing a personal check. 5. The Seller does not recommend that this Blackness be used while making intellectual claims. 6. The Seller does not recommend that this Blackness be used while voting in the United States or Florida. 7. The Seller does not recommend that this Blackness be used while demanding fairness. 8. The Seller does not recommend that this Blackness be used while demanding. 9. The Seller does not recommend that this Blackness be used in Hollywood. 10. The Seller does not recommend that this Blackness be used by whites looking for a wild weekend. ©Keith Townsend Obadike ###

Internet zone

160 **Keith Obadike**,
Blackness for Sale, 2001

artists also sought to unsettle the processes of more traditional consumption, namely buying and selling. 'E-commerce', the nickname for electronic commerce, includes modes of conducting business online, like purchasing products with digital cash, through auction platforms such as eBay and via electronic data interchanges.

Many works in this genre imply that identities are structured in relation to the ways they can be objectified or commodified. These projects, with their arresting titles – *Shop Mandiberg* (2000–1) [159] by Michael Mandiberg, *All My Life for Sale* (2001) [157] by John D. Freyer, Keith Obadike's *Blackness for Sale* (2001) [160], Michael Daines's *The Body of Michael Daines* (2000) and Damali Ayo's *rent-a-negro.com* (2003) – are deliberate allusions to the all-inclusive properties of the online marketplace. Mandiberg is one among thousands to sell his old socks on the internet; his presentation of his possessions as a boutique is aimed at developing brand recognition beyond his own status as an emerging artist. Engaging race and commodification, Keith Obadike put his blackness up for sale, drawing attention to widescale ethnicity-based marketing and valuations. For sale on eBay for less than a week before being removed by the management as a violation of vending policy, Obadike's blackness was set in the Collectibles/Culture/Black Americana section amidst various figurines, records and old slave tags offered by

161 Millie Niss, *Self-help*, 2002. This advert endorses James Joyce's *Finnegan's Wake* as therapeutic and comments on the proliferation of web advertisements for pharmaceuticals. It is taken from *Bannerart*, a project in which artists observe the specifications of standardized web advertisements in order to encourage critical readings of advertising and cross-pollination along commercial and artistic lines.

other vendors. Obadike (b. 1973) catalogues himself in the roots of African-American history and inventories the aspects of his blackness that may or may not have value in the marketplace: 'This Blackness may be used for creating "black art", gaining access to exclusive, "high risk" neighbourhoods' and 'accessing some affirmative action benefits' (the latter with the qualifier, 'Limited time offer. May already be prohibited in some areas'). In the eBay field, where vendors can describe the condition of their wares, called 'Warnings', Obadike cautioned: '1. The Seller does not recommend that this Blackness be used during legal proceedings of any sort. 2. The Seller does not recommend that this Blackness be used while seeking employment. 3. The Seller does not recommend that this Blackness be used in the process of making or selling "serious" art. 4. The Seller does not recommend that this Blackness be used while shopping or writing a personal check….' Identifying and commodifying these racialized aspects into both active concepts and sterilized commodities, Obadike's work explores the subjugation of African-American identity by historic and social conventions that themselves seem the basis for forms of economic exchange.

Similarly, American artist Damali Ayo (b. 1972) launched *rent-a-negro.com* in 2003, in which racially objectified and stereotyped roles are offered as services. The project's FAQ explains:

As we all know, the purchase of African Americans was outlawed many years ago. As times have changed the need for black people in your life has changed but not diminished. The presence of black people in your

life can advance business and social reputation.These days those who claim black friends and colleagues are on the cutting edge of social and political trends. As our country strives to incorporate the faces of African Americans, you have to keep up. rent-a-negro offers you the chance to capitalize on your connection with a black person. At any gathering our service can bring a freshness and tension that will keep things lively. This adds currency to your image and events.We all go out for ethnic food every once in a while, why not bring some new flavor to your home or office…for all your friends and colleagues to enjoy!

In this work, as in Obadike's *Blackness for Sale*, stereotypes and economic containers are deployed against a backdrop of artistic agency. The liberatory potential of these works resides in the dramatization of stereotypes brought to bear on African-American lives and, as both address their audience as expert consumers of goods and services, the freedom to sell. Indeed, the two projects also function to foreground a dominant contemporary activity facilitated by the web: shopping. Rather than eschewing the art marketplace, or more generally the shopping public, these works invoke the codes of marketing language as subsets of the common vernacular.

In *Dot-Store* (2002) [162] Thomson & Craighead develop a range of ready-to-sell objects that drive a wedge between historic marketing of the web and its emotional and social content. Tea

162 **Thomson & Craighead,**
Dot-Store, 2002

towels, emblazoned with the diverse and highly personal results from a Google search for the phrase 'help me', construct a complicated and psychological identification between consumers and the things they buy. The adoption of a lifestyle, as critic David Joselit describes it, is a 'mode of positioning oneself socio-economically…the preference for and the capacity to buy certain products…the adoption of a wholesale identity'. Here, the 'dotcom' or 'nethead' lifestyle is alluded to in items like the lenticular badges derived from common cursor animations. The colonization of natural spaces by new technologies is emblematized in CDs designed to be played near domestic or wild birds: on them, a collection of mobile phone ringtones.

Forms of Sharing

In a recent curatorial selection of web sites for online platform low-fi.org.uk, German critic Armin Medosch, the founder of *Telepolis*, prefaced his grouping of artworks by noting: 'In a networked environment it is not so much individuality and expression that count but increasingly new ways of creating, sharing, disseminating and scheduling digital work. Through

163 **Sebastian Luetgert**, *textz.com*, 2002

collective action the field progresses as a whole. Sharing and collaborating means learning from each other.' Many internet artworks take sharing as their premise, including *Life_Sharing*, *Frequency Clock* and some of the wireless-related projects previously discussed. These exist in dialogue with a slew of file-sharing or 'p2p' (peer to peer) applications that enable creative activity as well as the proliferation of media files such as music in MP3 format, which have given rise to fiercely contested debates about what constitutes property and which activities require permission within the channels of the net.

The net vernacular term 'warez' is defined by the online resource Webopedia as follows: 'Commercial software that has been pirated and made available to the public via a BBS or the internet. Typically, the pirate has figured out a way to de-activate the copy-protection or registration scheme used by the software. Note that the use and distribution of warez software is illegal. In contrast, shareware and freeware may be freely copied and distributed....' A riff on this paradigm is *textz.com* (2002) [163], an open archive of sometimes closed works of authorship. Curated by German artist and activist Sebastian Luetgert (b. 1969), the texts in the database include works by Charles Baudelaire (1821–67), Georges Bataille (1897–1962), Theodor W. Adorno (1903–69) and more technology-orientated authors such as Geert Lovink, McKenzie Wark and the Critical Art Ensemble. The warez on this site invokes a broad and progressive intellectual history, positioning itself as an analogue of software tools. Luetgert writes in an introduction to the site: 'There was a time when content was king, but we have seen his head rolling. Our week beats their year. Ever since we have been moving from content to discontent, collecting scripts and viruses, writing programs and bots [computer programs that run automatically], dealing with textz as warez, as executables – something that is able to change your life.' If texts like Baudelaire's *Les fleurs du mal* can take on the character of artefacts or inert objects sitting on bookshelves, here they are reinscribed with some of their radical potential by being positioned as critical software.

Music sharing, which has been blamed for a drop in record sales over the past few years, has led to increased assaults on peer-to-peer networks and file-sharing applications by entertainment associations defending 'proprietary intellectual property'. While the details of what constitutes fair use online remain murky, freeware and underground projects have innovated their engineering and legal structures in order to preserve

autonomous spaces for unrestricted activities that do not require participants to seek permission from media companies. Many artists who are deeply opposed to stringent forms of digital property control have responded accordingly. A sample of these works was assembled for the 'Kingdom of Piracy' exhibition (2001–3), curated by Armin Medosch, Shu Lea Cheang and Yukiko Shikata. Defence mechanisms protecting the digital commons are elaborate and varied. IPNIC's *Injunction Generator* automates the issue of legal injunctions that can freeze ISP services. *Burn* (2003) [164], a work developed in response to the anti-piracy laws in Asia and the abundance of copy-and-burn facilities in Bangkok, consists of an installation and web site; the latter offers an overview of China's shift in policy towards pirating based on its entry into the World Trade Organization. The lively, graphic browser-based upload and download/sharing space encodes MP3 files in assorted colours according to user selections. Created by Shu Lea Cheang, British design company yippieyeah and programmer Roger Sennert (b. 1975), *Burn* has a decorative and appealing interface that suggests a creatively defiant relationship between piracy and mixing: on one page the user sees images of officials destroying CDs; the next page invites the viewer to assemble and colour code music playlists. 'Kingdom of Piracy', which exhibits, according to its curators, 'artistic acts of "piracy" as a strategy for intellectual discourse and poetic intervention, but not as any endorsement of piracy as a business model', carries implications for the role of

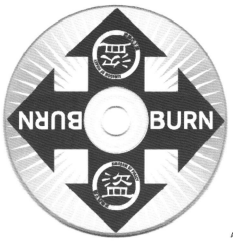

ABOUT

164 **Shu Lea Cheang**, **yippieyeah Design** and **Roger Sennert**, *Burn*, 2003

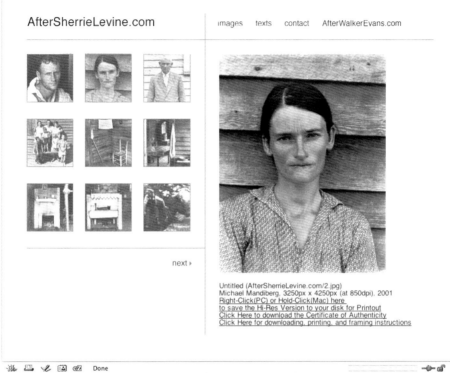

Back Forward Reload Stop http://www.aftersherrielevine.com/images2.html

AfterSherrieLevine.com images texts contact AfterWalkerEvans.com

next ›

Untitled (AfterSherrieLevine.com/2.jpg)
Michael Mandiberg, 3250px x 4250px (at 850dpi), 2001
Right-Click(PC) or Hold-Click(Mac) here
to save the Hi-Res Version to your disk for Printout
Click Here to download the Certificate of Authenticity
Click Here for downloading, printing, and framing instructions

Done

165 **Michael Mandiberg**, *AfterSherrieLevine.com*, 2001. Mandiberg's work, which also included a sister site, *AfterWalkerEvans.com*, features high-resolution images from Sherrie Levine's oeuvre. The famous appropriations of Walker Evans's photography by Levine are downloadable as Mandiberg's along with 'Certificates of Authenticity'. The title *AfterSherrieLevine.com* refers not only to Levine's famous title of her own, *After Walker Evans*, but also to an often hermetic and insider field of conceptual art now exposed to internet culture.

the artist working with new technologies. The active contestation of ownership and the establishment of open systems of exchange, pursuits that have countless complements in art of recent decades, sometimes become illegal modes of critique within the internet context of software and functional applications.

Video and Filmic Discourses

A 2003 feature for the magazine *Game Girl Advance* compared the properties of the video game Donkey Kong to Matthew Barney's *Cremaster 3*. Author Wayne Bremser argued, sometimes in a tongue-in-cheek manner, that while 'painters have created canvases with game characters…*Cremaster 3* lacks the obvious cultural references, but its absurdity, repetition, level design and use of landscape as narrative establishes a stronger connection to video games than [previous] other works'. The essay lays out parallels involving the way 'Barney and game designers look for

strong visual landscapes that are ripe for a character's running, jumping, smashing and climbing', and Donkey Kong's setting is compared to the Guggenheim Museum or Chrysler buildings in New York City that appear in the *Cremaster* cycle – redolent with themes of hubris, bodily limits and ascension. While the proposed similarities between Donkey Kong and Barney's works may not hold with many viewers (or players), recent artworks have successfully considered video and film in dialogue with digital aesthetics such as algorithms, Photoshop, games and databases. Jon Haddock's computer game drawings, Sue de Beer's (b. 1973) 1997 video tribute to Photoshop, *Making Out With Myself*, and Jennifer and Kevin McCoy's (b. 1967) *Every Shot Every Episode*, which uses database fields to organize *Starsky and Hutch* episodes into three hundred categories such as 'Every Establishing Shot', 'Every Red' or 'Every Stunt' are exemplary in this regard.

In the 2002–3 exhibition 'Future Cinema', curated by Jeffrey Shaw and Peter Weibel at the ZKM in Karlsruhe, Germany, installation- and DVD-based works presented new conditions of narrative and 'image languages' using GPS, virtual-reality technologies and interactive software. The internet is home to many works that diversify and innovate cinematic and televisual methods. For example, ASCII Art Ensemble's conversions of cinema classics like *Psycho* and *Blow Up* into ASCII compositions in 1999 replace filmic surfaces with alphanumeric ones more conducive to low-speed internet access and bandwidth constraints. By early 2003, more compact methods for creating and exhibiting time-based artwork existed, and a larger number of users had high-speed access to the net. Applications like Flash and After Effects allowed filmic experimentation to flower into lush, rich, dynamic projects.

Bcc (2001) [166] by Japanese-born artist Motomichi Nakamura is one example of this genre. It consists of four animations, executed in the artist's signature palette of red, grey, black and white; scored, dynamic and graphically arresting, all four works feature a deliberate flatness, referring figuratively to the artist's favourite historical aesthetics – Japanese *manga* (comic), Dutch graphic design of the 1920s and 1930s and Russian avant-garde posters. However historical some of its formal conventions may be, *Bcc*'s internal content is remarkably contemporary. The title refers to the acronym for 'blank carbon copy', a common email function that enables users to send a message to a recipient without his or her name or email address appearing in the message header. Most email clients include two fields labelled 'cc' and 'bcc'. The psychological

SYNOPSIS ■ CREDITS

and social factors of 'bcc' usage (it is commonly invoked to hide recipients from one another and to avoid circulating their email addresses) introduces the four narratives as emotionally wrought. Each darkly humorous story is in part technically themed: for example, one animation features a couple holding hands only to be separated by an adjudicative email list moderator, who recites the list's terms of usage verbally and in sign language. A short satire on netiquette (a play on 'etiquette'), the word describes internet deportment and manners perhaps, but Nakamura's execution also portrays delicate and intricate social opportunities colonized by technological aesthetics.

Rather than eschewing the often foggy resolution of webcams, New York-based artist Elka Krajewska (b. 1967) modifies and uses them to create works described on low-fi.org.uk as 'resembling pinhole films and microscopes in their intimacy, accuracy and abstraction'. Krajewska's titles often refer to their duration, expressing a relationship with minimalism and structuralist films. Her more recent works in colour, such as *54:06* (2003) and *47 Seconds* (2002) [168], use languages of medieval or Renaissance art while negotiating with natural topics like gravity and brumal observations of the sea. Overall, they give the impression of painterly experiments with colour and organic forms, while other artists have been more focused on delineating aspects of online cinema.

In the ongoing project called *Unmovie*, artists Axel Heide, onesandzeroes, Philip Pocock and Gregor Stehle remove standard filmmaking procedures altogether, using bots, web users, found

2002/02/08 1:00

167 **Victor Liu**, *Delter*, 2002.
Liu's *Delter* software isolates what
lies between the frames of MPEG
movies. By extracting and
rendering only inter-frame motion
vectors, the movie's central
narrative features are effaced,
leaving behind ghostly traces
of what was never meant to
be visualized.

Above:
168 **Elka Krajewska**, still from
47 Seconds, 2002

Below:
169 **Adrian Miles**, *Bergen Sky*,
2002

170 **Scott Pagano**, *Ephemeral Textures*, 2002–present. Via Pagano's custom application, selections from a database of sixty QuickTime movies are treated, combined and published online. The results: ten beautiful, collaged, abstract videos. Once these ten have played, the automatic production cycle begins again, overwriting previous images with new ones, lending a fleeting temporality to these delicate textural fragments.

footage and webcams to generate narratives and scripts. Adrian Miles's web site *VLOG* takes its name from 'blogging' – from web log, or blog, a widespread practice in which auteurs regularly update their web pages with publicly accessible confessional entries or explanations, in the form of text and images – with a diary comprised of video entries. Miles's 'Vogma manifesto' pronounces a respect for bandwidth, an aversion to straightforward streaming media which is akin to broadcast ('this is not television') and an interest in 'performative video and/or audio' and the exploration of 'the proximate distance of words and moving media'. Some of Miles's vogs create miniature monitors on one's computer laptop: in a 2002 piece called *Bergen Sky* [169], the desktop is transformed into a natural setting in which the QuickTime viewer takes the shape of clouds while the filmic content scans a peaceful sky. Others are more experimental in composition. *Desktop Doco*, a recent work, presents ten views of the artist's desk simultaneously, and viewers can click on another layer of media in which Miles explains his premise of experimenting with Deleuze and Guattari's notion of 'facility', or making his work out of the everyday.

The decidedly low-fi series *Zombie and Mummy* (2002–present) [173] showcases digital graphics over the high-resolution, slick capabilities of QuickTime. Commissioned by the Dia Center for the Arts in New York as part of their long-standing programme supporting internet projects, artist Olia Lialina and music producer and programmer Dragan Espenschied (b. 1975) scripted a number of capers for the two fantastical title monsters – from going swimming to making a family tree to attending the

171 Ricardo Miranda Zúñiga, *1000 Icons*, 2002. Even as many artists chose low-fi formal aesthetics in the early part of the decade, the contents of their work often occupied a grave point on the political spectrum. Zúñiga's colourful icons simultaneously allude to media-based representation and stand on their own as painful visualizations of world events.

172 Prema Murthy, *Mythic Hybrid*, 2002. Mimicking the structure of online searches, this project explores a group of women working in Indian microelectronics factories who reported having collective hallucinations. Search results like 'Health Effects on Shift Workers' are associated with QuickTime videos and interviews with the workers.

173 Screenshots from
Olia Lialina and
Dragan Espenschied's
Zombie and Mummy, 2002–present

'Future Cinema' exhibition at the ZKM. All are executed in colourful, witty, terse episodes, made in part from web debris (images, animations, backgrounds) and line drawings in the comic strip mode made with Palm Pilot applications, and feature original goofy music. The narrative series is more sophisticated than it initially appears: episodes can be downloaded onto Palm Pilots and, taken together, they accumulate a broad catalogue of internet aesthetic idioms, from 3D graphics to home page wallpapers and e-cards. Lialina and Espenschied are experienced programmers, but their use of clichéd, recycled or non-art debris testifies to a different skill – what the artists refer to in their introduction to the project as 'the art of surfing the web (and not just looking at what Google spits out)'.

Low-fi Aesthetics
The first few years of the twenty-first century have already witnessed considerable political and economic upheaval: financial destabilization, erosion of social programmes worldwide, rising incidence of global terrorism and wars in Iraq and Afghanistan. These conditions have in turn had a palpable impact on artistic and cultural circles. Though dissent and protest have taken many forms, some internet artists and curators initiated projects that demystify, domesticate and familiarize technologies, perhaps also as a way to resolve the real-world uses of military technologies being deployed in countries such as Iraq. In *Data Diaries* (2002) [175–176], a work by Cory Arcangel (b. 1978), the artist transgresses the sanctity of the hard drive by feeding its core memory archive into a QuickTime player. The results of the 'data conversion' are colourful exhortations of an application reading a file it should not, QuickTime files organized by day and month that the artist likens to 'watching your computer suffocate and yell at the same time'. The web-site design has a certain Bart Simpson mentality, with its hand-drawn graphics, cartoonish backgrounds and adolescent titles like 'love is needed for fat-bit status' and 'TOTALLY PSYCHED DATA!!!!!' The overall aesthetic is conceptually controlled programming-cum-thrift store aesthetics, evidencing a love for computer innards, old televisions and cosy, degraded visuals.

Most of Arcangel's work centres around a sense of play and challenging the regimen or usefulness of contemporary programming, in part by investigating the material that has been relegated to the status of marginal or obsolete by dominant discourse. One hack of outdated Super Mario Brothers games

174 **Lew Baldwin**, *Good World*, 2002. *Good World* visually domesticates the web by simplifying interfaces into minimal compositions, reinterpreting a web site's contents to create an entirely new abstract work. In a message posted on Rhizome.org, Baldwin explains: 'In reaction to the onslaught of media and advertising that has sunk web browsing to unimaginable levels…, *Good World* is a cleansing of sorts. An idealistic overture to the utopian vision… or possibly an unsettled dilution of the safe and familiar we've come to expect.'

cartridges, *Naptime* (2003), rewrote the narrative of the game to feature Mario fantasizing about attending raves, not saving the damsel in distress. Another removed the characters and sets of the games altogether, leaving only some animated clouds. Arcangel's projects often approach a totality like a theme park, with gleeful possibilities, kitsch factors and high entertainment values. *Beige*, the online home of Arcangel's collaborations with artists Joe Beuckman (b. 1978), Joseph Bonn (b. 1978) and Paul Davis (b. 1977), is a repository for various light-hearted multimedia projects. They yoke together pop cultural debris with hacking in clever and sometimes perversely weird ways: like the Photoshop modification that adds a 'Boo-Yaa Tribe Paintbrush' to the program's existing tool set (The Boo-Yaa Tribe was an early 1990s hip-hop ensemble), or the professional wrestling clips that loop as background animation with a tongue-in-cheek soundtrack (currently a version of hip-hop artist Jay-Z's hit of several years ago, 'Big Pimpin') as its score.

Learning to Love You More [179], a project by American artists Harrell Fletcher (b. 1967) and Miranda July (b. 1974) along with other collaborators, uses the web as a point from which to disseminate instructions for quirky projects: 'Recreate a scene from Laura Lark's life story', 'Make a child's outfit in an adult size', 'Record your own guided meditation'. Like event scores by Yoko Ono, La Monte Young or George Brecht, these works, as David Joselit notes, 'function as art by drawing attention to humble objects and simple, though often absurd, actions'. Participants who execute instructions submit documentation to the web site,

Above:
175 **Cory Arcangel**, still from
Data Diaries, 2002

Below:
176 **Cory Arcangel**,
Data Diaries, 2002

Opposite above:
177 **Paperrad**, *Homepage*, 2002.
Forgoing tougher formal or
conceptual notions in favour of
handmade, show-and-tell and
scrapbook aesthetics, Paperrad's
colourful compositions are
seemingly childlike. The
deployment of performance, offline
events, comics, and an excess of
pop culture and media debris point
to a form of artistic production
that is not overly encumbered by
art history, not limited by genre or
medium, and empowered by
consumer experience and
computer-geek know-how.

Opposite below:
178 **Paperrad**, *New sponsors'
page*, 2002

and the objects they produce, be they film, clothes, drawings or recordings, are also used in installations curated by Fletcher and July. The artists' roles as enablers of volks-artists and challengers of specialized aesthetics, are matched by a friendly email list and basic web site with unpretentious rubric: 'Hello', 'Assignments', 'Friends' and 'Love' are section names.

A genre of net art aesthetics nicknamed 'contagious media' took penetration as its priority: that is, how quickly and extensively a project could spread via the viral networks of email, web and instant messaging. Its credo, as noted by artist Jonah Peretti, is to 'make something that people want to share with their friends. If you do that successfully, you can reach a large audience through word of mouth. This creates new opportunities for art distribution and activism.' Peretti (b. 1974), an artist based in New York, coined the term 'contagious media' after an email correspondence with the sportswear company Nike regarding his

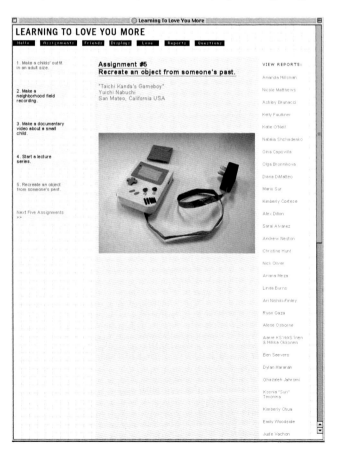

179 **Miranda July** and
Harrell Fletcher, *Learning to Love You More*, 2002

180 **Michael Weinkove**, *Talkaoke* table animation, 2002. *Talkaoke*, a web-cast, itinerant, temporary installation, exemplifies an engaging new form of low-fi interactive entertainment. The project, inspired in part by television talk shows, chat-room aesthetics and, of course, karaoke, encourages participation and conversation in social settings, and pits itself against the 'shut up and dance' mentality of clubs and bars.

181 **Jonah Peretti** and **Chelsea Peretti**, *Black People Love Us*, 2002

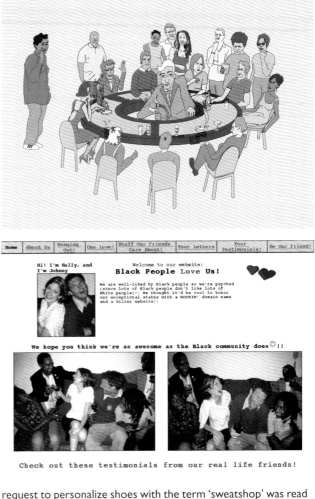

request to personalize shoes with the term 'sweatshop' was read by millions and covered by international news media. Describing the balancing act of concept, content, URL and design that constitute successful 'contagious media', Peretti explains that his works 'pay homage to hobbyist and amateur web design. So it is a sort of anti-design….' Peretti's most recent project, made in collaboration with his sister Chelsea Peretti and others, *Black People Love Us* (2002) [181], satirizes subtle forms of white racism by parodying a couple who think themselves politically progressive and emancipated. The wide reach of 'contagious media' – the Nike sweatshop email and *Black People Love Us* together drew more than fifteen million viewers – recalls experimental TV broadcasts of the 1970s in America and Germany. David Joselit talks about

Nam June Paik's work in this vein, noting: 'The public sphere is identified as the electronic stream of programming and advertising carried by television sets…. Paik modestly suggested that anyone who dares may intervene in the corporate economy of information if only by jamming its messages and transposing them as a different mode of communication founded in a different kind of eloquence.' Peretti's work resembles Paik's jamming of television in the scale of its audience, but unlike the video artist's experimental visuals, 'contagious media' projects 'pass' as normative even though they originate in a critical context. The deliberate obscuring of sophisticated formal arrangements or politicized rhetoric creates socially efficacious portraits of labour issues or subtleties of racism that are delineated in witty detail throughout the works.

'Art for Networks'
As internet artworks seemed to reflect the kind of mass media-focused sensibility of information networks, some exhibitions considered it as part of expanded fields of production. In 2002, the multiple format exhibition 'Art for Networks' show began to tour venues in the United Kingdom. While its premise – that artists, regardless of medium, are exploring and interacting with network structures of many kinds – may seem obvious, the exhibition's singularity is striking, pointing to a consistent segregation from other formats in the showcasing of internet-based art. Curator Simon Pope, who was one of the developers of *The Web Stalker*, included among other works Adam Chodzko's *Product Recall* [182] (about the invisible consumer network of wearers of a particular Vivienne Westwood jacket), Radioqualia's *Free Radio Linux* [183] (a transmission of a computerized reading of the code at the basis of open-software system Linux) and *Platfrom* [185] (Rachel Baker's mixture of travelogues and reports from the train networks between London and Paris). The obscuring of medium-based distinctions between projects was an efficacious strategy for highlighting the ubiquity of networks as a contemporary theme.

Many of the works in this chapter, such as Sebastian Luetgert's *textz.com*, the projects featured in the 'Kingdom of Piracy' exhibition and Jonah Peretti's 'contagious media', suggest an arc in the development of internet art away from interface or object towards tactics and strategies. Experiments with cinematic or televisual idioms have been another brick in the proverbial wall that makes the internet a platform of information, communication

PRODUCT RECALL
Vivienne Westwood *Worlds End* 'Clint Eastwood' Jacket

It has been discovered that this design was based on an early scheme for a memory jacket

All possessors of *Clint Eastwood* jackets (first produced 1984 then 1992) are urged to contact
Adam on 071 737 0651 for research and filming

182 **Adam Chodzko**, *Product Recall*, 1994. A work exploring the clothing network of a particular Vivienne Westwood jacket that, along with other projects in the 'Art for Networks' exhibition, suggests a more expansive understanding of network-based art.

183 **Radioqualia** (**Honor Harger** and **Adam Hyde**), *Free Radio Linux*, 2002–present. An online and on-air radio station distributing the Linux Kernel in the form of an audio reading, *Free Radio Linux* references open-radio networks and oral narrative traditions, as well as the systems of collaboration that constitute free software.

De Geuzen⁺ D.I.Y

instructional manuals for popular use and abuse

[] [Find!]

⦿ search www.geuzen.org ○ web search

please keep us posted
of your appropriations,
use and abuse

www.geuzen.org

Related Terms

- Open Source
- Self Organising Systems
- Hospitality
- Gift

* De Geuzen a foundation for multi-visual research more...

Welcome to De Geuzen D.I.Y.

These manuals offer a step by step guide to appropriating Geuzen tactics. All of these elements can be re configured and combined to create multi-faceted situations, events and happenings.

De Geuzen Research Accessories

So you want to research something but don't know where to begin. Start with our exclusively designed set of Research Accessories. Decorated in a delicate floral pattern, our collection of eight items will assist you in exploring just about anything in orderly yet stylish fashion. More...

BRAINS NOT BOMBS Because after all, our minds are stealth

More...

Geuzen Uniform #3: Do-It-Yourself Paper Dress

Make your own Geuzen Uniform

Easy Iron On Geuzennaam

Make your own graphic T-shirt and wear it with pride. More...

Basics for Making Your Own Uniform

More...

Geuzen Paper Dolls

Try out the Geuzen Uniform Collection with these charming paper dolls. More...

Proposal for Sending Analog Messages in a Wired World

Ever had a message that couldn't be sent by email? Here is a simple solution to getting your point across. More... View, print, publish and fly

AVAILABLE SOON:
D.I.Y. Chalkboard

184 **De Geuzen** (**Riek Sijbring**, **Renee Turner**, **Femke Snelting**), *D.I.Y.*, 2002. As file sharing and free software have become more historicized and institutionalized fields, De Geuzen expands their implications to reveal how many women's practices and social techniques have long made use of their constituent forms of sharing, self-organization, hospitality and gifts.

185 **Rachel Baker**, *Platfrom*, 2002. In this project exhibited in 'Art for Networks', the artist has devised a system that encourages train travellers to transform their usually asocial, private trips into material for stories and anecdotes they deliver via SMS. Mobile phones, which often feature internet or SMS tools, are just one popular device among many extending the grip of proprietary media channels into everyday life.

186 **Graham Harwood** and **Matthew Fuller**, *Text FM*, 2000–1. *Text FM* software makes use of networks (i.e. SMS and email) to create a local, open-media system. Users participate by sending a text message to a stated number. Received by a computer, which converts text to speech and reads it out, the message is then broadcast via radio.

about code context contact links supporters

Base de Datos para un Intercambio de Identidad

Внести *Buscar* Главная страница

Resultados de la búsqueda de la identidad

Geschlecht	female	Цвет кожи	white
Haarfarbe	brown	*Color de ojos*	brown
Национальность	english	Muttersprache	english
Duration of donated identity	permanently	Year of birth	1977
Peso (en kg)	55	Height (in cm)	173

21% 5% 0% 0% -1%

-1% -1% -2% -2% -2% -2%

-2% -2% -2% -2% -2% -2%

-2% -2% -2% -2% -2% -2%

-2% -2% -2% -2% -2% -2%

-2% -2% -2% -2% -3%

-3% -3% -3% -3% -3% -3%

and broadcasting. Coupled with its capacity for diverse users and feedback, the net is not just interface, music, video or poetics but all of them, even as it retains the scope and commercial components of a mass-culture phenomenon. Other projects, such as those relying on the auction context established by eBay, on an artist's knowledge of software development or on his or her use of corporate monikers, involve strategies that challenge conventional models of the artist's self and skills. The exploration of wireless, border and radio systems suggests a need to reimagine borders and territories, subject as they are to commercialization, medialization or policing.

In the 1990s, Heath Bunting had established a platform called Irational.org for works that were positioned across art, critical intervention and extemporized reflections upon various incursions into subjectivity (for, by example, commercial technology, borders and biotechnology). A work currently in development by Bunting, *The Status Project*, builds on the *IDENTITISWAPDATABASE* [187] made with Olia Lialina in 1999. Bunting, with Kayle Brandon, is developing a database through which individuals who feel themselves oppressively constricted by identifying data (such as age or nationality), can deploy net data and fragments for the purposes of consolidating or dissolving identities. Drawing from its database backend, *The Status Project* will consist of a web site that provides a critical path from junk-based identities, like those formed by supermarket loyalty cards or temporary online memberships, to other forms of status, such as being able to procure a passport. Similarly, those wanting to dissolve a legal identity can make use of what Bunting calls 'dataflage', a form of camouflage made up of internet debris.

This inquiry into what it means to be a person, legally, perceptually and linguistically, in which unstable data and functionality intermingle to form and deform identities, suggests, as do many of the works in this book, that the fledgling communication field of the internet, still less than twenty years old, is one in which strategies and tactics actually realize significant alternative cultures and fields of autonomy. Aside from commenting on dehumanizing and problematic aspects of internet and information culture, *The Status Project* implies that the opportunities made possible through these technologies, manifest here in the suspension of legal status, nationality, ethnicity and so on, create alternatives to more controlled fields of mass culture and can render the artist an enabler of change and influence.

187 **Olia Lialina** and **Heath Bunting**, *IDENTITISWAPDATABASE*, 1999. A multilingual database in which participants answer questions and upload (or download) images depending on whether they are sharing or looking for identities, this collaboration precedes the status-orientated project, *The Status Project*, currently underway by Bunting and Kayle Brandon.

Given the current pervasiveness of the internet, the historic rise of information media within the context of contemporary art is easily understood and can be considered fundamental. Net artists in particular play an important role in representing the paradigms of new media and its technologies, critiquing and vitalizing them. Since its earliest days, the field has borne interesting and compelling fruits that cross-pollinate between art, software, games, literature and activism. Beyond web sites, the free-software and software-culture genres of contemporary internet art offer alternative economic models and functionalities that can radically alter how we think, consume and behave in daily life. In addition, infowars and tactical media campaigns open up new opportunities, positioned on borderlines between art, politics, individual and collective action. It is difficult to turn one's attention away from a field in which so many diverse voices clamour and the most secret information is just a few clicks and hacks away.

188 **LAN**, *Tracenoizer*, 2001. Enlisting internet mechanisms to create false home pages and avatars is as old as the medium itself, and *Tracenoizer* and *IDENTITISWAPDATABASE* are two such tool sets that quickly produce web debris reflective and constructive of the user's identity. This is not a picture of me, but I built this faux home page effortlessly using LAN's automated identity tools.

Hi, thank you for visiting my Site
Rachel Greene Home

This site is about:

Timeline

Pre-Internet Art: Key Works, Events and Developments

Pre–1960s

1916 Emergence of the **Dada** movement in Zurich, which involves such influential artists as **Marcel Duchamp**

1926 **John Logie Baird** presents what is said to be the first demonstration of pure television

1945 **Vannevar Bush** imagines the Memex in a 1945 article entitled 'As We May Think', published in *Atlantic Monthly*

1946 **John Presper Eckert** and **John Mauchly** develop the first digital computer, the **ENIAC**, at the University of Pennsylvania

1951 Commercially available computers reach the market with the **UNIVAC**

1953 Colour television becomes available in the US

1959 **Allan Kaprow** comes up with the term **Happening** and his first public Happening, *18 Happenings in 6 Parts*, takes place

1960s

1961 **George Maciunas** coins the term 'Fluxus' for a group of artists including Allan Kaprow, Robert Watts, George Brecht and Yoko Ono

1963 *Participation TV* by **Nam June Paik**; *Gaussian Quadratic* by **Michael Noll** is among the first computer-generated images

1964 **Marshall McLuhan** publishes *Understanding Media*

1965 **Stan VanDerBeek**'s *Movie-Drome* is built; *Magnet TV* by **Nam June Paik**; **Theodor Nelson** reiterates Bush's ideas, coining the terms 'hypertext' and 'hypermedia'; **'Computer-Generated Pictures'** exhibition at the Howard Wise Gallery shows some of the earliest computer-generated images, including work by Michael Noll and Bela Julesz

1966 EAT formed by Bell Labs engineer **Billy Klüver**; **Nam June Paik** publishes 'Cybernated Art, Satellite Art'

1968 **'Cybernetic Serendipity'** exhibition takes place; **Valie Export** performs her *Touch Cinema*; **Douglas Engelbart** introduces the idea of bitmapping through a mouse

1969 The **ARPANET** is launched; artist collective, the **Raindance Corporation**, is formed; **'TV as a Creative Medium'** exhibition is held at the Howard Wise Gallery, including the works *Wipe Cycle* (**Gillette** and **Schneider**) and *Participation TV* (**Nam June Paik**); Jack Burnham's essay 'Real Time Systems' is published in *Artforum*

1970s

1970 **Radical Software** journal on art and video is launched; **'Software'** and **'Information'** exhibitions take place

1971 **Michael Shamberg** and **Raindance Corporation** publish *Guerrilla Television*, offering a blueprint for the decentralization of TV networks

1972 **Lawrence Alloway** publishes 'The Art World Described as a System'

1973 First **International Computer Art Festival**, The Kitchen, New York

1977 **Sherrie Rabinowitz** and **Kit Galloway**'s *Satellite Arts Project*; 'Documenta VI' holds the first live international satellite telecast by artists, including **Douglas Davis**, **Joseph Beuys** and **Nam June Paik**

1978 **Robert Wilson**'s video sketchbook *Video50*

1979 First **Ars Electronica festival** held in Linz, Austria

1980s

1981 The publication of **Jean Baudrillard**'s book *Simulacres et Simulation*; **IBM** releases its PC; *After Walker Evans* series by **Sherrie Levine**

1984 **Apple** introduces the Macintosh personal computer; *Electronic Café* by **Sherrie Rabinowitz** and **Kit Galloway** unites art, distribution and communication; **William Gibson** publishes *Neuromancer*, in which he coins the term 'cyberspace'

1985 Formation of the **Free Software Foundation**

1989 **Tim Berners-Lee** proposes a global hypertext project: the World Wide Web

1990s: The Emergence and Development of Internet Art

1991 **THE THING** begins as a BBS; **VNS Matrix** is formed and publishes the *Cyberfeminist Manifesto*

1993 First **Next 5 Minutes** conference is held in Amsterdam

1994 First web sites by net artists (including **Antonio Muntadas**, **Alexei Shulgin** and **Heath Bunting**) start to emerge; **äda'web** is founded

1995 **DIA Center** in New York commissions web projects by artists

1996 'Net.art Per Se' meeting in Trieste marks the use of the term 'net.art', coined by **Vuk Cosic**; **Rhizome.org** launched; **'Can You Digit?'** exhibition at Postmasters Gallery, New York; **Exposition NowHere**, Louisiana Museum of Modern Art

1997 **Marko Peljhan** debuts his research station *Makrolab* at 'Documenta X' in Kassel, which also holds the first Cyberfeminist International Meeting; **ZKM** opens in Karlsruhe, Germany; **'Beauty and the East'** conference held in Ljubljana, Slovenia; Microsoft's **Internet Explorer** is launched and, with it, the so-called 'browser wars' commence; **Geert Lovink** and **David Garcia** publish the 'ABC of Tactical Media' on Nettime

1998 The theme of the **Ars Electronica** festival is 'Infowar'; **Ricardo Dominguez** receives death threats for his Ars Electronica activist project *SWARM*; artist-orientated mailing list **7-11** founded; 'Relational Aesthetics' is published by **Nicholas Bourriaud**; the first International Browser Day takes place

1999 The volume of email exceeds that of standard mail for the first time; 'net_condition' exhibition at **ZKM** (Karlsruhe, Germany); a legal dispute between **etoy** and **eToys** leads to high-profile tactical media event *Toywar*

2000 Over thirty million registered web sites by the end of 2000, compared with just five million in 1998; collapse of the American stock market in spring 2000; **Tate** (Britain) commissions two internet artworks for its web site; **Tate Modern** opens

2001 MIT Press publishes *The Language of New Media* by **Lev Manovich**; **Vuk Cosic** represents Slovenia at the Venice Biennale; launch of new media centre **Sarai**; **Wolfgang Staehle**'s installation at Postmasters Gallery in September doubles as inadvertent journalism when it documents the terrorist attacks on Manhattan (originally called *To the People of New York* but now known as *Untitled*)

2002–3 Runme.org Software Art Repository founded; **'Kingdom of Piracy'** exhibition

Glossary

404 A common status code, indicating that a web page is no longer in that location and is 'not found' at that web address.

Algorithm A set of steps for solving a particular problem. Algorithms must have a clear stopping point and can be expressed in any language, from English or French to programming languages such as Perl.

ASCII (American Standard Code for Information Interchange) ASCII is a code for representing English characters as numbers, with each letter assigned a number from 0 to 127. Computers often use ASCII codes to represent text, which makes it possible to transfer data from one computer to another.

Avatar Derived from the Hindu religion, avatars in the computer context are graphical representations of real people in cyberspace.

BBS ('Bulletin Board System') Electronic message centres organized by topic, serving specific interest groups. Users review messages left by others and can leave their own messages.

Binary Computers are based on the binary numbering system, which consists of the two unique numbers: 0 and 1.

Bit 'Bit' is short for binary digit, the smallest unit of information on a machine. A single bit can hold only one of two values: 0 or 1. More meaningful information is obtained by combining consecutive bits into larger units.

Blog A noun and a verb, the term 'blog' is a contraction of 'web log' and is a web-based publicly accessible personal journal.

Clones Comparable to generic prescription medicines and their name brand counterparts, a clone is a computer or software product that functions exactly like another, better-known product. Generally the term refers to any personal computer not produced by one of the leading brand manufacturers (e.g. IBM and Compaq).

COBOL (Common Business Oriented Language) Developed in the late 1950s and early 1960s, COBOL is used widely in business applications that run on large computers. Although considered outdated and wordy by many programmers, COBOL remains the most widely used programming language in the world.

Crack To break into a computer system or unlock commercial software by dismantling its protective copyright and registration codes. Coined in the mid-1980s by hackers (expert programmers) to differentiate their practices

from breaking into secure systems or abusing information.

Crawler Also known as 'spider', a crawler is a program that automatically fetches web pages, following links to other pages in an ongoing cycle. Often used by search engines to retrieve web pages.

Cyberfeminism A term of identification (i.e. 'I am a cyberfeminist artist'), which generally includes three areas: the position of women in technological disciplines, women's experiences of technoculture; the gendering of various technologies.

Cyberspace Coined by William Gibson in the 1984 sci-fi novel *Neuromancer*, cyberspace describes the non-physical terrain created by computer systems.

Cyborg A term derived from 'cybernetics' and 'organism', coined by Manfred Clynes in 1960. The term initially referred to a human being with functions or appendages controlled by technological devices. Currently, 'cyborg' also connotes a cultural dependence on technology and, in the vernacular, someone who relies on a computer in his or her daily life.

DHTML (Dynamic HyperText Markup Language) Web content that changes dynamically each time it is viewed. Parameters that inform how a page might appear could include the geographic location of the user, time of day and previous pages viewed by the user, while technologies for producing Dynamic HTML include CGI scripts, Server-Side Includes (SSI), cookies, Java, JavaScript and ActiveX.

Email list or **list server** A shared distribution list wherein a message sent to a designated email address redistributes the message to all list subscribers. A mailing list that is administered automatically is called a list server.

F2F ('face to face') Part of the net vernacular and tailored to the immediacy and compactness of these new communication media. It is opposed to virtual communication (such as instant messaging or email).

Free software Software that can be freely used, modified and redistributed with the restriction that any redistributed version of the software must be accompanied by the original terms of free use, modification and distribution (known as copyleft). The definition of free software originates in the GNU Project and the Free Software Foundation (http://www.fsf.org). Free software may be packaged and distributed for a fee; 'free' refers to the ability to reuse it, modified or unmodified, as part of another software package.

Freeware Different from free software, freeware is programming offered at no cost. A common class of small applications available for download and use in most operating systems. Because freeware may be copyrighted, users may not be able to reuse it in development. When using and reusing public domain software, it can be helpful to know the history of the program to be sure if it really is in the public domain.

Game mods Game 'modifications' or customizations made by players, encouraged by some game development companies who leave their products open for these purposes.

Generative art According to Adrian Ward, a term given to work which stems from concentrating on the processes involved in producing an artwork, usually (although not strictly) automated by the use of a machine or computer, or by using mathematic or pragmatic instructions to define the rules by which such artworks are executed.

GPS Short for Global Positioning System, a worldwide satellite-based navigational system formed by satellites orbiting the earth and their corresponding receivers on the earth. GPS satellites continuously transmit digital radio signals that contain data on the satellites' location and the exact time to the earth-bound receivers. Using three satellites, GPS can calculate the longitude and latitude of the receiver based on where the three spheres intersect.

Handshake An abbreviation of 'Challenge Authentication Handshake Protocol'. A type of authentication in which the authentication agent (typically a network server) sends the client program a random value that is used only once and has an ID value. Both the sender and peer share a predefined secret. If, after exchanges, both agent and client have matching values or IDs, the connection is authenticated.

Hardware In contrast to software, which is made of code and symbols, hardware includes tangible objects such as discs, disc drives, display screens, keyboards, printers and chips.

HTML Stands for HyperText Markup Language and is used to create documents on the web.

Hypermedia An extension that supports linking graphics, sound and video files in addition to text elements. The web is partially a hypermedia system since it supports graphical hyperlinks and links to sound and video files.

Hypertext Based on a type of database invented by Theodor Nelson in the 1960s in which objects (text, pictures, music, programs and so on) can be creatively linked to each other. Now a literary genre of texts often characterized by lack of beginning and end and branching narratives.

ICQ An instant-messaging program, like AOL Instant Messenger, which can be used for conferencing, chat, email, and to perform file transfers and play computer games.

Infowar A term describing the critical and fundamental stakes of online security and information networks, which is meant to denote a different kind of frontier to geographic ones.

IP address An identity for a computer or device on a TCP/IP network, including the internet. Networks using the TCP/IP protocol route messages based on the IP address of the destination. The format of an IP address is a 32-bit numerical address written as four numbers separated by periods. Connecting to the internet requires using registered IP addresses (called internet addresses) to avoid duplicates.

Java An object-orientated (as opposed to procedural) programming language developed by Sun Microsystems.

Javascript Though it shares features and structures with Java, this programming language, intended for authoring interactive components for web sites, was developed by Netscape.

Linux A freely distributable open-source operating system that runs on a number of hardware platforms and has become an extremely popular alternative to proprietary operating systems.

Netiquette The term is a contraction of 'internet etiquette' and reflects guidelines for posting messages to online services such as email lists and newsgroups.

Open source In the context of this book, this term refers to a program in which the source code is available to the general public for use and/or modification from its original design free of charge.

P2P ('peer to peer') A type of network in which each workstation or computer has equivalent capabilities and responsibilities.

Perl A programming language developed by Larry Wall and especially designed for processing text, Perl is short for Practical Extraction and Report Language.

Real Players A popular software for broadcasting on the web. Real Audio supports audio content and Real Players tend to support video.

Screenshot Screenshots capture the contents of a computer screen. Many operating systems allow users to take screenshots using keystroke commands; there are also programs for screenshots such as Grab.

Software Software is computer data, programs and anything that can be stored electronically.

Software art Artist-written software. As Christiane Paul points out however, 'Software is generally defined as formal instructions that can be executed by a computer. However, there is no digital art that doesn't have a layer of code and algorithms, a procedure of formal instructions that accomplish a "result" in a finite number of steps. Even if the physical and visual manifestations of digital art distract from the layer of data and code, any "digital image" has ultimately been produced by instructions and the software that was used to create or manipulate it....'

Tactical media Known by net artists chiefly through the writings of David Garcia and Geert Lovink as well as events such as Next 5 Minutes, tactical media relies on 'do-it-yourself' media made possible by the revolution in consumer electronics. The use of these media in this context is by individuals or groups outside the normal hierarchies of power and knowledge.

Telepresence The technology-enabled feeling or sensation that a person is in a different place or time. A simple experience of telepresence would be when someone, caught up in an email from overseas, feels a surge of connection and intimacy with someone who is far away.

URL Stands for 'Uniform Resource Locator', the global address of documents and other resources on the web.

Warez Pirated commercial software, often available online, in which a hacker has de-activated the copyright or security systems used by the software manufacturer. In comparison with shareware and freeware, the use and distribution of warez is illegal.

Projects and Resources

'010101: Art In Technological Times' (2001)
http://010101.sfmoma.org/

1:1 (2) (1999/2001) *Lisa Jevbratt*
http://spike.sjsu.edu/~jevbratt/c5/onetoone/2/index_ng.html

34 NORTH 118 WEST *Jeff Knowlton, Naomi Spellman and Jeremy Hight* http://34n118w.net/

47 Seconds (2002) *Elka Krajewska*
http://www.elka.net/

79 Days (2003) *Trebor Scholz*
http://www.molodiez.org/

Acoustic Space http://xchange.re-lab.net/u/acoustic.space.lab
http://acoustic.space.re-lab.net/lab/

äda'web
http://adaweb.walkerart.org/home.shtml

Agatha Appears (1997) *Olia Lialina*
http://www.c3.hu/collection/agatha/

All My Life for Sale (2001) *John D. Freyer*
http://www.allmylifeforsale.com/

Alphabet Synthesis Machine (2002) *Golan Levin with Jonathan Feinberg and Cassidy Curtis*
http://alphabet.tmema.org/

ANAT http://www.anat.org.au/

Anime Noir-Playskins (2002) *Anne-Marie Schleiner* http://www.playskins.com/

Arctic Circle Double Travel (1994–95) *Felix Huber and Philip Pocock*
http://www.dom.de/acircle/acircle.htm

Artnetweb http://www.artnetweb.com/

Artport, Whitney Museum of American Art http://artport.whitney.org/

ASCI http://www.asci.org/

asdfg.jodi.org jodi.org http://asdfg.jodi.org/

A story of net art (open source) by Natalie Bookchin
http://www.calarts.edu/~line/history.html

A Visitor's Guide to London (1995) *Heath Bunting*
http://www.irational.org/london/

Backspace http://bak.spc.org/

Banff New Media Institute at the Banff Center http://www.banffcentre.ca/bnmi/

BBC Arts (Digtial Arts)
http://www.bbc.co.uk/arts/digital/interviews/

bcc (2001) *Motomichi Nakamura*
http://www.uiowa.edu/~iareview/tirweb/feature/motomichi/bcc/bcc.html

Beige (2000–present) *Joe Beuckman, Paul Davis, Cory Arcangel and Joseph Bonn*
http://www.post-data.org/beige/

Bindigirl (1999) *Prema Murthy*
http://www.thing.net/~bindigrl/

Biotech Hobbyist (1998) *Heath Bunting and Natalie Jeremijenko*
http://www.irational.org/biotech/

BlackLash (1998) *Mongrel*
http://www.mongrel.org.uk/Natural/BlackLash/down.html

Blackness for Sale (2001) *Keith Obadike*
http://Obadike.tripod.com/ebay.html

Black People Love Us (2002) *Jonah Peretti, Chelsea Peretti, Josh Kinberg, Andrea Harner*
http://www.blackpeopleloveus.com/

Bodies Inc. (1996) *Victoria Vesna and collaborators*
http://www.bodiesinc.ucla.edu/

The Body (1997) *Shelley Jackson*
http://www.altx.com/thebody/body.html

The Body of Michael Daines (2000) *Michael Daines* http://www.mdaines.com/body/

BorderXing (2002) *Heath Bunting*
http://www.tate.org.uk/netart/borderxingguide.htm

Boston Cyberarts Gallery
http://gallery.bostoncyberarts.org/

Bureau d'Etudes http://utangente.free.fr/

Burn (2003) *Shu Lea Cheang, yippieyeah Design and Roger Sennert*
http://residence.aec.at/kop/burn/index.html

C3 Center for Culture and Communication
http://www.c3.hu/

The CADRE Laboratory for New Media
http://cadre.sjsu.edu/

Candy Factory *Takuji Kogo*
http://www.bekkoame.ne.jp/i/ga2750/

'Can You Digit?' (1996) *Postmasters Gallery*
http://www.thing.net/~pomaga/digit/

Carnivore *RSG* http://rhizome.org/carnivore/

Centre Pompidou Net Art
http://www.centrepompidou.fr/netart/

'CODeDOC' (2002) *Various Artists*
http://www.whitney.org/artport/commissions/codedoc/index.shtml

Colour Separation (1998) *Mongrel*
http://www.mongrelx.org/

Communication Creates Conflict (1995) *Heath Bunting*
http://www.irational.org/tokyo/index.html

communimage (1999) *calc and Johannes Gees*
http://www.communimage.ch/

Computer Fine Arts
http://computerfinearts.com/

Consume.net (2002) *James Stevens*
http://consume.net/

Cream http://cream.artcriticism.org/

Crossfade http://crossfade.walkerart.org/

CRUMB (*Curatorial Resource for New Media Bliss*)
http://www.newmedia.sunderland.ac.uk/crumb/

DAKOTA (2001–3) *YOUNG-HAE CHANG HEAVY INDUSTRIES*
http://www.yhchang.com/DAKOTA.html

Darko Maver (1998–99) *0100101110101101.ORG*
http://0100101110101101.ORG/home/darko_maver/

Data Diaries (2002) *Cory Arcangel*
http://www.turbulence.org/Works/arcangel/

Deep ASCII (1998) *Vuk Cosic*
http://www.ljudmila.org/~vuk/ascii/deep.htm

Desktop Is (1997) *Alexei Shulgin*
http://www.easylife.org/desktop/

DIA Center – Artists' Web Projects
http://www.diacenter.org/webproj/index.html

DIAN (Digital Interactive Artists' Network)
http://dian-network.com/

Digital Arts Development Agency
http://www.da2.org.uk/da2.htm

Digital Craft http://www.digitalcraft.org/

Digital Landfill (1998) *Mark Napier*
http://www.potatoland.org/landfill/

The Digital Pocket Gallery
http://www.ikatun.com/digitalpocketgallery/

Documenta Done (1997) *Vuk Cosic*
http://www.ljudmila.org/~vuk/dx/

Dot-Store (2002) *Thomson & Craighead*
http://www.dot-store.com

Dru (Digital Research Unit)
http://www.druh.co.uk/

Easylife http://www.easylife.org/

etoy http://www.etoy.com

Every Icon (1997) *John Simon Jr*
http://www.numeral.com/everyicon.html

Eyebeam Atelier http://www.eyebeam.org/

Female Extension (1997) *Cornelia Sollfrank*
http://www.artwarez.org/femext/

Flesh Machine *Critical Art Ensemble*

http://www.critical-art.net/biotech/biocom/index.html

FloodNet *Electronic Disturbance Theater*
http://www.thing.net/~rdom/ecd/ecd.html

Form Art (1997) *Alexei Shulgin*
http://www.c3.hu/collection/form/

Franklin Furnace
http://www.franklinfurnace.org/

Free Radio Linux (2002–present) *Radioqualia (Adam Hyde and Honor Harger)*
http://radioqualia.va.com.au/freeradiolinux/

Free Software Foundation http://www.fsf.org

Frequency Clock (1998) *Radioqualia (Honor Harger and Adam Hyde)*
http://www.radioqualia.va.com.au/

Furtherfield
http://www.furtherfield.org/index.php

'Future Cinema' (2002–3) *Curated by Peter Weibel and Jeffrey Shaw*
http://www.zkm.de/futurecinema/index_e.html

Gallery 9, Walker Art Center
http://gallery9.walkerart.org/

Glyphiti (2001) *Andy Deck*
http://artcontext.net/glyphiti/index.php

Grammatron (1997) *Mark Amerika*
http://www.grammatron.com/

Ground Zero http://www.groundzero.org/

Halbeath (2002) *Candy Factory and YOUNG-HAE CHANG HEAVY INDUSTRIES*
http://www.trans.artnet.or.jp/~transart/halbeath/

Handshake (1993) *Joachim Blank, Karl Heinz Jeron, Barbara Aselmeier and Armin Haase*
http://sero.org/handshake/

Harvestworks Media Arts Center
http://www.harvestworks.org/

Heritage Gold (1998) *Mongrel*
http://www.mongrelx.org/

HF Critical Mass (2002) *Barbara Lattanzi*
http://www.wildernesspuppets.net/yarns/hfcriticalmass/main.html

Hiroshima Project (1995) *Akke Wagenaar*
www.xs4all.nl/~akkefall/err.org/akke/HiroshimaProject

Hot Pictures (1994) *Alexei Shulgin*
http://sunsite.cs.msu.su/wwwart/hotpics/

http://404.jodi.org (1997) *Jodi*
http://404.jodi.org/

http://wwwwwwwww.jodi.org *jodi.org*
http://wwwwwwwww.jodi.org/

Hybrids (1999) *0100101110101101.ORG*
http://0100101110101101.ORG/home/hybrids/

IDENTITISWAPDATABASE (1999) *Heath Bunting and Olia Lialina*
http://www.teleportacia.org/swap/

'Infowar' web site, *Ars Electronica*
http://www.aec.at/infowar/eng.html

Injunction Generator (2002) *IPNIC*
http://www.ipnic.org/

Institute for Applied Autonomy
http://www.appliedautonomy.com/

Intercommunication Center Tokyo
http://www.ntticc.or.jp/

The Intruder (1999) *Natalie Bookchin*
http://www.calarts.edu/~bookchin/intruder/

Irational.org http://www.irational.org/

I Was a Soldier on Kosovo (1999) *Teo Spiller*
http://www.teo-spiller.org/kosovo/

'Kingdom of Piracy' (2001–3)
http://kop.fact.co.uk/

King's Cross Phone In (1994) *Heath Bunting*
http://www.irational.org/cybercafe/xrel.html

Krematorium (1999) *Miklos Legrady*
http://rhizome.org/artbase/2224/
krematorium/holokaust/index.html
Lab 404 http://lab404.com/
Latin American Net Art
http://netart.org.uy/latino/index.html
Learning to Love You More (2002) *Miranda July and Harrell Fletcher*
http://www.learningtoloveyoumore.com/
The Leonardo Gallery
http://mitpress2.mit.edu/
e-journals/Leonardo/gallery/index.html
Life_Sharing (2001) *010010111010101.ORG*
http://www.010010111010101.org/
Link X (1996) *Alexei Shulgin*
http://basis.Desk.nl/~you/linkx/
Ljubljana Digital Media Lab
http://www.ljudmila.org/
London.pl (2001) *Graham Harwood*
http://www.scotoma.org/lungs/
Low-Fi http://www.low-fi.org.uk/
Makrolab (debuted in 1997) *Marko Peljhan*
http://makrolab.ljudmila.org/
Mapping Contemporary Capitalism
http://docs.metamute.com/view/Home/McC
MECAD – Media Centre of Art and Design
http://www.mecad.org/
Mejor Vida Corp. *Minerva Cuevas*
http://www.irational.org/mvc/
Mouchette (1996) *Anonymous*
http://www.mouchette.org/
Mr. Net.Art (1998) *Kathryn Schmitt, Natalie Bookchin, Sandra Fauconnier, Diana McCarty, Keiko Suzuki, Cornelia Sollfrank, Trina Mould, Olia Lialina, Vesna Manojlovic, Josephine Bosma, Rachel Greene, Carey Young, Barbara Strebel*
http://www.netzwissenschaft.de/tm/mr/
My Boyfriend Came Back From the War (1996) *Olia Lialina*
http://www.teleportacia.org/war/
Natural Selection (1998) *Mongrel*
http://www.mongrel.org.uk/
NetArt Initiative http://www.netart-init.org/
Net.art per se (1996) *Vuk Cosic*
http://www.ljudmila.org/naps/cnn/cnn.htm
NetArt Review http://www.netartreview.net/
Net Criticism Juke Box (1997) *Vuk Cosic*
http://www.ljudmila.org/nettime/
jukebox.htm
Net.Culture Club Mama
http://www.mi2.hr/eng/
Netomat (debuted in 1999) *Maciej Wisniewski*
http://www.netomat.net/
Nettime http://www.nettime.org/
Netzspannung Internet Media Laboratory
http://netzspannung.org/
Netzwissenschaft
http://www.netzwissenschaft.de/kuenst.htm
New Center for Art & Technology
http://www.newcat.org/
New Media Scotland
http://www.mediascot.org/index.htm
Nike sweatshop email (2001) *Jonah Peretti*
http://www.shey.net/niked.html
Nine(9) (2003) *Graham Harwood*
http://9.waag.org/
Nomad.net http://www.nomadnet.org/
Opensorcery *Anne-Marie Schleiner*
http://www.opensorcery.net/
Platform (2002) *Rachel Baker*
http://www.platfrom.net/index.html
Pleix http://www.pleix.net/films.html
Polymorphous Space
http://anarchy.k2.tku.ac.jp/
Post Media Network
http://www.michelethursz.com

QQQ (2002) *Nullpointer* http://q-q-q.net/
Radio 90 (1998) *Heath Bunting* http://radio90.fm/
Radioqualia http://www.radioqualia.net/
Radiospace http://rad.spc.org/
Random Access Mortality (2002) *MTAA*
http://www.mteww.com/RAM/index.html
_readme.html (Own, Be Owned or Remain Invisible) (1996) *Heath Bunting*
http://www.irational.org/heath/
_readme.html
rent-a-negro.com (2003) *Damali Ayo*
http://www.rent-a-negro.com
Rhizome.org http://www.rhizome.org/
Rhizome ArtBase
http://rhizome.org/fresh/art/
®TMark http://www.rtmark.com
Runme.org (2002) *Amy Alexander, Florian Cramer, Matthew Fuller, Olga Goriunova, Thomax Kaulmann, Alex McLean, Pit Schultz, Alexei Shulgin and The Yes Men*
http://www.runme.org/
Sarai http://www.sarai.net/
SAUL (2001) *YOUNG-HAE CHANG HEAVY INDUSTRIES*
http://www.yhchang.com/SAUL.html
SFMOMA e-space
http://www.sfmoma.org/espace/
espace_overview.html
'The Shock of the View' (1998) *Walker Art Center with the Davis Museum and Cultural Center, Wellesley College, San Jose Museum of Art, the Wexner Center for the Arts, Ohio State University and Rhizome.org.*
http://www.walkerart.org/salons/
shockoftheview/sv_front.html
Shop Mandiberg (2001) *Michael Mandiberg*
http://www.mandiberg.com/shop/
The Shredder (1998) *Mark Napier*
http://www.potatoland.org/shredder/
Siberian Deal (1995) *Kathy Rae Huffman and Eva Wohlgemuth*
http://www.t0.or.at/~siberian/vrteil.htm
SOD (1999) *Jodi.org* http://sod.jodi.org/
Soundtoys http://www.soundtoys.net/
SPC http://www.spc.org/
Summons to Surrender (2000) *Eddo Stern*
http://stern.aen.walkerart.org/
Superbad *Ben Benjamin*
http://www.superbad.com/1/trunk/
trunk.html
Superweed Project (1999) *Heath Bunting and Rachel Baker*
http://www.irational.org/cta/superweed/
SWITCH http://switch.sjsu.edu/nextswitch/
switch_engine/front/front.php?cat=44
Tank TV http://tank.tv/
Tate Webart http://www.tate.org.uk/webart/
The Telegarden (1995) *Ken Goldberg and collaborators* http://telegarden.aec.at/
Teleportacia http://art.teleportacia.org/
Tetsuo Kogawa http://anarchy.k2.tku.ac.jp/
textz.com *Sebastian Luetgert*
http://www.textz.com
THE THING http://bbs.thing.net
Archives of THE THING http://old.thing.net/
They Rule (2001) *Josh On and Futurefarmers*
http://www.theyrule.net/
Trigger Happy (1998) *Thomson & Craighead*
http://www.triggerhappy.org/
tsunamii.net *Charles Lim Yi Yong and Woon Tien Wei*
Turbulence.org http://www.turbulence.org/
The University of Openness
http://twentiethcentury.com/uo/
index.php/HomePage
Unmovie (2002) *Axel Heide, onesandzeroes, Philip*

Pocock and Gregor Stehle
http://www.unmovie.org/
Untitled (1999) *Vuk Cosic*
http://www.ljudmila.org/~woelle/lajka/war/
V2, The Institute for Unstable Media
http://www.v2.nl/
VLOG (2001– present) *Adrian Miles*
http://hypertext.rmit.edu.au/vog/vlog/
Waag http://www.waag.org/
Web Net Museum
http://webnetmuseum.org/
The Web Stalker (1997) *I/O/D*
http://www.backspace.org/iod/iod4.html
Will-N-Testament (1998) *Olia Lialina*
http://will.teleportacia.org/
World of Awe (1995) *Yael Kanarek*
http://worldofawe.net/
WWW Art Center Moscow *jodi*
http://sunsite.cs.msu.su/wwwart/jodi.htm
Zombie and Mummy (2002–present) *Olia Lialina and Dragan Espenschied*
http://www.zombie-and-mummy.org/

Select Exhibitions

'Digital Studies', curated by Alexander Galloway and Mark Amerika, ALT X, November 1997
http://rhizome.org/ds/
'PORT: Navigating Digital Culture', curated by Robbin Murphy and Remo Campopiano, MIT List Visual Arts Center, 25 January – 29 March 1997
http://artnetweb.com/port/
'Beyond Interface', curated by Steve Dietz, Walker Art Center, January 1998
http://www.archimuse.com/mw98/
beyondinterface/
'The Shock of the View', Walker Art Center in collaboration with the Davis Museum and Cultural Center, Wellesley College, San Jose Museum of Art, the Wexner Center for the Arts, Ohio State University and Rhizome.org, 22 September 1998 – 14 April 1999 http://www.walkerart.org/salons/
shockoftheview/
'Cracking the Maze: Game Plug-ins and Patches as Hacker Art', curated by Anne-Marie Schleiner, 16 July 1999
http://switch.sjsu.edu/CrackingtheMaze/
'net_condition', curated by Peter Weibel, Walter van der Cruijsen, Johannes Goebel, Hans-Peter Schwarz, Jeffrey Shaw (ZKM), Golo Föllmer (University of Halle), Benjamin Weil (ICA London, New Media Center), ZKM, Germany, 1999
http://on1.zkm.de/netcondition/start/
language/default_e
'Art Entertainment Network', curated by Steve Dietz, Walker Art Center, 2000
http://aen.walkerart.org/
'Dystopia + Identity in the Age of Global Communications', curated by Cristine Wang, Tribes Gallery, New York, 2 December 2000 – 13 January 2001
http://www.tribes.org/dystopia/
'SHIFT-CTRL', curated by Antoinette LaFarge and Robert Nideffer, University of California at Irvine, 17 October – 3 December 2000
http://beallcenter.uci.edu/shift/home.html
'Through the Looking Glass', curated by Patrick Lichty, Beachwood Center for the Arts, Beachwood, Ohio, 15 – 30 April 2000
http://www.voyd.com/ttlg/

'010101: Art in Technological Times', curated by Benjamin Weil, San Francisco Museum of Modern Art, January 2001 http://010101.sfmoma.org/

'::contagion::', curated by Linda Wallace, The New Zealand Film Archive, 12 September – 14 November 2001 http://www.filmarchive.org.nz/viewing/fc_past_exhibits.html#contagion

'Game Show', curated by Mark Tribe and Alexander Galloway, MASS MoCA, MA, May 2001 – April 2002 http://www.massmoca.org/

'[re]distributions', curated by Patrick Lichty, 2001 http://www.voyd.com/ia/

'The Open Museum Net.Art', curated by Arthur X. Doyle, The Irish Museum of Modern Art, Dublin, Ireland, November 2001 http://www.irishmuseumofmodernart.com/netart_open.htm

'Under_Score', curated by Wayne Ashley, Brooklyn Academy of Music, Brooklyn, New York, October – November 2001 http://www.bam.org/

'<ALT> DigitalMedia', American Museum of the Moving Image, New York, launched 27 November 2002 http://www.movingimage.us/alt/alt.html

'BananaRAM', curated by Gianluca D'Agostino and Maria Rita Silvestri, Ancona, Italy, 18 – 22 September 2002 http://www.bananaram.org/

'Defining Lines: <Breaking Down Borders>', curated by Cristine Wang, 25 May – 25 August 2002 http://cristine.org/borders/

'Mapping Transitions', curated by Christiane Paul and Mark Amerika, University of Colorado at Boulder, 12–14 September 2002 http://www.altx.com/mappingtransitions/

'Net.Film @ The Ides of March', curated by BULL.MILETIC, ABC No Rio, New York, 14 March – 11 April 2002 http://bull.miletic.info/netfilm/

'Netizens', curated by Valentina Tanni, Sala 1 Galleria, Centro Internazionale d'Arte Contemporanea, Rome, 4 – 22 December 2002 http://www.netizensonline.it/

'net.narrative', curated by Marisa S. Olson, SF Cameraworks, San Francisco, September 2002 http://www.sfcamerawork.org/netnarrative.html

'Open_Source_Art_Hack', curated by Steve Dietz and Jenny Marketou in collaboration with Anne Barlow, The New Museum, New York, 3 May – 30 June 2002 http://www.netartcommons.net/

'Re-media', curated by Christiane Paul, FotoFest, Houston, Texas, 1 March – 1 April 2002 http://www.fotofest.org/ff2002/remedia.htm

'Web as Canvas', curated by Roberta Bosco and Stefano Caldana, Art Futura 2002, Barcelona, October 2002 http://www.artfutura.org/02/expo_lared_e.html

'Web Racket: Contemporary Interactive Web Art', curated by George Fifield, Media Space @ DeCordova/Phyllis and Jerome Lyle Rappaport Gallery, Lincoln, MA, 8 June – 1 September 2002 http://www.decordova.org/decordova/exhibit/webracket/Default02.htm

'NetNoise', curated by Arthur and Marilouise Kroker and Timothy Murray, July 2003 http://ctheory.library.cornell.edu/four.php

'Translocations', organized by Steve Dietz, Walker Art Center, February 2003 http://translocations.walkerart.org/

'Curating Degree Zero' http://www.curatingdegreezero.org/

'Day Jobs' – online exhibition, curated by Richard Rinehart, New Langton Arts, San Francisco http://www.newlangtonarts.org/view_event.php/?category=Network&archive=&&eventId=35

'Kingdom of Piracy', curated by Shu Lea Cheang, Armin Medosch and Yukiko Shikata, Acer Digital Art Center, Taiwan (December 2001), Ars Electronica, Linz (September 2002), FACT, Liverpool, UK (February – March 2003) http://kop.fact.co.uk/

'telematic connections: the virtual embrace', curated by Steve Dietz http://telematic.walkerart.org/

Festivals, Events and Venues

Ars Electronica, Linz, Austria, http://www.aec.at/

Backup festival – new media in film, Weimar, Germany, http://www.backup-festival.com

c-level, Los Angeles, http://www.c-level.cc/history.html

DEAF, Rotterdam, the Netherlands, http://deaf.v2.nl/

D-I-N-A (Digital-Is-Not-Analog), Barcelona, http://www.d-i-n-a.net/

Electronic Orphanage, Los Angeles, http://www.electronicorphanage.com/

EMAF, European Media Art Festival, Osnabrück, Germany, http://www.emaf.de/

FILE Electronic Language International Festival, São Paulo, Brazil, http://www.file.org.br/file2003ins/english/insc_file2003.htm

Filmwinter: Festival for Expanded Media, Stuttgart, Germany, http://www.filmwinter.de/

Impakt, Utrecht, the Netherlands, http://www.impakt.nl/

International Browser Day, variable location, http://www.nl-design.net/browserday/

ISEA, Inter-Society for the Electronic Arts, Canada, variable location, http://www.isea-web.org/

Korea Web Art Festival, Korea, http://www.koreawebart.org/

Make-World Festival, Munich, Germany, http://www.muffathalle.de/

Multimedia Art Asia Pacific, variable location (Beijing 2002, Singapore 2003, Seoul 2004, Brisbane 2005), http://www.maap.org.au/

New Forms Fesival, Vancouver, Canada, http://www.newformsfestival.com/

Next 5 Minutes, Amsterdam, the Netherlands, http://www.next5minutes.org/

Public Netbase t0, Vienna, Austria, http://www.t0.or.at/

Read_Me Festival, http://www.m-cult.org/read_me/

Root Festival, Hull Time Based Arts, Hull, UK, http://www.root2002.org/

Spark Festival, New Zealand, http://spark.mediarts.net.nz/

Transmediale, Berlin, Germany, http://www.transmediale.de/

Version Festival, http://versionfest.com/default/archives/000052.html

VIPER, International Festival of Film, Video and Media Arts, Lucerne, Switzerland, http://www.viper.ch/

Mailing Lists

AHA, mailing list on artistic activism, chiefly in Italian, https://www.ecn.org/wws/info/aha

Ambit, networking media arts in Scotland, http://www.mediascot.org/ambit/index.html

Cinemätik, http://www.egroups.com/group/cinematik/

Empyre, an arena for the discussion of media arts practice, http://www.subtle.net/empyrean/empyre/

Faces, a mailing list for women in new media, http://www.faces-l.net/

Fibre Culture, http://www.fibreculture.org/

Internodium, http://www.internodium.org.yu/

Old Boys Network (obn), http://www.nettime.org/

Rekombinant (in Italian, mostly), http://rekombinant.org/

Rhizome, http://www.rhizome.org/

[rohrpost] (in German), http://post.openoffice.de/cgi-bin/mailman/listinfo/rohrpost

Rolux, http://www.rolux.org/

Sarai-Reader-List, http://mail.sarai.net/mailman/listinfo/reader-list

SPECTRE, http://coredump.buug.de/cgi-bin/mailman/listinfo/spectre

Syndicate, network for media culture and media art, http://anart.no/~syndicate/

Xchange, http://xchange.re-lab.net/m/list.html

Select Bibliography

Alloway, Lawrence, Network (UMI Research Press: Ann Arbor, 1984)

Alloway, Lawrence, 'The Arts and the Mass Media' in Art in Theory 1900–1990: An Anthology of Changing Ideas, edited by Charles Harrison and Paul Wood (Blackwell: Oxford, 1992)

Alloway, Lawrence, 'Ray Johnson', in Art Journal (spring 1977)

Baudrillard, Jean, 'The Hyper-realism of Simulation' in Art in Theory 1900–1990: An Anthology of Changing Ideas, edited by Charles Harrison and Paul Wood (Blackwell: Oxford, 1992)

Baumgärtel, Tilman, 'The Rough Remix' in Read Me!: ASCII Culture and the Revenge of Knowledge, edited by Josephine Bosma, Pauline van Mourik Broekman, Ted Byfield, Matthew Fuller, Geert Lovink, Diana McCarty, Pit Schultz, Felix Stalder, McKenzie Wark and Faith Wilding (Autonomedia: New York, 1999)

Berry, Josephine, 'Bare Code: Net Art and the Free Software Movement', http://textz.gnutenberg.net/textz/berry_josephine_bare_code.txt

Bookchin (Natalie), Lee (Jin), Massu (Isabelle), Derain (Martine), Klayman (Melinda) and Schleiner (Anne-Marie), 'For the Love of the Game', http://www.artbyte.com

Brusadin, Vanni, 'Hacker Techniques', http://www.fiftyfifty.org/hack_tech/txt_artware.html

Buchloh, Benjamin and Rodenbeck, Judith, *Experiments in the Everyday: Allan Kaprow and Robert Watts – Events, Objects, Documents* (Miriam and Ira D. Wallach Art Gallery: New York, 1999)

Bullock, Alan and Trombley, Stephen (eds), *The New Fontana Dictionary of Modern Thought* (HarperCollins: London, 1999)

Burnham, Jack, 'Real Time Systems', *Artforum*, vol. 8, no. 1 (September 1969)

Cosic, Vuk, 'Predstavitev – Net.art, text', http://www.ljudmila.org/scca/worldofart/98/98vuk2.htm

Cosic, Vuk and van der Haagen, Michiel, 'Interview', http://www.calarts.edu/~bookchin/vuk_interview.html

Cramer, Florian, 'Discordia Concors www.jodi.org' in *install.exe/Jodi* (Christoph Merian Verlag: Berlin, 2002)

Crary, Jonathan, 'Critical Reflections', *Artforum* (February 1994)

Dietz, Steve, 'Why Have There Been No Great Net Artists?', http://www.voyd.com/ttlg/textual/dietzessay.htm

Dodge, Martin and Kitchin, Rob, *Mapping Cyberspace* (Routledge: London, 2001)

Druckrey, Timothy (ed.), *Electronic Culture* (Aperture: New York, 1996)

Druckrey, Timothy (ed.), *Ars Electronica: Facing the Future* (MIT Press: Cambridge, Mass., 1999)

Druckrey, Timothy and Weibel, Peter (eds), *net_condition: art and global media* (Cambridge, Mass., Graz, Austria, and Karlsruhe, Germany, 2001)

Foster, Hal, *Design and Crime* (Verso: London, 2002)

Frieling, Rudolf, 'Context Video Art', translated by Tom Morrison, http://www.mediaartnet.org/Starte.html

Frohne, Ursula, '"Screen Tests": Media Narcissism, Theatricality, and the Internalized Observer' in *CTRL Space: Rhetorics of Surveillance from Bentham to Big Brother*, edited by Thomas Y. Levin, Ursula Frohne and Peter Weibel (Cambridge, Mass., and London 2002)

Fuller, Matthew, 'A Means of Mutation', in *Behind the Blip: Essays on the Culture of Software* (Autonomedia: New York, 2003)

Fuller, Matthew, 'It looks like you're writing a letter: Microsoft Word', in *Behind the Blip: Essays on the Culture of Software* (Autonomedia: New York, 2003)

Galloway, Alexander, 'net.art Year in Review: State of net.art '99', http://switch.sjsu.edu/web/v5n3/D-1.html

Garcia, David and Lovink, Geert, 'The ABC of Tactical Media', http://www.nettime.org

Generative.net, http://www.generative.net/

Godfrey, Tony, *Conceptual Art* (Phaidon: London, 1998)

Gohlke, Gerrit (ed.), 'Tour de Fence – Heath Bunting and Kayle Brandon' (Kunstlerhaus Bethanien: Berlin, 2003)

Hall, Doug and Fifer, Sally Jo (eds), *Illuminating Video* (Aperture: New York, c. 1990)

Haraway, Donna, *Simians, Cyborgs, and Women: the Reinvention of Nature* (Routledge: New York, 1991)

Harrison, Charles and Wood, Paul (eds), *Art in Theory 1900–1990: An Anthology of Changing Ideas* (Blackwell: Oxford, 1992)

Harwood, Graham, 'Artists Statement –

Rehearsal of Memory', *Rehearsal of Memory* CD-ROM (co-published with ARTECH, 1996)

Holmes, Brian, 'Maps for the Outside', http://twenteenthcentury.com/uo/index.php/BrianHolmesMapsfortheOutside#ftnt_2

Huhtamo, Erkki, 'Game Patch – the Son of Scratch?', http://switch.sjsu.edu/CrackingtheMaze/erkki.html

Jeremijenko, Natalie, 'Database Politics and Social Simulations', http://tech90s.net/nj/index.html

Johnson, Steven, *Interface Culture* (Basic Books: New York, 1999)

Joselit, David, *American Art Since 1945* (Thames and Hudson: London, 2003)

Joselit, David, 'Radical Software', *Artforum* (May 2002)

Kaprow, Allan, *The Blurring of Art and Life*, edited by Jeff Kelley (University of California Press: Berkeley, 1993)

Kaprow, Allan, from *Assemblages, Environments and Happenings*, excerpted in *Art in Theory 1900–1990: An Anthology of Changing Ideas* (p. 703) edited by Charles Harrison and Paul Wood (Blackwell: Oxford, 1992)

Krauss, Rosalind, *A Voyage on the North Sea: Art in the Age of the Post-Medium Condition* (31st Walter Neurath Memorial Lecture, 1999) (Thames and Hudson: New York, 2000)

Lippard, Lucy, *Pop Art* (Fredrick A. Praeger: New York, 1966)

Lovink, Geert, *Dark Fiber: Tracking Critical Internet Culture* (MIT Press: Cambridge, Mass., 2002)

Lovink, Geert, *Uncanny Networks: Dialogues with the Virtual Intelligentsia* (MIT Press: Cambridge, Mass., 2002)

Lovink, Geert, 'New Media Culture in the Age of the New Economy', http://subsol.c3.hu/subsol_2/contributors/lovinktext.html

Manovich, Lev, *The Language of New Media* (MIT Press: Cambridge, Mass., 2001)

Manovich, Lev, 'Avant-garde as Software', http://www.uoc.edu/artnodes/eng/art/manovich1002/manovich1002.html

Manovich, Lev, 'The Anti-Sublime Ideal in New Media', http://www.chairetmetal.com/cm07/manovich-complet.htm

McGann, Jerome, *Radiant Textuality: Literature after the World Wide Web* (Palgrave: New York, 2001)

McRae, Shannon, 'Coming Apart at the Seams: Sex, Text and the Virtual Body', 1995, http://www.usyd.edu.au/su/social/papers/mcrae.html

Ono, Yoko, *Grapefruit* (Simon & Schuster: New York, 2000)

Paul, Christiane, *Digital Art* (Thames and Hudson: New York and London, 2003)

Paul, Christiane, 'Introduction to CODeDOC', http://www.whitney.org/artport/commissions/codedoc/index.shtml

Penny, Simon, 'Systems Aesthetics + Cyborg Art: The Legacy of Jack Burnham', *Sculpture* (January/February 1999), http://www.sculpture.org/documents/scmag99/jan99/burnham/sm-burnh.htm

Plant, Sadie, *Zeroes and Ones: Digital Women and the New Technoculture* (Doubleday: New York, 1997)

Pokorny, Sydney, 'Things that Go Bleep', *Artforum* (April 1993)

Pope, Simon, 'This is London', http://www.nettime.org/ListsArchives/nettime-l-9802/msg00105.html, 1998

Raley, Rita, 'Of Dolls and Monsters: An Interview with Shelley Jackson', http://www.uiowa.edu/~iareview/tirweb/feature/jackson/jackson.htm

Ross, Andrew, *No-Collar: The Humane Workplace and Its Hidden Costs* (Basic Books: New York, 2003)

Ross, David, 'Art and the Age of the Digital', http://switch.sjsu.edu/web/ross.html

Saul, Shiralee, 'Hyper Hyper Text', http://www.labyrinth.net.au/~saul/essays/04hyper.html

Schleiner, Anne-Marie, 'CRACKING THE MAZE: Game Plug-ins and Patches as Hacker Art', '//LUCKYKISS_xxx: Adult Kisekae Ningyou Sampling', 'MUTATION.FEM: An Underworld Game Patch Router to Female Monsters, Frag Queens and Bobs whose first name is Betty' and 'Snow Blossom House', curator's note, http://www.opensorcery.net

Sekula, Allan, *Fish Story* (Richter Verlag: Düsseldorf, 1995)

Shanken, Edward, 'The House That Jack Built: Jack Burnham's Concept of "Software" as a Metaphor for Art', http://www.duke.edu/~giftwrap/House.html

Shulgin, Alexei, 'Art, Power, and Communication', http://sunsite.cs.msu.su/wwwart/apc.htm

Slater, Howard, 'The Spoiled Ideals of Lost Situations: Some Notes on Political Conceptual Art', http://www.infopool.org.uk

Stein, Joseph (ed.), *Bauhaus*, translated by Wolfgang Jabs and Basil Gilbert (MIT Press: Cambridge, Mass., 1969)

Steinbach (Haim), Koons (Jeff), Levine (Sherrie), Taaffe (Philip), Halley (Peter) and Bickerton (Ashley), 'From Criticism to Complicity', in *Art in Theory 1900–1990: An Anthology of Changing Ideas*, edited by Charles Harrison and Paul Wood (Blackwell: Oxford, 1992)

Stocker, Gerfried, Statement about the Ars Electronica 1998 theme, 'Infowar', http://www.aec.at/infowar/STATEM/text_.html

Sturken, Marita, 'TV As a Creative Medium: Howard Wise and Video Art', *Afterimage*, vol. 11, no. 10 (May 1984)

Sutton, Gloria, 'Movie-Drome: Networking the Subject', in *Future Cinema: The Cinematic Imaginary After Film*, Jeffrey Shaw and Peter Weibel (eds) (MIT Press: Cambridge, Mass., 2003)

Sutton, Gloria, 'Diagramming Network Aesthetics', unpublished, 2003

Wallis, Brian (ed.), *Art After Modernism: Rethinking Representation* (The New Museum of Contemporary Art: New York, 1984)

Weil, Benjamin, 'Art in Digital Times: From Technology to Instrument', http://www.sva.edu/salon/salon_10/essay.php?nav=essays&essay=9

Whitelaw, Mitchell, '1968/1998: Rethinking A Systems Aesthetic', http://www.anat.org.au

Wilding, Faith and Critical Art Ensemble, 'Notes on the Political Conditions of Cyberfeminism'

Wishart, Adam and Bochsler, Regula, *Leaving Reality Behind: etoy vs. etoys.com & Other Battles to Control Cyberspace* (HarperCollins: New York, 2003)

Illustration List

Dimensions of works are given in centimetres and inches, height before width.

1 Shu Lea Cheang, *Burn*, 2003. Web interface. Courtesy the artist. **2** Jodi.org, *http://404.jodi.org*, 1997. JODI. **3** Nam June Paik, *Participation TV*, 1963 (1988 version). Manipulated television with signal amplifiers and microphone, black and white, silent, dimensions vary with installation. Photo Jon Huffman. **4** Front cover of *Radical Software*, vol. 1, no. 3. Beryl Korot, Phyllis Segura and Ira Schneider. **5** Radio Taxis, *Taxi Art*, 2002. Design agency SAS. Designer Ben Tomlinson. Client Radio Taxis. © Konrad Zuse's third computer Z3. Photograph. Siemens Institut, Munich. **7** BEA Reservations Hall, Heathrow, c. 1960s. Photograph. Courtesy British European Airways. **8** Allan Kaprow, *18 Happenings in 6 Parts*, 1959. Happening (View of Room 2 from Room 1). Courtesy the Getty Research Institute, Research Library. Photo Scott Hyde. **9** Stan VanDerBeek in front of his environmental movie theatre Movie-Drome, Stoney Point, New York, c. 1966. Photo © Lenny Lipton. **10** Exhibition poster for 'Cybernetic Serendipity', 1968. Institute of Contemporary Art, London. © Tate, London, 2004. **11** Kit Galloway and Sherrie Rabinowitz, *Electronic Café*, 1984. 'Mosaic from The Original 1984 Electronic Café Network'. © 1984–present Galloway/Rabinowitz. **12** Nam June Paik, *Magnet TV*, 1965. Television and magnet, dimensions variable. Whitney Museum of Art, New York, purchased with funds from Dieter Rosenkranz. Photo Peter Moore © Estate of Peter Moore/VAGA, New York/DACS, London, 2004. **13** Ira Schneider and Frank Gillette, *Wipe Cycle*. From the exhibition 'TV as a Creative Medium', Howard Wise Gallery, 1969. Video still from Ira Schneider's 'TV as a Creative Medium', 1969–84. Courtesy Electronic Arts Intermix (EAI), New York. **14** Rirkrit Tiravanija, *Community Cinema for a Quiet Intersection (after Oldenburg)*, 1999. Installation view in Glasgow. Courtesy GBE (Modern), New York. Photo Andrew Lee. **15** Tony Oursler, *Judy*, 1997. Institute of Contemporary Art, Philadelphia. Courtesy the artist and Metro Pictures. **16** Cindy Sherman, *Untitled Film Still*, 1978. Courtesy the artist and Metro Pictures. **17** Ken Feingold, *JCJ-Junkman*, 1995. (www.kenfeingold.com/jcj1.html) **18** Douglas Davis, *The World's First Collaborative Sentence*, 1994. Commissioned by the Lehman College Gallery of Art, New York, 1994. Collection The Whitney Museum of American Art, New York. Gift of the late Eugene M. Schwartz and Mrs. Barbara Schwartz, New York. Courtesy the artist. **19** Heath Bunting, *King's Cross Phone In*, 1994. Courtesy the artist. **20** Olia Lialina, *My Boyfriend Came Back From the War*, 1996. Courtesy the artist. **21** Evgeni Likhoshert, From the series 'The Quiet', 1990. Screenshot of the project from *Hot Pictures*' virtual photo gallery, 1995. Courtesy Easylife.org. (http://sunsite.cs.msu.su/wwwart/hotpics/likh/) **22** Jodi.org, *http://wwwwww.jodi.org*, 1995. JODI. **23** Alexei Shulgin, *Link X*, 1996. Courtesy Alexei Shulgin. (http://basis.Desk.nl/~you/linkx/) **24** Heath Bunting, *_readme.html (Own, Be Owned or Remain Invisible)*, 1996. Courtesy the artist. **25** Joy Garnett, *The Bomb Project*, 2000–present. Courtesy the artist. Photo U.S. Department of Energy. **26** Eva Wohlgemuth & Kathy Rae Huffman, *Siberian Deal*, 1995. Chrono Popp (technical support). (www.to.or.at/~siberian/vrteil.htm). Project hosted by Public Netbase, Vienna. Original travel reports and original 1995 web site hosted by Rhizome.org. **27** Philip Pocock and Felix Stephan Huber, *Arctic Circle Double Travel*, 1994–95. Courtesy the artists. (www.dom.de/acircle) **28** Heath Bunting, *Communication Creates Conflict*, 1995. Courtesy the artist. **29** Simon Biggs, *Great Wall of China*, 1996. Courtesy the artist. Net version produced whilst

artist in residence at Oxford Brookes University, UK. Funded by the Arts Council of England. (www.greatwall.org.uk/) **30** Vuk Cosic, *Net.art per se/CNN Interactive*, 1996. Part of the web site of the Net.art per se conference. Courtesy the artist. **31** THE THING, c. 1992–93. Photo courtesy of Wolfgang Staehle. **32** Peter Halley, *Superdream Mutation*, 1993. GIF. Courtesy THE THING. (http://bbs.thing.net) **33** Mariko Mori, *Angel Paint*, 1995. GIF and WAV file. Courtesy THE THING. (http://bbs.thing.net). Project located at http://old.thing.net/html/artstuff.html. **34** Group Z, Belgium (hosted by äda'web), *Home*, 1995. Courtesy Michaël Samyn. (http://adaweb.com/~groupz/home) **35** Jenny Holzer, *Please Change Beliefs*, 1995. © ARS, New York and DACS, London, 2004. **36** Vivian Selbo, *Vertical Blanking Interval* and *Consider Something Intangible*, from *Vertical Blanking Interval*, 1996. HTML 3.2 with Javascript 1.0., dimensions variable. Collection San Francisco Museum of Modern Art and The Walker Art Center. (© http://adaweb.walkerart.org/project/selbo/) © Vivian Selbo, 1996. **37** Peter Halley, *Exploding Cell*, 1997. Interactive web project created by the artist in conjunction with the Museum of Modern Art, New York. **38** Illustration from *Stir Fry: A Video Curator's Dispatches from China*, 1997. Produced by Barbara London. © The Museum of Modern Art, New York. **39** VNS Matrix, *A Cyberfeminist Manifesto for the 21st Century*, 1991. © VNS Matrix, 1991. **40** VNS Matrix, *Cortex Crones*, 1993. Still from All New Gen, computer game. © VNS Matrix, 1993. **41** Eva Grubinger, *Netzbikini*, 1995. © Eva Grubinger. **42** Ben Benjamin, *Bingo skills-building seminar and strategy workshop*, 1995. Courtesy the artist. (www.superbad.com/1/man.index.html) **43** Ben Benjamin, *Earman*, 1997. Courtesy the artist. (www.superbad.com/1/superbad/sbad.html) **44** Michaël Samyn, *Zuper2: spring*, 1995. Courtesy the artist. (www.zuper.com/portfolio/zx3/zx2.html) **45** *The Telegarden* user interface, 1995–present: Ken Goldberg & Joseph Santarromana, George Bekey, Steven Gentner, Rosemary Morris, Carl Sutter, Jeff Wiegley. (http://telegarden.aec.at). *The Telegarden*, 1995–present, networked robot installation at Ars Electronica Museum, Austria: Ken Goldberg and Joseph Santarromana (co-directors), George Bekey, Steven Gentner, Rosemary Morris, Carl Sutter, Jeff Wiegley, Erich Berger (project team). Photograph Robert Wedemeyer. **46** Natalie Jeremijenko, *Live Wire*, 2003. Courtesy the artist. **47** Alexei Shulgin, *Form WWWART Award Java Flash* for 'Flashing', 1997. Courtesy Alexei Shulgin. (www.easylife.org/award/fnew.htm) **48** Alexei Shulgin, Award for 'Research in Touristic Semiotics', 1997. Courtesy Alexei Shulgin. **49** Jodi.org, **Yeeha*, 1996. JODI. **50** Heath Bunting and Natalie Bookchin, *Criticism Curator Commodity Collector Disinformation*, 1999. Courtesy the artists. **51** Vuk Cosic, *Net Criticism Juke Box*, 1997. Courtesy the artist. **52** Rachel Baker and Kass Schmitt, Jury page from *Mr. Net.Art competition*, 1997. Courtesy the artists. **53** Kass Schmitt, *Choose*, 1997. Winning entry, *Form Art* competition. Courtesy the artist. (www.backspace.org/choose) **54** Alexei Shulgin, *Form Art* competition, 1997. Courtesy Alexei Shulgin (www.c3.hu/collection/form) **55** Alexei Shulgin, Explanation page, *Desktop Is*, 1997. Courtesy Alexei Shulgin. (www.easylife.org/desktop/desktop_is.html) **56** Rachel Baker, Desktop for *Desktop Is*, 1997. Courtesy the artist. **57** Garnet Hertz, Desktop for *Desktop Is*, 1997. Courtesy the artist. **58** Natalie Bookchin, Desktop for *Desktop Is*, 1997. Courtesy Natalie Bookchin. **59** Cornelia Sollfrank, *Female Extension*, 1997. Courtesy the artist. (Screenshot website: www.artwarez.org/femext) **60** I/O/D 4, *The Web Stalker*, 1997. Software. Courtesy I/O/D (Matthew Fuller, Colin Green, Simon Pope). (http://bak.spc.org/iod/) **61** Jodi.org, *http://wrongbrowser.jodi.org*, 2001. JODI. **62** Jonah-

Brucker Cohen, *Crank the Web*, 2001. Interactive, networked installation. Courtesy the artist. (www.coin operated.com/projects) **63** Kasselpunk, *Samurai.remix* 2002. © Jimpunk 2002. (www.jimpunk.com) **64** Trina Mould aka Rachel Baker, *Dot2Dot Porn*, 1997. Courtesy the artist. **65** Vuk Cosic, *Deep ASCII*, 1998. Java movie player displaying the first online ASCII feature movie. Courtesy the artist. **66** John Simon Jr, *Every Icon*, 1997 © 1997 John F. Simon, Jr. (www.numeral.com) **67** Anni Abrahams, *I Only Have My Name*, 1999. IRC experiment with four Annies. Courtesy the artist. Documentation and reactions on www.bram.org/ident/log2.htm. **68** ®TMark, *Untitled*, from artists' promotional materials, 1999–2000. Courtesy ®TMark. (www.rtmark.com/ads.html) **69** Barbie Liberation Organization (BLO), *Media debris from Barbie Liberation Army campaign*, 1993. Barbie Liberation Organization. (http://users.lmi.net/~eve/barbie.html) **70** Maxis, Inc., *SimCopter Hack*, 1997. Courtesy Maxis, Inc. (www.rtmark.com/simcopter.html) **71** Clover Leary, *Gay Gamete*, 2000. Courtesy the artist. (www.gaygamete.com) **72** Vuk Cosic, *Documenta Done* 1997. Readymade detourné, an artist's copy of the Documenta site after it was taken down by the original publishers. Courtesy the artist. **73** 010010111010101.ORG, *vieweratstar67 @yahoo.com*, 1999. Remix of web pages. No copyright. **74** 010010111010101.ORG, \\0f0003.772p7712 c698c6986, 1999. Remix of web pages. No copyright. **75** Mark Napier, *Digital Landfill*, 1998. HTML, Javascript, Perl. Potatoland.org © Mark Napier. **76** Mark Napier, *The Shredder*, 1998. HTML, Javascript, Perl. Potatoland.org © Mark Napier. **77** Mark Napier, *Riot*, 1999. HTML, Javascript, Perl. Potatoland.org © Mark Napier. **78** 010010111010101.ORG, *Darko Maver*, 1998. Portrait of the non-existent artist. No Copyright. **79** Olia Lialina, *Agatha Appears*, 1997. Courtesy the artist. **80** YOUNG-HAE CHANG HEAVY INDUSTRIES, *Rain on the Sea*, 2001. Courtesy YOUNG-HAE CHANG HEAVY INDUSTRIES. (www.yhchang.com/rain_on_the_sea.html) **81** YOUNG-HAE CHANG HEAVY INDUSTRIES, *Half Breed Apache*, 2001. Courtesy YOUNG-HAE CHANG HEAVY INDUSTRIES. (www.yhchang.com/half_breed_apache.html) **82** Olia Lialina, *Will-N-Testament*, 1997–present. Courtesy the artist. **83** Yael Kanarek, *World of Awe*, 1995–present. Mountain 6_1, Nowheres series, 86.4 x 111.8 (34 x 44), edition 1/1. Courtesy the artist. **84** Shu Lea Cheang, *Buy One Get One*, 1997. Courtesy the artist. **85** Victoria Vesna in collaboration with Robert Nideffer, Ken Fields and Nathan Freitas, *Bodies Inc.*, 1997. Courtesy Victoria Vesna. **86** Heath Bunting and Natalie Jeremijenko, *Biotech Hobbyist*, 1998. Courtesy the artists. **87** Heath Bunting, *Superweed Project*, 1999. Concept and realization Bunting, funded by internet contributors, support by Rachel Baker. **88** Alexei Shulgin, *386 DX*, 1998–present. Sergei Leontiev and Yuri Palmin. **89** Prema Murthy, *Bindigirl*, 1999. Courtesy the artist. **90** *Fakeshop* (Jeff Gompertz, Prema Murthy, Eugene Thacker), *fakeshop.com*, 2002. Courtesy the artists. **91** Graham Crawford, *Mirror Wound*, 1999. Courtesy QAR. © The artist. **92** Mouchette, *Mouchette*, 1996–present. (http://mouchette.org) **93** Candy Factory and YOUNG-HAE CHANG HEAVY INDUSTRIES, *Halbeath*, 2002. Courtesy Candy Factory. (www.trans.artnet.or.jp/~transart/halbeath.html) **94** Candy Factory, *Think The Same*, 2000. For 'project 8' at Total Museum, Seoul, Korea. Courtesy Candy Factory. (www.totalmuseum.org/webproject8/candyfactory/index.html) **95** Candy Factory, *Joyful*, 2000. Courtesy Candy Factory. (www.bekkoame.ne.jp/i/ga2750/joyful/index.html) **96** Takuji Kogo, *Entangled Smile*, 1998. Installation view of first Candy Factory exhibition, Yokohama, Japan, 1998. Courtesy Candy Factory. (www.bekkoame.ne.jp/i/ga2750/oct98.i01.html) **97** Takuji Kogo and Tetsu Takagi, *What an Interesting*

Finger Let Me Suck It, 2001. For Yokohama triennial, Japan, 2001. Courtesy Candy Factory. (www.trans.artnet.or.jp/%7Etransart/index2.html) **98** Carlo Zanni, Landscape, Untitled Napster (alias), 2001. Oil on linen, 128 x 140 (50 x 55). Courtesy the artist. **99** Carmin Karasic, Brett Stalbaum, Ricardo Dominguez and Stefan Wray, FloodNet, 1998. Courtesy Ricardo Dominguez. **100** Mongrel X, From Heritage Gold activities page, 1998. © Mongrel. **101** Mervin Jarman, Container, 1999. Community Art Hactivist 'mongrel' & Interactive Multimedia Designer. (www.container.access-it.org.uk/C-WEB/diag.htm). **102** TOYWAR.battlefield on the internet: showing some of the 2500 TOYWAR. Agents in January 2000, two weeks before eToys INC. signed a settlement and dropped its lawsuit against etoy 2000 © The TOYWAR.soldiers represented by the etoy VC group. **103** Trebor Scholz, 79 Days, 2003. All rights by the artist; produced in co-production with The Banff New Media Institute, The Banff Centre, Banff, Alberta, Canada; and ARTSLINK. **104** Maciej Wisniewski, Instant Places, 2002. Custom-designed software. Courtesy Postmasters Gallery, New York. **105** 01001011010101101.ORG, Life_Sharing, 1999–present. Data visualization made with The Web Stalker. No copyright. **106** Valie Export, Touch Cinema, 1968. Expanded cinema, documentary-photo second presentation, first European meeting of Independent filmmakers, Nov. 1968, Munich/Stacchus. Photo Werner Schulz, Archive Valie Export. **107** Amy Alexander, b0timati0n, 2001. Live performance with search engine. http://botimation.org. **108** Coco Fusco and Ricardo Dominguez, Dolores from 10 to 10, 2001. A net.performance. Presented by Kiasma, Helskini Museum of Contemporary Art, 2001. Courtesy the artists. **109** Josh On, Futurefarmers, They Rule, 2001. Courtesy the artist. (http://www.TheyRule.net) **110** De Geuzen (Riek Sijbring, Renee Turner, Femke Snelting) in collaboration with Michael Murtaugh, Unravelling Histories, 2002. Courtesy the artists. **111** Lisa Jevbratt, 1:1 (2) – Interface: every, 1999/2001. Courtesy the artist. (http://jevbratt.com/1_to_1/) **112** Lisa Jevbratt, 1:1 (2) - Interface: hierarchical, 1999/2001. Courtesy the artist. (http://jevbratt.com/1_to_1/) **113** Lisa Jevbratt, 1:1 (2) - Interface: migration, 1999/2001. Courtesy the artist. (http://jevbratt.com/1_to_1/) **114** Erik Adigard/m.a.d. (with Dave Thau), Timelocator, 2001. Courtesy Erik Adigard/M.A.D. Programming Dave Thau. Curator Benjamin Weil. **115** Benjamin Fry, Anemone, 1999. Courtesy the artist. © 1999–2002 MIT Media Laboratory, Aesthetics + Computation Group. **116** Benjamin Fry, Valence, 1999. Courtesy the artist. © 1999–2002 MIT Media Laboratory, Aesthetics + Computation Group. **117** MTAA (M. River & T. Whid Art Assoc.), website unseen #01: Random Access Mortality, 2002. Multimedia web site. Courtesy computerfinearts.com. (www.mtewww.com/RAM/) **118** Natalie Bookchin, The Intruder, 1999. Courtesy the artist. **119** Paul Johnson, Green v2.0, 2002. Game console, vacuum-formed styrene and computer components, 193 x 193 (76 x 76). Courtesy Postmasters Gallery. © The artist. **120** Brody Condon, love_2.swd (Velvet-Strike spray), 2002. Digital Image. (www.tmpspace.com) **121** Brody Condon, Adam Killer, 2000–2. Computer game modification. (www.tmpspace.com) **122** Documentation of 'Cracking the Maze', curator Anne-Marie Schleiner, site designer Matt Hoessli, 'Cracking the Maze', 1999. Courtesy Anne-Marie Schleiner. (http://switch.sjsu. edu/crackingthemaze/index.html) **123** Melinda Klayman, Sushi Fight, 2001. Courtesy the artist. **124** Eddo Stern, Sheik Attack, 1999, slightly re-edited 2000. Courtesy Eddo Stern. **125** Thomson & Craighead, Trigger Happy, 1998. Courtesy Mobile Home, London. (www.triggerhappy.org) **126** Richard Pierre-Davis/Mongrel, BlackLash, 1998. © Mongrel. **127** Victor Liu, Children of the Bureaucrats of the

Revolution, 2002. Courtesy the artist. **128** Runme.org software art repository, 2003. Developed by Amy Alexander, Olga Goriunova, Alex McLean and Alexei Shulgin. Coded by Alex McLean. Initiated by Alexei Shulgin. Administered by Olga Goriunova and Alexei Shulgin. From 2003 team includes Hans Bernhard and Alessandro Ludovico. **129** Golan Levin, Yearbook Pictures, 2000. © Golan Levin, 2000–1. **130** Golan Levin with Jonathan Feinberg and Cassidy Curtis, Alphabet Synthesis Machine, 2002. Courtesy the artists. **131** Barbara Lattanzi, HF Critical Mass software applied to The Zapruder Film, 2002. Software application, display dimensions 800 x 600 pixels, video still. Courtesy the artist. **132** Tom Betts, QQQ, 2002. Courtesy the artist. www.nullpointer.co.uk and www.q-q-q.net) **133** Sawad Brooks, the code for Global City, for Saskia Sassen, 2002. Custom and open-source software, and internet. Courtesy Sawad Brooks. **134** Sawad Brooks, Global City, for Saskia Sassen, 2002. Custom and open-source software, and internet. Courtesy Sawad Brooks. **135** Camille Utterback, Linescape.cpp, 2002. Courtesy the artist. **136** Martin Wattenberg, Connection Study, 2002. © The artist, 2002. Commission of the Whitney Museum of American Art as part of the 'CODeDOC' project. **137** Golan Levin, Axis, 2002. Online Java applet. © Golan Levin, 2002. Commission of the Whitney Museum of American Art as part of the 'CODeDOC' project. **138** Graham Harwood, Code for London.pl, 2002. © Mongrel. **139** Andy Deck, Glyphiti, 2001. Courtesy the artist. (www.artcontext.org/glyphiti) **140** Mongrel, Linker, 1999. © Mongrel. **141** c a l c (Teresa Alonso Novo, Looks Brunner, tOmi Scheiderbauer, Silke Sporn) and Johannes Gees, communimage, 1999. Collaborative net art project. (www.communimage.net) © c a l c and Johannes Gees. **142** Josh On, Amy Franceschini and Brian Won of Futurefarmers, Communiculture, 2001. Courtesy the artists. **143** Mongrel, Nine(9), 2003. Currently running at (www.9.waag.org). © The artists. **144** Mongrel, Nine(9), 2003. Left: An image from the Map: 'Killing Snails' at Archive: 'Invisibles' at Group: Group 8. Currently running at (www.9.waag.org). © The artists Mongrel, Nine (9), 2003. Right: An image from the Map: 'No Camping' at Archive: 'Invisibles' at Group: Group 8. Currently running at (www.9.waag.org). © The artists. **145** Harwood/Mongrel, Uncomfortable Proximity, 2000. Courtesy the artists. (http://www.tate.org.uk/netart/mongrel/home/default.htm) **146** Wolfgang Staehle, Untitled, 2001. Live video projection at Postmasters Gallery, New York. Courtesy the artist. **147** Jonah Brucker-Cohen and RSG, PoliceState, 2003. A Carnivore client. © Jonah Brucker-Cohen and RSG. **148** Yucef Merhi, Maximum Security, 2002. The project – Christian Haye. **149** Alex Jarrett, Confluence, 1996–present. (www.confluence.org/photo.php?visitid=6302&pic=1). Confluence 2ON 56E, 25 November 2002, Axel Nelms. **150** tsunamii.net (Charles Lim Yi Yong and Woon Tien Wei), Alpha 3.3 (detail of the walk), 2001. Photo Foo. © tsunamii.net. **151** James Buckhouse, Tap, 2002. Software project for Personal Digital Assistants, Internet and BeamingStations. In collaboration with Holly Brubach, with dancer Christopher Wheeldon and programmer Scott Snibbe. © James Buckhouse. **152** Heath Bunting, from BorderXing, 2002. Courtesy the artist. **153** warchalking.org, Warchalking Pocket Card, 2001–present. Courtesy warchalking.org. **154** Bureau d'Etudes, Lagardère, Chroniques de guerre, 2003. © Bureau d'Etudes. (www.universite-tangente.fr.st) **155** Yuri Gitman and Carlos Gomez de Llarena, Noderunner, 2002. Produced and curated by Jonah Peretti/Eyebeam. Courtesy Eyebeam and NYCwireless/noderunner.com. **156** Minerva Cuevas, MejorVida Corporation, 1999. Courtesy the artist. (Mejor Vida Corp. web site: www.irational.org/mvc) **157** John D. Freyer, All My Life for Sale, 2001. Courtesy the artist. **158** AKSHUN (artists' group), 73,440

Minutes Of Fame Available Now On eBay, 1999. Akshun Artists' Group – Calarts 1999. **159** Michael Mandiberg, Shop Mandiberg, 2000–1. Web site and performance. Courtesy the artist. © Walker Evans Archive, The Metropolitan Museum of Art, New York. **160** Keith Obadike, Blackness For Sale, 2001. (www.blacknetart.com) © Keith Townsend Obadike. All rights reserved. **161** Millie Niss, Self-help, 2002. Courtesy the artist. First appeared on www.bannerart.org, edited by Brandan Barr and Garrett Lynch. **162** Thomson & Craighead, Dot-Store, 2002. (www.dot-store.com) © The artists. **163** Sebastian Luetgert, Textz.com, 2002. No copyright textz.com. **164** Shu Lea Cheang, Burn, 2003. Web interface. Courtesy the artist **165** Michael Mandiberg, AfterSherrieLevine.com, 2001. Web site. Courtesy the artist. **166** Motomichi Nakamura, Bcc (Blank Carbon Copy), December 2001. Still image. Interactive animation created with macromedia Flash. © C 2003, Motomichi Nakamura. All rights reserved. (www.motomichi.com) **167** Victor Liu, Delter, 2002. Courtesy the artist. **168** Elka Krajewska, still from 47 Seconds, 2002. Digital movie, colour with sound, approx. viewing size 7 x 12.1 (2 3/4 x 4 3/4). (www.elka.net) **169** Adrian Miles, Bergen Sky, 12.9.02. Net art, networked interactive desktop video. Courtesy the artist. **170** Scott Pagano, Ephemeral Textures, 2002–present. Courtesy the artist. (www.neither-field.com) **171** Ricardo Miranda Zúñiga, 1000 Icons, 2002. Software and technology used: Illustrator, HTML, Javascript and Macromedia Flash. Concept, design and implementation by Ricardo Miranda Zúñiga. **172** Prema Murthy, Mythic Hybrid, 2002. 2002 commission of New Radio and Performing Arts, Inc., for its Turbulence.org web site. It was made possible with funding from the Greenwall Foundation. **173** Olia Lialina and Dragan Espenschied, Zombie and Mummy, 2002–present. Courtesy the artists. **174** Lew Baldwin, Good World, 2002. Programmer Charlie Killian. Courtesy the artist. **175** Cory Arcangel, still from the Turbulence.org commission Data Diaries, movies made out of the raw RAM data from a personal computer, 2002. © Cory Archangel/Beige. **176** Cory Arcangel, Data Diaries, 2003. Commission of New Radio and Performing Arts, Inc. (aka Ether-Ore), for its Turbulence.org web site. It was made possible with funding from the Jerome Foundation. © Cory Arcangel/Beige. **177** Paperrad, Homepage, 2002. HTML art with animated GIF retinal dazzle background and table using Dreamweaver 1.0. Courtesy the artists. (www.paperrad.org). **178** Paperrad, New Sponsors Page, 2002. HTML art with hand-scanned images of real-life pictures using Dreamweaver 1.0. Courtesy the artists. (www.paperrad.org) **179** Miranda July and Harrell Fletcher, Learning to Love You More, 2002–present. Courtesy the artists. Web design by Yuri Ono. **180** Michael Weinkove, Talkaoke table animation, 2002. GIF animation from the front page of www.talkaoke.com. **181** Jonah Peretti and Chelsea Peretti, Black People Love Us, 2002. Courtesy Jonah Peretti. (www.blackpeopleloveus.com) **182** Adam Chodzko, Product Recall, 1994. Off-set lithographic poster, 29.8 x 21.1 (11 ¾ x 8 ¼) and 8 minute video. Courtesy the artist. **183** Radioqualia (Honor Harger and Adam Hyde), Free Radio Linux, 3 February 2002–present. Courtesy Radioqualia. (www.radioqualia.net/freeradiolinux) **184** De Geuzen (Riek Sijbring, Renee Turner, Femke Snelting), D.I.Y., 2002. Courtesy the artists. **185** Rachel Baker, Platform, 2002. Courtesy the artist. **186** Graham Harwood and Matthew Fuller, Text FM, 2000–1. © Mongrel. **187** Olia Lialina and Heath Bunting, IDENTITISWAPDATABASE, 1999. Courtesy the artists. **188** LAN, Tracenoizer, 2001. © LAN

Index

Page numbers in *italic* refer to illustrations